A PASSION FOR RENOIR

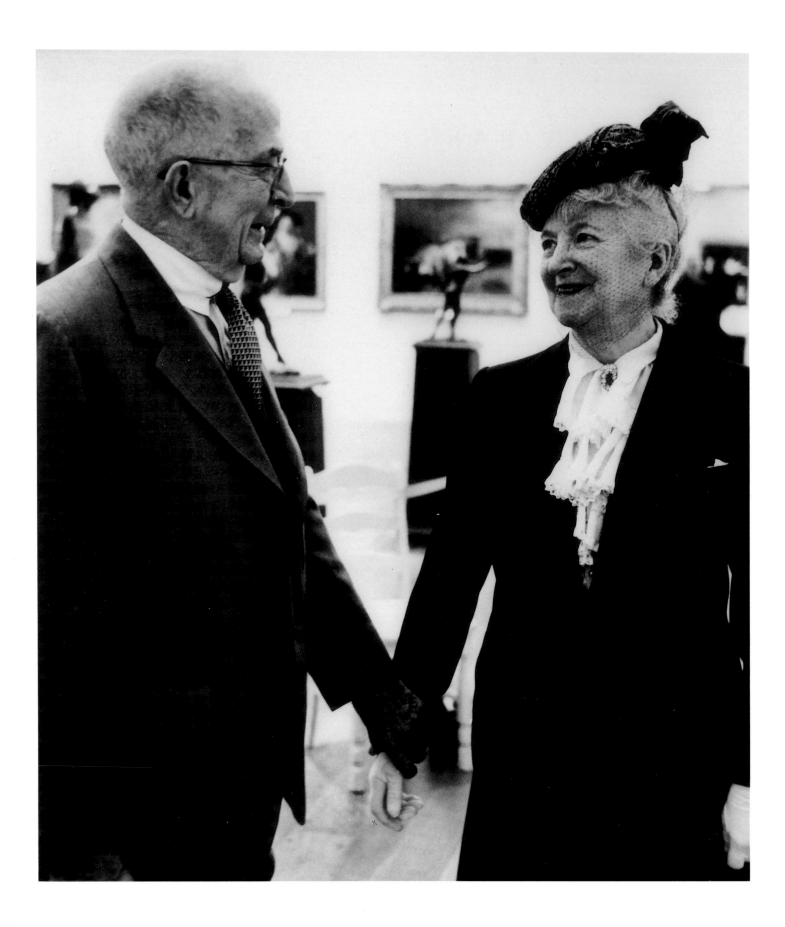

A PASSION FOR
RENOIR

Sterling and Francine Clark Collect
1916–1951

STEVEN KERN

KARYN ESIELONIS

PATRICIA R. IVINSKI

REBECCA MOLHOLT

KATE BURKE

HARRY N. ABRAMS, INC., PUBLISHERS
IN ASSOCIATION WITH
STERLING AND FRANCINE CLARK ART INSTITUTE

PROJECT MANAGER: MARGARET RENNOLDS CHACE

EDITOR: MARGARET DONOVAN

DESIGNERS: JUDITH MICHAEL AND BETH TONDREAU

This catalogue was published in conjunction with the exhibition
"A Passion for Renoir: Sterling and Francine Clark Collect, 1916–1951,"
Sterling and Francine Clark Art Institute, Williamstown, Massachusetts,
August 3, 1996–January 5, 1997.

Page 2: Sterling and Francine Clark at the opening of the Institute, May 1955
Page 8: Sterling and Francine Clark Art Institute, gallery 2, popularly known
as the Renoir room, November 1995

LIBRARY OF CONGRESS
CATALOGING-IN-PUBLICATION DATA
Kern, Steven.
A passion for Renoir : Sterling and Francine Clark collect,
1916–1951 / director's preface by Michael Conforti ; text by Steven
Kern ; catalogue entries by Karyn Esielonis . . . [et al.].
p. cm.
"In association with Sterling and Francine Clark Art Institute."
Includes bibliographical references and index.
ISBN 0–8109–3746–8 (clothbound). — ISBN 0–931102–37–5 (museum pbk.)
1. Renoir, Auguste, 1841–1919—Exhibitions. 2. Painting—
Massachusetts—Williamstown—Exhibitions. 3. Sterling and Francine
Clark Art Institute—Exhibitions. I. Title.
ND553.R45A4 1996
759.4—dc20 95–47829

CONTENTS

PREFACE

In 1918 Leo Stein, the brother of the author Gertrude and a Parisian art world cognoscente in his own right, commented on the current popularity of one of the original and regular exhibitors to the Impressionist exhibitions of the 1870s: "Renoir lovers are insatiable, collectors of his pictures have them by the scores and find that each accession adds not itself alone, but gives addition also to the life of all the others." Stein was referring to a group of collectors who had begun to buy important works by Renoir. Dr. Albert C. Barnes, Sterling Clark, Duncan Phillips, and Chester Dale, among others, would make the best of the artist's works their own. Each was reacting in the marketplace to the artist's current critical popularity, which Guillaume Apollinaire had expressed in these words in 1912: "aged Renoir, the greatest painter of our time and one of the greatest painters of all time." It was this widely held belief that motivated auction and dealer transactions in the 1920s and 1930s, and that placed the prices for Renoir far above those for artists we now seem to favor more—from Degas to Monet, to Post-Impressionists like Cézanne, van Gogh, and Gauguin.

In his essay for this book, Steven Kern explores the early-twentieth-century taste for Renoir through an analysis of the extensive diary entries of Robert Sterling Clark, who with the constant and much valued advice of his wife, Francine, collected some of the finest of Renoir's works. By 1942 Clark had acquired more than thirty paintings by the artist; he was to give thirty-eight to the museum he founded when it opened in 1955. Clark's opinions, as revealed in his personal diaries—especially his opinions regarding the importance of Renoir's early work—show a passionate commitment to works of art in general, and to paintings by Renoir in particular.

Sterling Clark's taste was an international one, formed in the period between the wars, and it now has permanent expression in the museum he established in Williamstown, Massachusetts.

MICHAEL CONFORTI
Director

ACKNOWLEDGMENTS

It happens, as everyone knows, that the best ideas are often overlooked, thought to be much too obvious for attention. Such is the case with Sterling and Francine Clark and their collection of paintings by Renoir. The French Impressionist artist was certainly the Clarks' favorite (they purchased thirty-eight paintings); they were highly selective in their choice of paintings and clearly prejudiced in their likes and dislikes (the majority of the paintings are early works, completed before 1885); Robert Sterling Clark kept extensive diaries (so we know at least some of his thoughts and opinions as he collected). Yet the subject of the Clarks and Renoir has never been seriously discussed and explored. It was thus with great excitement that we all embraced this project as the culmination of the fortieth anniversary of the Sterling and Francine Clark Art Institute.

Many people worked hard to guarantee the success of this catalogue. I would first like to thank the writers who contributed essays: assistant curator Patricia R. Ivinski, curatorial assistant Rebecca Molholt, and Karyn Esielonis, who made the task look easy, provided insightful conversation, and always laughed at just the right time. I am deeply grateful to all of them for their intelligence and hard work. I would also like to thank curatorial assistant Kate Burke, who came in at the eleventh hour and diligently pulled together many details, including the chronology and bibliography. Many others at the Institute deserve heartfelt thanks: in the library, Paige Carter, Susan Roeper, and Sally Gibson spent many hours tracking down early periodicals, articles, catalogues, and reviews of Renoir's work; in the curatorial department, Lisa Jolin, Beth Wees, Paul Dion, and Martha Asher offered steady and cheerful support. I was rescued on a number of occasions by Sherrill Ingalls and Ben Hogue, whose computer expertise saved me, the project, and the hardware from serious harm. I am grateful to Arthur Evans and Merry Armata for their fine work behind the camera and in the darkroom. I would like to extend special thanks to Mary Jo Carpenter for her attention to detail, Michael Conforti for his drive for excellence, and David Brooke for his unparalleled knowledge of Clark archival material and the diaries.

In trying to place the Clarks and their collecting in a greater context, I required the assistance of many colleagues at other organizations who provided valuable advice and information: Robert Boardingham, Carol Troyon, and Patricia Loiko at the Museum of Fine Arts, Boston; Mary Suzor at the National Gallery of Art; Mary Solt at the Art Institute of Chicago; Katie Rothkopf at the Phillips Collection; Laura Linton at the Barnes Foundation; James Martin at the Williamstown Art Conservation Center; Barbara File at the Metropolitan Museum of Art; Dominic Tambini at Wildenstein and Company; and Norman Hirschl. I am grateful for their time and efforts.

The production of the catalogue has benefited greatly from the expertise of several people. I would like to thank Fronia W. Simpson, who served as both reader and editor in the early stages of the manuscript. Her knowledge of the collection, keen mind, and sense of humor were terrific. It was also a privilege to work with the staff at Abrams: Margaret Rennolds Chace, Margaret Donovan, Judith Michael, Beth Tondreau, and Amy Vinchesi. Their professionalism, patience, and high standards are exemplary, and I thank them for it.

Finally, I would like to thank my wife, Joséphine, as well as Sally and Jake for their tolerance of the demands that the Clarks and Renoir made on my time.

STEVEN KERN
Curator of Paintings

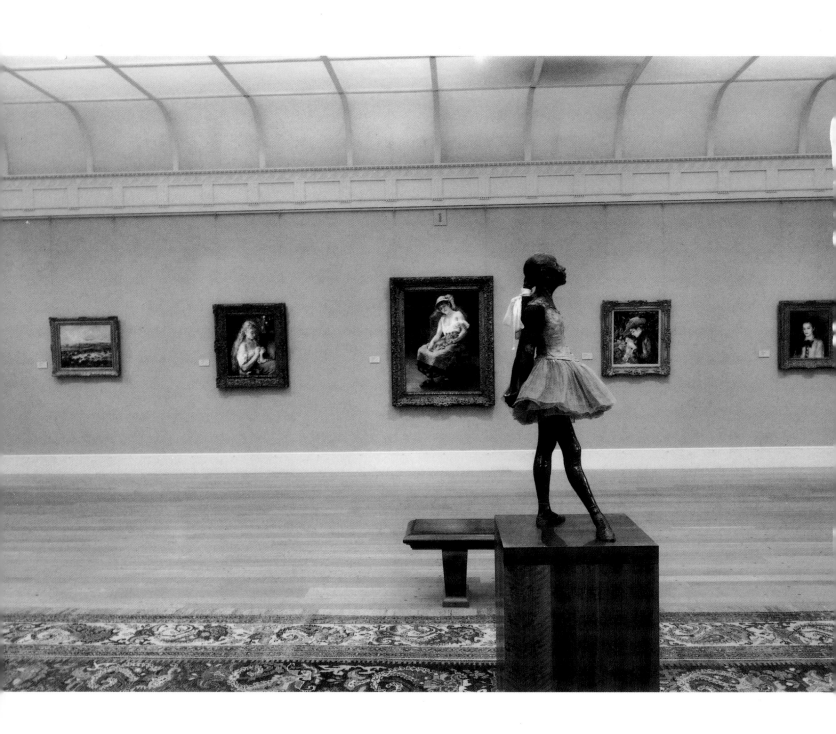

A PASSION FOR RENOIR

At the beginning of April 1942, the staff of the Durand-Ruel Galleries in New York were putting the finishing touches on an exhibition of late paintings by Pierre-Auguste Renoir, their second in six years. After one of his almost daily visits to the gallery, Robert Sterling Clark wrote in his diary, "Elfers [the gallery's director] occupied with opening of Late Renoir Exhibition. [He] told me that the critics had praised the Renoir Exhibition & most satisfactory opening."[1] Clark did not share the opinion of either Herbert Elfers or the critics regarding Renoir's late work. By 1942 Clark owned about thirty canvases by the French Impressionist master, all but a few painted before 1885. Elfers had tried in vain to convince Clark to add a major late work to his collection, but Clark wrote of their discussion, "I could not agree entirely with him on his [Renoir's] late manner—Elfers acknowledged that [in] 1879–1882 all or at least 90% of Renoirs were wonderful & after 1900 only some 10% but insisted they had more volume. . . . I could not agree they had more volume nor that any were as fine as the 1879–1882 period—limbs filled with air" (January 22, 1942).

While Clark's sentiments may have paralleled some of those of Renoir's critics,[2] Edward Alden Jewell of the *New York Times* was favorably struck by the exhibition and "emerged an ardent admirer."[3] He referred to the work of Renoir's last two decades as the artist's "culminating triumph."[4] The reviewer for *Artnews* compared the style of Renoir's old age with that of Titian and Rembrandt and found in his late paintings "as veracious an expression of the twentieth century as his earlier gracious and pearly pieces were of the nineteenth."[5] Collectors agreed with Elfers and the critics as well, and especially during World War II, demand for Renoir's work, whether early or late, was so great that dealers were unable to keep up with it and prices were at a premium. "People are positively crazy about Renoir," Clark wrote near the end of the war (May 19, 1945), and it was no exaggeration. For many reasons—financial, philosophical, and aesthetic—Pierre-Auguste Renoir, in terms of sales and public appreciation, was perhaps the most successful artist in America in the first half of the twentieth century. Clark had neither the largest collection of Renoir's paintings (Dr. Albert C. Barnes owned 181) nor the most important work (Duncan Phillips, who purchased *Luncheon of the Boating Party* in 1923, had that distinction). With a highly personal eye for paint and subject matter, and a prejudice for Renoir's early work, however, Clark was arguably the greatest private collector of the French Impressionist's work.

Robert Sterling Clark was born into a prominent New York family in 1877, the second of the four sons of Alfred Corning and Elizabeth Scriven Clark. New York socialites, collectors, and patrons of the arts, the couple must have instilled the principles of public service and love of art in their boys along with the appreciation of genteel living that only substantial wealth can support.[6] This came in the form of a sizable inheritance from Edward Cabot Clark, Alfred Corning's father. He had been Isaac Singer's business partner and had helped the inventor navigate the stormy waters of patent law relating to the sewing machine.[7] The interests of the four brothers did not vary greatly and included a deep devotion to their hometown, Cooperstown, New York, an avid interest in breeding Thoroughbred horses, and the passionate collecting of art.

Following his graduation from Yale's Sheffield School in 1899, Clark served for six years in the United States Army, where he saw action against the Moros in the Philippines and later against the Boxers in China, where he won a Silver Star. In 1908 and 1909 he led a scientific expedition to the deserts of northern China and in 1912 published its results.[8] These military

and expeditionary experiences made a strong impression on Clark, and he kept a certain air of the military in his demeanor throughout his life. He was known for being gruff and formal; Charles Durand-Ruel recalled, many years later, that "he [Clark] retained a certain roughness and picturesque manners. He used, only among men, military language where 'Son of a b . . . ,' 'Son of a g . . . ' or 'Stick in the mud' were frequent."[9]

In 1909 Sterling and his three brothers divided their parents' estate.[10] By 1913 Théodore Géricault's *Trumpeter of the Hussars on Horseback* (c. 1815–20), Jean-François Millet's *Water Carrier* (c. 1860; fig. 1), and Gilbert Stuart's *George Washington* (after 1796), among other pictures, had passed from his parents' to Clark's growing collection. As correspondence between Sterling and his younger brother Stephen indicates, in 1910 Sterling went to Europe and by 1911 had settled in Paris. In 1913 he and Stephen engaged the services of George Grey Barnard as guide for an art-buying trip from March through May, beginning in Paris and ending in Florence.[11] Barnard was a well-known sculptor, patronized by Alfred Corning Clark, and a celebrated collector.[12] Even as he made his first steps as a collector, Clark was both confident and independent, and Barnard cannot be credited with advising Clark on any purchases. His principal role

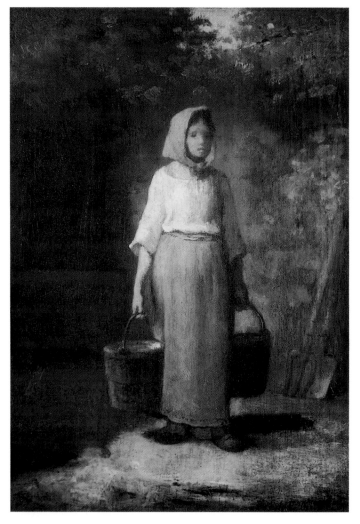

Figure 1. Jean-François Millet
The Water Carrier
c. 1860
Oil on panel, 10¼ x 7³⁄₁₆ in. (26.1 x 18.3 cm)
Sterling and Francine Clark Art Institute, 1955.551

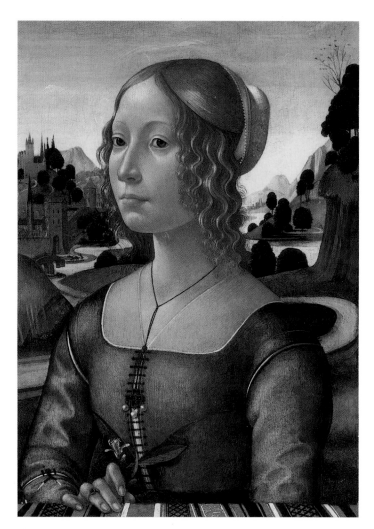

Figure 2. Domenico Ghirlandaio
Portrait of a Lady
c. 1490
Tempera and oil on panel, 22¹⁄₁₆ x 14¹³⁄₁₆ in. (56.1 x 37.7 cm)
Sterling and Francine Clark Art Institute, 1955.938

on the Clark trip was as a facilitator in negotiating the details of sale.

Clark's initial purchases focused largely on the finest old masters, an emphasis that was a relatively new direction for American collectors to take. It had begun in Boston about 1890 with Isabella Stewart Gardner, who collected under the guidance of Bernard Berenson. The collecting of Renaissance masters in the period before World War I, while seemingly conservative, was at the forefront of taste, driven largely by dealers working with wealthy American industrialists. This taste for the old masters increased through the war and reached a zenith in the 1920s with now-famous collectors such as Andrew Mellon and Henry Frick. Clark's first purchase, on his trip with his brother and Barnard, was Domenico Ghirlandaio's *Portrait of a Lady* (c. 1490; fig. 2), followed a year later by *Virgin and Child Enthroned with Four Angels* by Piero della Francesca (c. 1460–70; fig. 3) and *Sepulcrum Christi* (c. 1498) by Perugino. His purchases of more contemporary works were almost exclusively restricted to American art, for example, John Singer Sargent's *Venetian Interior* (c. 1880–82; fig. 4), purchased from M. Knoedler and Company, Paris, also in 1913.

In 1916, when Clark bought his first painting by Renoir,

he had already been a full-time resident of Paris for about five years. The attraction of the French capital was understandable: excitement, entertainment, museums, and culture. Clark would have had access to everything from café-concerts and music halls to cinema and highbrow theater. On the one hand, Paris was a city "which laughs, sings, dances, and shouts, eats and drinks from twilight to dawn,"[13] and on the other, it was the world of Gertrude Stein, who said that Paris was the twentieth century.[14] Whether or not Clark was familiar with the expression "Good Americans, when they die, go to Paris,"[15] his letters to his brother Stephen are an accurate indication, without specific references to either artists or works, that he had settled nicely into the life of connoisseur and art collector. His principal residence remained in Paris until his return to New York, with his wife, Francine, in the early 1920s.

Francine's importance in Sterling's collecting cannot be stressed highly enough. While little is known about her—unlike her husband, she did not keep diaries and much of their time together in Paris remains undocumented—it seems that Sterling met Francine Clary shortly after his arrival in Paris about 1910. She had been a member of the acting company at the Comédie-Française, the most prestigious theater in France, from 1904 until 1910, and would have been familiar with Parisian society as well as the arts establishment of the city. Francine became an

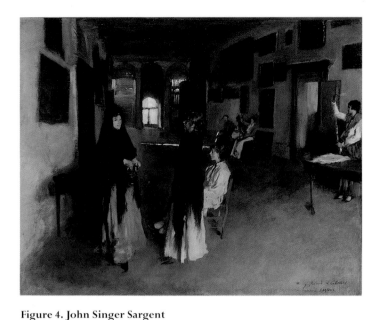

Figure 4. John Singer Sargent
A Venetian Interior
c. 1880–82
Oil on canvas, 19⅟₁₆ x 23¹⁵⁄₁₆ in. (48.4 x 60.8 cm)
Sterling and Francine Clark Art Institute, 1955.580

active collecting partner with Sterling, and it is possible to read her influence on his taste as early as the 1916 Renoir purchase, for the Clark collection was taking a decidedly French turn. While it is true that Sterling did not rely on outside advisers while forming his collection, Francine was an exception, and the documentation of her importance is found throughout his diaries. Virtually not a single painting was purchased by Sterling after about 1920 without the opinion of Francine, whom he married in 1919. Sterling admitted that he "never bought a painting without her" (May 9, 1928). He considered her his touchstone in evaluating pictures, "an excellent judge, much better than I at times."[16]

Francine Clark did indeed help shape the collection with her views. Perhaps the most notable example is the case of Henri de Toulouse-Lautrec's *Jane Avril* (c. 1891–92; fig. 5). "I could see that Francine was impressed and very much so," Clark wrote. "I asked how much—Felix Wildenstein said $45,000 to me, asking $55,000. . . . Expensive yes but a fancy picture. . . . Francine was very strong for buying the 'Jeanne Avril' —A Chef d'oeuvre she said—we returned and she said she would like it. . . . Home— never saw Francine more enthusiastic over a picture!!!!" (February 3, 1940). Her opinions, though, were equally as strong concerning Renoir. About *Sleeping Girl with a Cat,* Clark recorded that "Francine was right, it is a marvellous picture" (June 1, 1926) and about *At the Concert,* "F. thought it great & as fine as the 'Fille au Chat'" (May 10, 1928). About the *Blonde Bather,* "she thought it a marvel," even though Clark himself considered it weak in both drawing and composition. The weight of Francine's opinion is perhaps most evident with regard to *Mademoiselle Fleury in Algerian Costume.* When the Clarks were discussing this painting with Stevenson Scott in 1929, Clark admitted he knew the picture,[17] and that "notwithstanding [Scott's] enthusiasm for its quality it had a fault, the little girl was dwarfish & my wife had

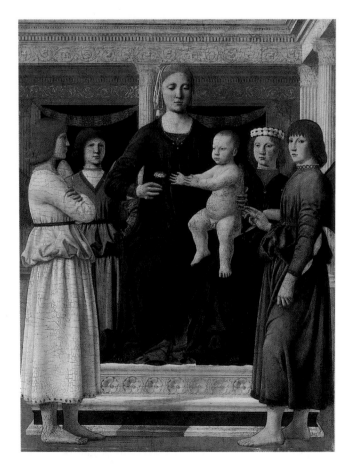

Figure 3. Piero della Francesca
Virgin and Child Enthroned with Four Angels
c. 1460–70
Oil, possibly with some tempera, on panel, transferred to fabric on panel,
42⁷⁄₁₆ x 30⅞ in. (107.8 x 78.4 cm)
Sterling and Francine Clark Art Institute, 1955.948

remarked on this feature" (April 8, 1929). Clark let the painting pass. Eight years later, however, the painting was offered again. This time Clark wrote that "it looked fine & the child less dwarf than I remembered it" (January 19, 1937). Francine also passed judgment on the painting again, "and this time . . . wondered why she had thought the child dwarfish before" (March 23, 1937).

It is, indeed, tempting to see Francine as a primary force in turning Clark toward collecting Impressionism. Her influence, combined with that of Paris during the late Belle Epoque, must have exerted pressure on the relatively young collector. It has, in fact, been suggested that in her own refined, quiet way, it was Francine who had the stronger opinions.[18]

With collecting in his blood, a supportive and strong partner, and a fine collection of drawings, rare books, and old-master and American paintings, Clark embarked on a great adventure in 1916 when he purchased Renoir's *Girl Crocheting* from Stevenson Scott of Scott and Fowles in New York. Clark repeated the story in his diaries a number of times through the years: "The first Renoir [Scott] had ever bought was the 'Fille blonde tricottant' from the Lambert Sale[19] & which he sold to

Figure 5. Henri de Toulouse-Lautrec
Jane Avril
c. 1891–92
Oil on cardboard, mounted on panel, 24⅞ x 16⅝ in. (63.2 x 42.2 cm)
Sterling and Francine Clark Art Institute, 1955.566

me. He got it for $16,300 & sold it to me for $25,000" (April 8, 1929).[20] Within a matter of years, Renoir was to become a consuming passion, certainly Clark's favorite artist. Leo Stein, the famous expatriate collector, and brother of the more famous expatriate writer Gertrude Stein, was known for his remarkable collection of Renoirs, with sixteen paintings in his collection by the early 1920s.[21] "Renoir lovers are insatiable," Stein wrote in 1918. "Collectors of his pictures have them by the scores and find that each accession adds not itself alone, but gives addition also to the life of all the others."[22]

Besides Francine's influence on him, other important factors encouraged Clark to turn toward the collecting of Renoir and the Impressionists. First of all, he had a perception that the old-master market had begun to dry up. "The big American collections like Frick, Widener, Taft, Altman, Huntington have absorbed most of the available ones." The New York dealers "have not been able to buy many good pictures. Stock low. And they could sell them if they had them. There is no doubt about it, the old master is a thing of the past" (October 2, 1924). Clark's perception is particularly interesting given that the collectors he mentioned continued to purchase old-master paintings, with significant acquisitions being made until quite late in the 1920s.

As a keen follower of Wall Street and of changes in the stock market, Clark was certainly aware that the Impressionists were a relative bargain on the art market. In 1914 Clark purchased Piero della Francesca's important altarpiece *Virgin and Child Enthroned with Four Angels* from Colnaghi's in London for $35,000. That same year he bought John Singer Sargent's *Smoke of Ambergris* (1880) from Knoedler's for $27,500. Paying $20,000 in 1916 for a major Renoir, Clark was certainly pleased with the price as well as the picture: "The girl was pretty & the coloring & paint particularly attractive. . . . I had seen Renoirs at the Dollfus Sale in 1911 [*sic*][23] & after buying 'la Fille blonde tricottant' [*A Girl Crocheting*] I had been astonished I had not appreciated those more & had looked them up in the catalogue & that I had found they were nothing like as fine" (April 8, 1929).

Clark was also acutely aware of purchasing art that retained its value. "Same old story about fashion in pictures," he wrote in his diary. "40 years ago [about 1900] my mother gave somewhere near $50,000 for the fine Wazermann Mauve—It would not bring more than $10,000 at most today & probably only $5,000!!!!" (January 28, 1939). About his purchases of Impressionist paintings, Clark was more optimistic, if hopelessly mistaken. "Van Goghs and Toulouse-Lautrecs and Cézannes are 4 to 5 times the price they will bring 20 or 30 years from now—Degas will hold better—Monets, Pissarros, Sisleys are not nearly so high in proportion & should lose about 50%—Renoirs, early ones, should lose not more than 50% and in some cases the very fine ones should nearly keep their present price although they are very expensive pictures at the present time!!!! I speak of such works as my 'La Fille au Chat' [*Sleeping Girl with a Cat*], 'Le Concert' [*At the Concert*] . . . or 'La Baigneuse blonde' [*Blonde Bather*] . . . all $100,000 pictures" (January 29, 1939).

Clark knew the market well and monitored prices at all times; keeping track of the value of paintings was an intellectual

exercise for him. In 1943, when Renoir prices seemed to be at their highest, he wrote, "Heaven knows what my finest Renoirs are worth!!!! I should say [they] have doubled in value at least!!!! As to 'la Fille au Crochet' [*A Girl Crocheting*] I bought from Scott & Fowles in 1917 [*sic*] it is worth at least 5 times what I paid for it!!!!" (March 6, 1943). Even more dramatic was the increase in value of *Marie-Thérèse Durand-Ruel Sewing* in only two years. After the picture was shown in an exhibition at the Durand-Ruel Galleries in 1939, Clark was surprised that "one man said he would give $100,000 for it!!!! I paid $25,000 for it . . . in 1937 [*sic*] when things were low" (March 31, 1939). While Clark clearly enjoyed the return on his money, investment was not his reason for purchasing paintings; love for the artwork came first. For example, when it was suggested that, in 1942, Renoir was at his highest point whereas Monet was only at about half,[24] Clark did not turn from Renoir to the other Impressionist master in search of a bargain; in fact, he didn't purchase a painting by Monet until five years later, when he found one he liked.

Clark was a self-trained connoisseur. With no formal education in art history or art appreciation, he relied on his own eye and, above all, his innate taste, which he believed was the key to success. He recorded his observations on this subject in his diaries: "Kitty wants to learn but I am not sure she has the natural taste. Told her to form her taste by seeing art, not by reading about it" (December 5, 1924). On another occasion, after having dinner with a Harvard art student, Clark wrote, "He was frank enough to say he could not stand Gauguin, Cézanne etc. & was jumped on by professor. Told him he was right from my point of view . . . that if one did not have his own appreciation & opinion he could judge nothing. Art history very secondary. Seeing, seeing only way to learn to have a trained eye. Showed him my Renoirs. He was wild about them. Said he would tell them at Harvard he had seen Renoirs the Fogg Museum did not have" (April 8, 1929). And not only was art history secondary, so was technical analysis, which was becoming an increasingly dominant method of art research:[25] "All the x-rays, chemical analyses, and scientific approach of art is all piffle if you have not an eye!!!" (March 26, 1942). In short, Clark's method can be summed up as "look, look, and look again, and [don't] be influenced by anyone in . . . likes and dislikes" (April 26, 1945).

Given his highly personal approach to art, paired with his disdain for formal art study, it is no surprise that Clark looked at the art historians, professors, curators, and museum directors of his time with a jaundiced eye. He thought they knew a lot about a very limited area and relied too heavily on studies rather than their eyes. While Clark may have felt a certain distaste for scholars, he did maintain a library, containing mostly reference books—exhibition or collection catalogues, art-history surveys, and current volumes anecdotal in nature. Much of his understanding of Renoir, for example, came from Ambroise Vollard's very popular 1919 biography of the artist,[26] now regarded as a confection by the dealer based more on tradition, invention, and hearsay than on fact.[27] It is interesting to note, however, that Clark recognized the limitations of his chosen reading. He wrote to a friend, "If you have not read it read

Renoir by Ambrose [*sic*] Vollard. The old man gives some reflections which are not bad on painting in general." Clark continued, "The first half of the book is good—Vollard got in Renoir late & tried to persuade buyers his later works were the best after 1887." Clark, of course, disagreed with Vollard's assessment, since he believed Renoir was at his best in 1880 or 1881.[28]

One of Clark's most important sources of information on Renoir was personal contact with people who had known the artist. The anecdotes they shared, while often critical of the artist, certainly brought him to life for the collector. Clark received the French restorer M. J. Rougeron at his New York apartment. After a few minutes of formality, and the arrival of Francine to break the ice, Rougeron began telling stories of the artists he had known: Carolus-Duran, Jules Lefebvre, Berthe Morisot, and Renoir himself. Clark recorded in his diary that Renoir was described as "disorderly & dirty drunk twice a week, always after the women but what an eye & what taste & what an imagination!! He would get any sort of little model off the boulevards exterieurs, pose her on the side of platform & make an idealized 'baigneuse'" (January 29, 1929).

From Charles Durand-Ruel, Clark learned that "Renoir not educated but wonderfully sensitive & with that wonderful innate French taste—Mme Renoir could hardly write and was a peasant—Charles had spent three weeks with them in 1915 when he was 15 years old . . . Mme Renoir frequently raised hell but Renoir simply said nothing & took refuge in painting" (March 20, 1939).

Clark's greatest source of intellectual stimulation on the subject of art and painters was contact with dealers. While he was suspicious of art historians, critics, and museum people, he entered with relish into the circle of picture sellers, especially on what he called the Fifty-seventh Street art island, the location of his favorite New York galleries. His visits to the dealers were an almost daily activity, and his diaries record his going from one to the next to chat and check out the stock. Charles Durand-Ruel described Clark's visits: "When a painting captured his imagination, he brandished the cane he usually carried with him, twirling it and pointing at the canvas, much to the alarm of our faithful black porters who adored him since he treated them as old friends."[29] Aside from serious and often lengthy conversations about art, Clark's visits to the dealers included gossip, quizzing, goading, and even advice. He considered himself so much in kinship with dealers that when, on at least two occasions, he was mistaken for one, he thought it the highest of praise.[30]

Just as Clark had his favorite artists, he had his favorite dealers. In fact, he purchased well over half his paintings from the houses of Knoedler and Durand-Ruel. Of his collection of thirty-eight paintings by Renoir, Clark bought twenty-eight from Durand-Ruel.[31] Following the purchase of his first Renoir from them, *The Onions*, in 1922, Clark developed a friendly relationship with the gallery and the people who ran it. He was very close to Paul and Georges Durand-Ruel, a relationship that grew even deeper with Paul's sons. "In 1946, when my brother and I took turns going to New York," wrote Charles Durand-

Ruel, "our friendship with the Clarks became real affection. . . . [They] could have been our parents and they treated us like their children."[32] From 1938 Durand-Ruel's let Clark "have [a] big room for airing [his] pictures" (October 4, 1938). Until then, he had rented space at Manhattan Storage for the bulk of his collection, with some works in Paris and at Sundridge, his estate in Upperville, Virginia, as well as selected paintings rotating at his New York apartment. On the third floor of Durand-Ruel's building, a gallery was fashioned into a storage area with room to hang a few pictures. As Charles Durand-Ruel described it, "Some paintings were hung rather high and the rest, without frames, were stacked by the dozen in order of size along the walls. He would spend hours looking at them . . . [and] when he found one that particularly pleased him, he made us take it from the stack . . . [and he] would look at it at length while discussing its qualities with us."[33]

Clark's affection for the Durand-Ruel Galleries was not restricted to the owners but extended to Herbert Elfers, the director, as well. Judging from his diaries, Clark trusted Elfers completely and often took him into his confidence. They compared notes on the other dealers, their stock, and their prices. Paul Rosenberg was one New York dealer about whom Clark and Elfers had many lively conversations. Clark described to Elfers one visit to Rosenberg: when asked to date a work by Renoir, Clark "said 1892—Rosy yelled 'You are marvellous!!!!' I said $1500 to $2000—Rosy 'Correct $1500'—And I praised it as a good example of the period. Elfers much amused said 'You know what I told you. Rosy wants to sell you a picture even at a loss. Your not having bought from him rankles his blood. Some day he will offer you one you like. And then you must take him up'" (April 6, 1943). Wildenstein's was another gallery the two men often discussed, typically condemning their prices as too high. For example, shortly after the Clarks had bought Toulouse-Lautrec's masterpiece *Jane Avril*, Elfers said, "What makes me angry is the prices Wildenstein asks. The Toulouse-Lautrec you paid $45,000 [for,] they bought . . . for $12,000!!!!" (November 7, 1940). Interestingly, Clark never seemed to hold Wildenstein's huge profit on the Lautrec against him. Apparently, the picture was such a fabulous purchase that Clark was pleased to own it at any price. On a related subject, Clark admitted that he had actually gotten the best of Georges Wildenstein: "'It commences to look as though I had skinned Wildenstein on the last two pictures I bought'—and Elfers riposted 'And how about us at Durand-Ruel's'!!!!—And I added 'You know I never bargained on a picture I bought from you.'!!!!" (April 6, 1943).

Clark and Elfers must have gotten quite a laugh out of the collector's tongue-in-cheek assertion that he had never bargained for a picture. In reality, Clark's knowledge of prices, stock, and the pictures themselves was extraordinary. And his behavior earlier in his career must have been legendary in the house of Durand-Ruel. In 1926, after being offered the *Blonde Bather*, Clark returned to the gallery to decline the offer because he felt the price was too high in comparison with other recently sold works. Referring to Elfers's predecessor, he wrote in his diary:

Noticed he was all for selling it. He begged me to come & take one more look at it. I went upstairs to see it. Did not change my mind about its price but inwardly felt it was finer than I had thought the first time. Remarked that I knew exactly the prices paid for the others and that I also knew customers did not pay cash down, but took a hell of a long time about it. That I knew who paid well & who did not around town & that his 8 aspirants for the picture would probably not pay like I would. Suddenly he said "What will you give for the 'Girl with the Cat'?" I replied almost in the same breath "$100,000." "Well I think you can have it for cash 90 days only. . . ." I replied "All right but you must guarantee it is in very good state." He did. Then he went on in rhapsodies about the Nude. I pushed all rhapsodies aside & said first the price must be reduced very substantially & second I must have it at my apartment for a week at least (April 3, 1926).

Clark took great pleasure in the hunt for paintings: "I certainly have fun buying pictures" (February 11, 1942). His method was an easy one to understand: chum around with the dealers, use your eye, react with your gut. And indeed, his observations are often so enthusiastic they seem visceral. "The woman is lovely, the coloring, facture & composition great" (May 9, 1928), Clark wrote about *At the Concert*. His *Sleeping Girl with a Cat* he considered "really a magnificent piece of painting, color & art" (December 31, 1926). Of a still life of roses, one that got away, Clark said, "gorgeous . . . [and] luxuriant" (March 14, 1941). Clark reacted to the physicality of the paint as much as to the subject. He once told a dealer who "went into dreams on Renoir & how Renoir dreamed. 'I don't care a damn about painters' dreams. What I want is paint'" (April 30, 1926).

Another important factor affecting Clark's reaction to a painting was its size. As a collector purchasing works of art for his residences, he was most interested in domestically scaled works. He also believed, however, that good paintings were generally smaller in scale and that there was "loss of control in big pictures. Almost all artists should paint small ones" (February 19, 1928). "As a matter of fact," he wrote to a friend, "very few painters could paint equally well in small and in large with the notable exception of Mr. Rembrandt who could paint 6 x 6 in. & the Night Watch of equal quality."[34] After visiting an exhibition of the work of Camille Corot,[35] Clark observed, "I was struck by the extra quality of the smaller pictures. The poorest pictures were big ones. And those were good. . . . Truly one of the greatest artists of all time and like Renoir capable of doing anything."[36]

Renoir preoccupied Clark throughout the 1930s, and he went to great lengths to understand the artist as well as the paintings. Clark's opinions may seem anti-intellectual, with both art history and scientific analysis relegated to secondary importance after a well-trained eye. Yet his comments, based on direct and careful observation, are often extraordinarily cogent. In 1939 he recorded his thoughts on the artist. At Durand-Ruel's,

I asked to see the Self-portrait by Renoir 1872, the "Girls with the Crab" and the "Girl at piano with companion." We went upstairs—I

was curious to see the "Girls with the Crab" to see what I did not like in the Girl leaning over the rock with crab in her hand—The face & head give the impression of being too big & flattened out on shoulder—it is about the only serious fault in the group but as it is an important figure it is serious—I decided it was the neck, some change in tone of paint or something similar—The more I looked at it the more I felt it was in the neck which not only flattened head on shoulders, but also enlarged the face!!!! The picture is delightful in color, and group of nudes well composed. . . . It is later than I thought between 1894 & 1896!!!! Besides it is a nice medium sized picture. The Renoir Self portrait 1872 is painted in a very broad manner, almost a sketch—I have always admired it for paint—Discovered in changing its position that the reason for not liking it more was because we always have it under too strong a light, which paled out the very light rose on skin & flattened face—The face is extremely light & background dark which was what deceived us!!!!—It does not belong to Durand-Ruel's but price asked is $17,000—Too much but a very nice portrait of a particularly sensitive and agreeable face—It shows a man of genius & energy. We looked over the "Girls at piano" in red & white, with horses of Degas on wall—1889–1890 about—Good but not as good as mine, "La Lettre," just about the same period. Several other Renoirs were taken out and dates fixed by Charles D-R.—Tremendous variations in color & paint from one date to another—Right up to 1905 to 1910 Renoir painted some good pictures and always good in color up to 1913 when he commenced to see red flesh!!!! His really great year, the "apogée de son talent" was 1881—something happened in that year or in 1882 sexually[37]—Some day I shall find out—But from then on he drew and composed less well, with flashes of his best work from time to time—Like the bust profile of Mlle Durand-Ruel in a red hat 1883 [sic] [*Marie-Thérèse Durand-Ruel Sewing*] and my lovely Nude brunette seated & fixing her hair in a landscape background seen from the side dated 1885 [*Bather Arranging Her Hair*]—Light to delicate in tone the paint is heavy & smooth like enamel. He still produced some excellent pictures . . . but the drawing & models become worse and worse with common women & dreadful nudes who looked as though their legs & arms were inflated bladders—Sense of perspective also lacked in many cases—But right up to the red period 1913 his color never lacked in harmony—After 1881 that inimitable freshness of hope & youth lacked—But what a great master!!!! Perhaps the greatest that ever lived—certainly among the first 10 or 12—And so varied—Never the same in subject, color or composition both in figures, portraits and landscape!!!!—As a colorist never equalled by anyone—No one so far as we know ever had an eye as sensitive to harmony of color!!!!—True the Venetians have suffered by time & restorers but I do not believe they ever had the palette of Renoir!!!! We should find traces if they had had —And his greys are as fine as Velasquez & his reds as fine as Rubens—His flesh both dark and light as fine as Rubens or the Venetians—The only thing the Venetians, the Primitives, the people like Velasquez and Van Dyck were superior in line, the suave line like Leonardo, Ingres, Degas, Bouguereau etc. but Renoir could draw & his best pictures are good in line—But as a painter I do claim he has never been surpassed—As a colorist he has never been equalled—Of course Rembrandt gave more volume, Van Dyck had more elegance in line etc. etc. but I would much rather live with 20 Renoirs than 20 Rembrandts!!!!—Turner to be sure one would like 20 Turners but he was essentially a landscape painter whereas Renoir was both & could rival Turner as a landscapist!!!! for color—And now I have 27 Renoirs!!!! (January 21, 1939).

Clark's acquisition of *A Girl with a Fan* is a wonderful example of the combination of the collector's judgment, his keen memory of paintings, and his creativity in locating superior works. "I have been thinking for some time of the fine Renoir 'Girl with flowers' about 1878 or 1879 [*A Girl with a Fan*] which I saw some 3 or 4 years ago at Mme Coinse's," Clark wrote in his diary. "Such a fine picture & such a pretty charming girl—Charles D-R said owner had been offered $50,000, but might take $60,000—A big price to be sure but what quality" (December 7, 1938). Charles Durand-Ruel agreed not to buy the painting for himself and represented Clark through Pierre Durand-Ruel in Paris. One month later Clark owned the painting. At the Durand-Ruel Galleries, "asked to see my new purchase . . . I only saw it once about 5 or 6 years ago at Mme Coinse's when it was not for sale—I was quite right in buying it from memory . . . of course Pierre Durand-Ruel saw it and passed on its condition—Francine was delighted with it & said I had done right!!!!—It must have been painted between 1878 and 1880—Very fresh & young in sentiment & a lovely young girl" (January 10, 1939). Adding to Clark's pleasure, Elfers told him he had "made no mistake" (January 11, 1939).

In April 1939 Wildenstein's offered Clark a still life of white roses, "a superb Renoir" (April 10, 1939). Clark began the work of visiting dealers to compare the stock of competing galleries. He discussed the painting with Elfers; they agreed the picture was fine and the price fair enough. After seeing the Durand-Ruel stock, Clark concluded the pictures were "good but nothing like the quality of the Wildenstein picture" (April 12, 1939). For the next week Clark continued to compare pictures and consult catalogues and books in an effort to establish the painting's history and guess the seller and circumstances of the sale (April 17, 1939).[38] When Clark returned to Wildenstein's with Francine, who was to give her opinion, the dealer apologized that the painting had been sold. "Truly a shock to me," wrote Clark, "but my own fault for not reserving it" (April 19, 1939). Clark conspired with Wildenstein to change the other collector's mind, but failed in his attempts to secure the still life. This experience whetted his appetite for a still life, and the subsequent hunt lasted approximately three years.

Clark finally found his excellent flower painting in early 1942. On a visit to Knoedler's, "Henschel[39] produced a very fine Renoir 'Peonies' 1879–81—The Chicago Art Institute wants to sell it because they have other Renoir flowers & want to buy another picture" (January 20, 1942). Clark was delighted with the painting, a "really fine picture" (January 31, 1942), but questioned how the museum could sell a work they had received as part of a bequest.[40] His concerns evaporated when, by the end of the month, his offer for *Peonies* had been accepted by the trustees of the museum.

Just as Clark was comfortable in the company of dealers, many of them looked forward to his arrival in their galleries. It was not just an opportunity to sell a painting or other valuable object, but also to share the company of a man with taste and the money to exercise it. He had a reputation for paying promptly,

"better buy it than too many securities & I can afford it" (April 23, 1937), an ability they clearly appreciated. Elfers once told another dealer who complained he had never sold anything to Clark that "no one sold [Clark] pictures; [he] bought them" (January 24, 1942). When the dealer Carroll Carstairs praised him as "the only real collector in America," Clark responded, "No, [John] Spaulding was another" (November 23, 1940). Indeed, Clark distanced himself from most collectors, and while he knew the collections and practices of many, few knew anything about him. Evidence of Clark's anonymity can be found in a 1937 article in *Artnews* that described Renoir's works in American collections. Column space was obviously dedicated to Dr. Albert C. Barnes and his foundation as well as to Duncan Phillips, who had bought *Luncheon of the Boating Party* (1880–81, The Phillips Collection, Washington, D.C.; see fig. 11), along with other collectors such as Chester Dale.[41] Sterling and Francine Clark are conspicuous in their absence. They lent pictures only rarely and always anonymously, earning Clark the nickname "Mr. Anonymous."[42] And when people spent the evening at the Clarks' apartment, they got no more than a glimpse of the collection, the only exceptions to this reticence being John Spaulding, the great Boston collector, and later, in New York, Chester Dale, with whom Clark had warm and open friendships.

Clark met John Spaulding through Charles Durand-Ruel, who had written a letter of introduction for Clark on a visit to Boston. Clark described Spaulding as a "medium height thick set energetic man who would not care a damn whom he fought with!!!!" Obviously, Clark had found a soul mate. Mrs. Spaulding and Francine Clark also seemed well suited to one another. "We made a good impression from the start." Of the Spaulding collection Clark recorded, "The first thing I saw was a Renoir 'Woman with parasol' seated on grass [fig. 6]—It was a picture I nearly bought myself years ago—I told Mr. Spaulding [who responded] 'I'm glad you didn't.'" The paintings Clark saw at Spaulding's house were impressive, masterpieces by Toulouse-Lautrec, Henri Rousseau, Paul Cézanne, Camille Pissarro, Vincent van Gogh, and Mary Cassatt. "I enthused," wrote Clark, "as all were good of their painters. Then lunch which was excellent too. . . . Upstairs . . . Rubens . . . Goya . . . wonderfully fine Monet snow scene most delicate—Best Pissarro group I have ever seen . . . next floor up a fine Remington drawing—5 excellent Winslow Homer watercolors & heaven knows what all!!!!—I told Mr. Spaulding he was a man after my own heart who bought everything he liked which was of good quality!!!!" (February 7, 1939). The friendship continued, and Clark added another story to his diary. Over dinner in the Clarks' New York apartment, the two collectors reminisced and discussed years of collecting. "We discussed Renoir—Spaulding thought the greatest colorist who ever lived—I quite agreed—I said I thought Renoir, Corot, Winslow Homer perhaps the greatest artists of the 19th century. Spaulding had a pleasant evening & said so" (February 9, 1943).

Chester Dale was the only other collector with whom Clark is known to have been friendly. As with Spaulding, part of this friendship was based on a common approach to collecting and similar taste. While discussing the rage in the mid-1940s for Renoir's work, for example, Dale explained to Clark his preference for paintings from before 1890,[43] an observation with which Clark wholeheartedly agreed: "We took to each other like ducks to water and in general agreed on pictures."[44]

Clark visited Dale to see his collection and noted that while Dale's principal pictures were at the National Gallery of Art, the Philadelphia Museum of Art, the Art Institute of Chicago, and the Minneapolis Institute of Arts, he still had about three hundred pictures in storage as well as the works in his residence. Clark did not agree with many of Dale's purchases, works by such artists as Paul Cézanne, Henri Matisse, Georges Rouault, Pablo Picasso, and Amedeo Modigliani that Clark believed Dale had purchased from "an archaeological or historical point of view."[45] But, as for the rest, Clark had only praise: "An early Millet portrait, small, two good Daumiers. An excellent medium size Renoir 1877 or 1878 of a pretty woman, a good early Degas of an ugly woman, an excellent Vuillard as good as I have seen, a Gilbert Stewart [*sic*] woman's portrait excellent quality, a charming medium size Baron Gérard of a little girl's back seated. In the big pictures two excellent Bellows, a landscape and a woman, a fine Renoir 1885 little girl with hoop [fig. 7]."[46] He even went so far as to refer to his fellow collector as "astounding . . . a remarkable man."[47] Clark later saw even greater depth in the collection when he viewed Dale's photo archives. "The son of a gun!" wrote Clark, "he had everything in the 19th century. Corots, Daubignys, Millets, Bastien-Lepage, Bouguereaus, Mary Cassatts, Carolus Durands, and numerous others, some Davids, Ingres, etc. etc. And they were all of good quality. One or two I had almost bought."[48]

Clark recalled one extraordinary day in November 1945 he spent with Dale visiting artists and galleries. The first stop was with George Bellows at the Allison Gallery, which represented

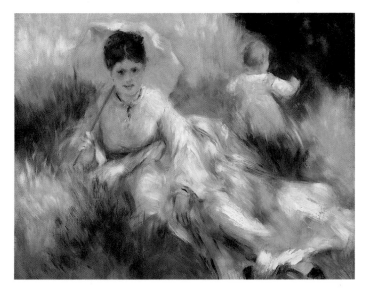

Figure 6. Pierre-Auguste Renoir
Woman with a Parasol and a Small Child on a Sunlit Hillside
c. 1874–76
Oil on canvas, 18½ x 22⅛ in. (47 x 56.2 cm)
Museum of Fine Arts, Boston. Bequest of John T. Spaulding

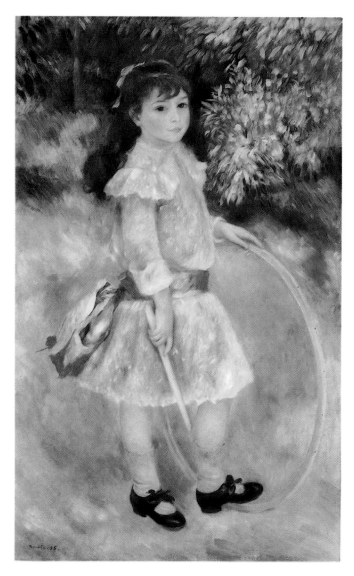

Figure 7. Pierre-Auguste Renoir
Girl with a Hoop
1885
Oil on canvas, 49½ x 30⅛ in. (125.7 x 76.6 cm)
National Gallery of Art, Washington, D.C. Chester Dale Collection

the artist in New York. Afterwards, the two collectors enthusiastically discussed Bellows's work at length, Clark finally asserting that his paintings were "powerful like a Winslow Homer but very personal. Chester claimed [Bellows was] the greatest American painter, greater than Homer. There we agreed to disagree."[49] The tour continued to Dale's house, where they were joined by Daniel Rich,[50] director of the Art Institute of Chicago. Discussion eventually turned to Renoir, and both Rich and Dale admitted they were "crazy about my Renoir of the nude tying up her hair 1883 [*Bather Arranging Her Hair*]. I don't think I would leave them alone with it."[51]

After Rich left, Clark decided that "everything clicked just right."[52] He was going to share with Chester Dale what he usually kept so private: a glimpse into his own collection. The two men went to Knoedler's "to see a couple of good pictures. . . . Brought in Winslow Homer 'West Point, Prout's Neck' [1900; fig. 8] and the Remington 'Cavalry Horses' galloping towards one [*Dismounted: The Fourth Trooper Moving the Led Horses*, 1890; fig. 9]. . . . Dale was positively stunned. Never said a word for 2

or 3 minutes. It takes something to stun him!"[53] Much discussion continued and focused in large part on American painting and the particular merits of Homer and Bellows. "What a day!" wrote Clark, "two crazy old picture collectors admiring each other's pictures and actually saying so. I think you could say a most unusual occurrence."[54]

During their lengthy discussions on art and collecting, Chester Dale described his approach to buying art. "A picture has to do something to his insides for him to buy it,"[55] Clark wrote. Not surprisingly, Clark agreed with this philosophy, for he also responded instantly to great pictures. On a visit with Francine in 1946 to Durand-Ruel's, "[Elfers] swore he had something to show me which would give me a shock. As I always like to be shocked pleasantly I said 'go ahead.' So he took us to the 4th floor. . . . It was a shock in one of the best female portraits by Renoir I have ever seen [*Thérèse Berard*]. 1879 same year as my girl knitting. Francine just so enthusiastic as I was. I bought it on the spot. After I had bought it, he told me he had showed it to Chester Dale yesterday and Chester . . . did not buy it. [He] always waits a couple of days. When Chester comes along in a couple of days & finds it has been sold he will swear it is I who have bought it."[56]

Clark's relationship with both John Spaulding and Chester Dale was clearly one of friends and colleagues. With similar tastes and habits as collectors, the three men must have felt a deep kinship with one another. Competition was in good spirit and envy did not exist. There were other collectors, however, with whom Clark felt no connection whatsoever. The most notable is Dr. Albert C. Barnes, the temperamental and controversial founder of the Barnes Foundation in Merion, Pennsylvania. Even though their taste in artists often matched, their taste in pictures and their purposes, procedures, and personalities were diametrically opposed.

In 1915 Albert Barnes had focused on Renoir's *Artist's Family* (1896; The Barnes Foundation, Merion, Pennsylvania) as a possible acquisition. The painting, however, was dear to Renoir, who would not part with it. Barnes, determined to win the painting, had Durand-Ruel argue his case to the aging artist. "You might explain to him," Barnes wrote, "that I now have 50 of his paintings . . . and it is my hope to make this collection one of the best in the world."[57] Barnes's appetite for Renoir's works was apparently insatiable, and he once wrote to his friend Leo Stein, "I am convinced I cannot get too many Renoirs."[58] It is quite easy to imagine Clark saying the same thing. Years later, when Clark and Barnes were both leading figures in the circle of Renoir collectors, Clark wrote, "I have the finest collection of Renoirs in existence without a doubt unless some 15 now unknown turn up????" (November 7, 1941). Although Renoir was clearly the shared passion, the Clark and Barnes collections could not be more different. Clark purchased works by Renoir—or any artist, for that matter—after a certain period of deliberation or, occasionally, on the spot when he felt a real *coup de foudre*. From the beginning he prided himself on buying only the best that was available and following, almost exclusively, his own heart. "I'm not an archaeologist but a collector" (February 14, 1929), he

asserted. He used the term *archaeologist* to designate those collectors who were more interested in history than personal taste. Chester Dale, whenever he made one of his worst acquisitions, was an archaeologist. Barnes, however, simply was one all the time. "[He] has archaeological interest in Renoir, some 350 of them to show Renoir's artistic history—knows that most are poor but has some fine early ones as well" (January 23, 1942).[59] Clark's guess at the size of Barnes's collection is clearly on the high side; the Barnes Foundation has 181 Renoirs. Regardless, with such a large number of works by Renoir, from all periods of the artist's production and an abundance of late works, to which he was particularly drawn, Barnes's collection shared very little with Clark's thirty-odd paintings, mostly from before 1885. Clark himself wrote, "Although he has some good ones none were in the class of my fine ones" (March 19, 1940).[60] In 1942 he recalled a conversation with Elfers in which he told the dealer, "I am a very lucky collector for I have a very fine lot of Renoirs [and] I believe this to be very near the truth!!!!" (January 22, 1942).

Gertrude Stein once described Dr. Barnes in Paris, where he "did literally wave his cheque book in the air."[61] Paul Guillaume, the dealer who was Barnes's unofficial representative in Paris, mentioned a visit in which "the auriferous jingle of dollars preceded his steps."[62] In contrast with Clark, Barnes was a flamboyant, controlling, and aggressive attention-getter and self-promoter. In April 1935 he caused a stir when he announced to the press the acquisition of two masterpieces by Renoir, *Mademoiselle Jeanne Durand-Ruel* (1876) and *The Henriot Family* (c. 1871).[63] This was repeated when, in 1942, he acquired *The Mussel Gatherers* (1879) from Durand-Ruel. On this occasion Barnes had gone to the press claiming to have spent $175,000 for the painting, whereas he had actually paid $25,000 and had given four lesser works by Renoir in exchange.[64] The deal was completed in the strictest confidence between Barnes and Elfers; as Clark wrote in his diary, "Only he & Mrs. E. and Francine & I knew the real deal . . . the whole thing is most amusing!!!!" (April 11, 1942). Not even the other dealers were to know the details. Quite clearly, Barnes's stunt was meant both to draw attention to his collection and to legitimize the purchase in the eyes of the public, where dollar amount equaled quality.

When Barnes purchased his first Renoir in 1912, taste for the artist was still growing and had yet to establish itself in

Figure 8. Winslow Homer
West Point, Prout's Neck
1900
Oil on canvas, 30¹⁄₁₆ x 48⅛ in. (76.4 x 122.2 cm)
Sterling and Francine Clark Art Institute, 1955.7

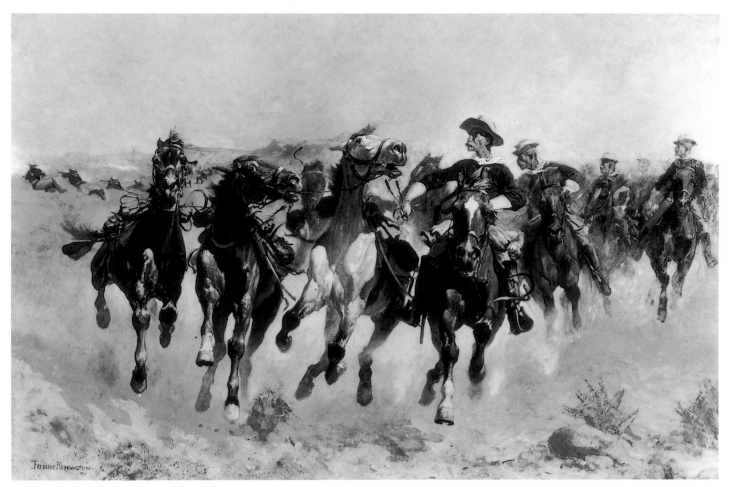

Figure 9. Frederic Remington
Dismounted: The Fourth Trooper Moving the Led Horses
1890
Oil on canvas, 34¹⁄₁₆ x 48¹⁵⁄₁₆ in. (86.5 x 124.3 cm)
Sterling and Francine Clark Art Institute, 1955.11

earnest on the international art market. Two key influences helped to establish Barnes as the twentieth century's most voracious appetite for the French Impressionist's work. Most important, perhaps, was his friendship with his fellow Philadelphian the artist William Glackens. Glackens was known for his unsentimental, realistic depictions of American life at the beginning of the century; his later work, from about 1905 until his death in 1938, was heavily influenced by Renoir. It is not surprising, therefore, that a taste for Renoir should pass to Barnes through Glackens. In 1912, when Barnes sent Glackens on an art-buying trip to Europe, one of the paintings with which the artist returned was a small portrait by Renoir of a girl reading. When Barnes himself went to Europe later that year, he continued to develop his interest in Renoir's work. If Glackens had played an aesthetic or artistic role in Barnes's turning to Renoir, Leo Stein, whom the new collector met in Paris, played an intellectual one. An established collector of work by such artists as Renoir, Matisse, and Cézanne, Stein was certainly an inspiring colleague, from whose experience Barnes could learn and with whom he could exchange ideas.[65]

Ailsa Mellon Bruce, of distinguished collecting lineage, was an active purchaser of Impressionist pictures in the 1940s. She had a reputation for being spoiled, for having more money than taste,[66] and while Clark did not consider her a competitor of any

consequence, she did, on one occasion, get in the way of a painting he wanted, "a really charming picture of 1878? entitled 'L'Ingenue.'. . . Unhappily Mrs. David Bruce (a Mellon) had first choice on it" (November 22, 1940). Clark worked with Carroll Carstairs to change Mrs. Bruce's mind on the picture. Unfortunately, the gallery had accepted the Bruces' offer of $40,000 for it. Because *The Ingenue* was with the dealer on consignment, however, Clark made a counteroffer of $50,000: "If she wants it over that let her have it" (November 22, 1940). Yet this was not to happen, for Clark apparently liked the portrait more and more. He eventually bid them up to $55,000 when, with a gasp of "but I'm being blackmailed" (November 25, 1940), Ailsa Mellon Bruce gave up the picture. "I was told the Renoir 'L'Ingenue' was mine—Perhaps I paid a high price but there is no such fine picture by Renoir on the market—I and F. were pleased" (November 26, 1940).

Ailsa Mellon Bruce continued to collect, and Clark to make observations on what she bought. He evidently derived much pleasure gossiping about her with the dealers. If Barnes had been an archaeologist in Clark's eyes, Mrs. Bruce was no more than a decorator, out to buy pictures to "go with curtains and drapes . . . decoration conscious" (December 14, 1940). Clark also believed that she did not take collecting seriously, but that "the $55,000 for the Renoir impressed her and gave her to think

modern pictures were worth something" (December 14, 1940).

If Clark could be said to have had a foe among collectors, it was surely his brother Stephen, with whom he developed an oil-and-water relationship. In the late 1920s, the brothers had a severe falling-out. It was so serious that, when Sterling bumped into his older brother, Ambrose, twenty years later, he did not speak to him because Ambrose had sided with Stephen years before. There has been much speculation about the nature of the disagreement, one theory being that the brothers disapproved of Francine.[67] This idea is supported by Charles Durand-Ruel's observation that it was perhaps Francine's time in the acting company of the Comédie-Française that was just too much for the stuffy, conservative brothers, who failed to recognize that an actress of Francine's stature was not in the same category as a performer at the Moulin Rouge.[68] It has also been suggested— and supported by letters between Sterling and Stephen—that the fight was the result of business and financial disagreements between the brothers.

Whatever the circumstances of the family schism, Sterling kept a watchful eye over Stephen's collection through the years, observing the areas in which their taste overlapped and rejoicing

when he found out that his brother had paid too much or, even better, missed a painting. About Duveen's 1941 "Centennial Loan Exhibition" of Renoir's work, Clark later commented, "I was amused to see that Stephen C. Clark owned 6 [Renoirs], 5 good early ones & one late one—He must have been buying in the last year or two. . . . It is remarkable how he has followed my track!!!!" (June 10, 1944).

Clark's acquisition of *A Girl Crocheting* in 1916 was a daring move more for his own collecting than for trends, taste, or collecting in general. For the first half of the twentieth century, in fact, great collectors were amassing works by Renoir, who, by the turn of the century, had achieved the status of the old master of Impressionism. "I am pleased to hear that collectors are more forthcoming. Better late than never," Renoir had written to Georges Durand-Ruel on February 11, 1909.[69] Indeed, such famous collectors as the prince de Wagram[70] and Maurice Gangnat[71] sustained demand for Renoir's work through the first decades of the twentieth century. Museums as well were becoming increasingly interested in the artist's work, with important paintings entering the collections of the French national museums as well as provincial institutions.[72] Renoir had

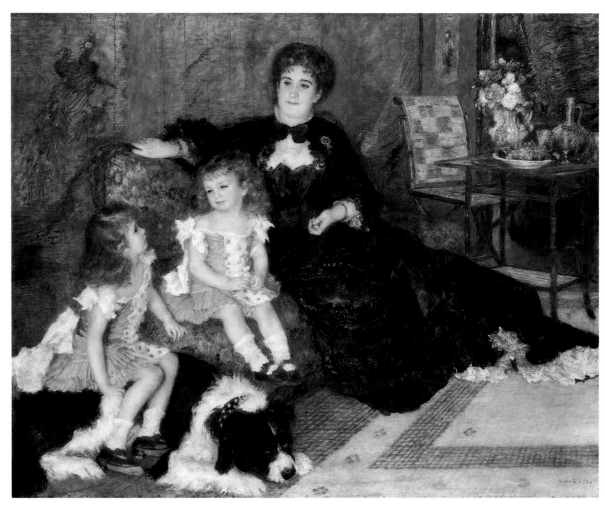

Figure 10. Pierre-Auguste Renoir
Madame Charpentier and Her Children
1878
Oil on canvas, 60½ x 74⅞ in. (153.7 x 190.2 cm)
The Metropolitan Museum of Art, New York. Wolfe Fund, 1907.
Catharine Lorillard Wolfe Collection, 07.122

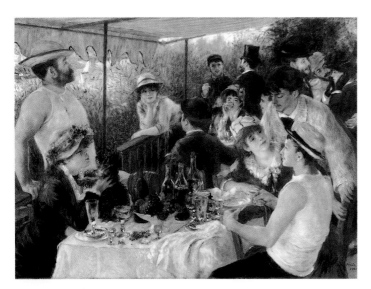

Figure 11. Pierre-Auguste Renoir
Luncheon of the Boating Party
1880–81
Oil on canvas, 51 x 68 in. (129.5 x 172.7 cm)
The Phillips Collection, Washington, D.C.

Figure 12. Pierre-Auguste Renoir
The Dancer
1874
Oil on canvas, 56⅛ x 37⅛ in. (142.5 x 94.5 cm)
National Gallery of Art, Washington, D.C.
Widener Collection

become a success: he was awarded the red ribbon of the French Legion of Honor in 1900; in 1911 Julius Meier-Graefe, the great German art historian, wrote a book-length biography on the artist, the first such publication on any of the Impressionists;[73] Guillaume Apollinaire, perhaps the most important writer of the French contemporary avant-garde, referred in 1912 to "aged Renoir, the greatest painter of our time and one of the greatest painters of all times."[74]

At the beginning of the twentieth century, Renoir's success was not limited to France, or even to Europe. In the United States important acquisitions of the artist's work were made: *Madame Charpentier and Her Children* (1878; fig. 10) by the Metropolitan Museum of Art in 1907 and *Luncheon of the Boating Party* (fig. 11) by Duncan Phillips in 1923. This was in addition to the high-profile collecting and championship of Renoir (especially of the late works) by Dr. Albert C. Barnes. An article on paintings by Renoir in America, written on the occasion of the 1937 Renoir exhibition at the Metropolitan Museum of Art, included a comprehensive list of works in American public and private collections, referred to as the "Renoir cult,"[75] and made several references to the market for Renoirs, including a partial list of works sold publicly and their prices. In the private sphere, Dr. Barnes made his first purchases of works by Renoir in 1912, acquiring *Reclining Nude* (1875) and *Girl Jumping Rope* (1876) from Durand-Ruel's New York gallery; by early 1921 Barnes owned one hundred paintings by Renoir. In 1923 Duncan Phillips made a successful bid to Durand-Ruel for the purchase of *Luncheon of the Boating Party,* which had first come to America in 1883 for a Durand-Ruel exhibition at Mechanics Hall in Boston. It remained

Figure 13. Paul Cézanne
Turn in the Road
c. 1879–82
Oil on canvas, 23⅞ x 28⅞ in. (60.5 x 73.5 cm)
Museum of Fine Arts, Boston. Bequest of John T. Spaulding

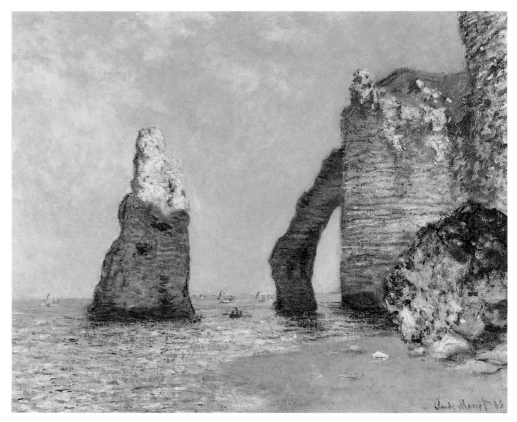

Figure 14. Claude Monet
Cliffs at Etretat
1885
Oil on canvas, 25⅕ x 31¹⁵⁄₁₆ in. (64.9 x 81.1 cm)
Sterling and Francine Clark Art Institute, 1955.528

Figure 15. Claude Monet
Tulip Fields at Sassenheim, near Leiden
1886
Oil on canvas, 23⅕ x 28¹¹⁄₁₆ in. (59.7 x 73.2 cm)
Sterling and Francine Clark Art Institute, 1955.615

Figure 16. Claude Monet
Spring in Giverny
1890
Oil on canvas, 25¹¹⁄₁₆ x 32 in. (65.2 x 81.3 cm)
Sterling and Francine Clark Art Institute, 1955.616

Figure 17. Camille Pissarro
Saint-Charles, Eragny
1891
Oil on canvas, 31¹¹⁄₁₆ x 25⁹⁄₁₆ in. (80.9 x 64.9 cm)
Sterling and Francine Clark Art Institute, 1955.524

in the Durand-Ruel private collection rather than gallery stock until Phillips named a price, "about $100,000," recalled Clark of the very secretive deal (April 3, 1926). The actual price was $125,000, a bargain when one considers that, within a year, offers were said to have been made to Phillips for as much as $300,000.[76] When Joseph Widener purchased Renoir's great painting *The Dancer* (1874; National Gallery of Art, Washington, D.C.; fig. 12) about 1925, it was said to have sold for $120,000.[77] Clark took notice of these purchases (he believed Widener's painting to be a great masterpiece: "What fools the French were not to have bought it. It is one of the things should never have left France" [March 24, 1926]) and discussed the prices with dealers, especially Charles Henschel at Knoedler's. The sales gave him firm prices for major pictures, touchstones to which he could refer when buying his own works.

Luncheon of the Boating Party and *The Dancer* are just two examples of how expensive Renoir's paintings had become by the 1920s; their prices translate into well over $1,000,000 today.[78] No other nineteenth-century artist could boast prices like those. Cézanne was often mentioned as trading in the same league as Renoir,[79] but when John Spaulding purchased Cézanne's *Turn in the Road* (c. 1879–82; Museum of Fine Arts, Boston; fig. 13) from Wildenstein's in 1929, he paid only $40,000,[80] half the price of a major work by Renoir, Clark's *Blonde Bather*, for example, purchased in 1926 for $80,000, or *At the Concert*, purchased in 1928 for $100,000. Works by other members of the Impressionist circle, Monet in particular, were less in demand, and much cheaper. In 1933, for example, Clark spent about the same amount of money for one Renoir as he did for three Monets: $25,000 (the equivalent of $285,000) for *Bay of Naples, with Vesuvius in the Background* (1881) in contrast with $5,500 (now $62,700) for *Cliffs at Etretat* (1885; fig. 14), $10,000 (now $114,000) for *Tulip Fields at Sassenheim, near Leiden* (1886; fig. 15), and $10,000 (now $114,000) for *Spring in Giverny* (1890; fig. 16). That same year Clark paid only $6,000 (now $68,400) for Pissarro's *Saint-Charles, Eragny* (1891; fig. 17).

The taste for Renoir's paintings continued to grow in the United States through the early twentieth century, culminating in the ten years from about 1935 until the end of World War II. Dealers were asking very high prices for even modestly scaled paintings. In 1940, for example, Clark paid $55,000 (now $582,214) for *The Ingenue*, the painting for which he outbid Ailsa Mellon Bruce. At the height of the war, Clark recorded that "the demand for [Renoir's] works is fantastic, crazy—and there are very few of first quality" (March 6, 1943). In 1944 the Art Institute of Chicago was showing interest in a large late painting, *Seated Nude*, "a great big mushy gelatinous fat woman with a sad face strawberry tint, has no bones only fat . . . [the Institute] wants late Renoirs to be in the swim!!!!" (June 13, 1944). Elfers told Clark that demand at Durand-Ruel was so great he was thinking of proposing an exchange with the great Chicago museum, "much better than cash" (June 13, 1944). A year later Elfers took two paintings in exchange along with a cash payment.[81] In the swim, indeed. Between 1935 and the Chicago purchase in 1945, important acquisitions of Renoir paintings were made by the Boston Museum of Fine Arts, the Worcester Art Museum, the Saint Louis Museum of Art, the Denver Art Museum, the Toledo Museum of Art, the Barnes Foundation, the Joslyn Art Museum in Omaha, the Columbus (Ohio) Art Museum, and the Cleveland Museum of Art. As Clark said, "All the museums and all the private collectors must have Renoirs." He quickly added that "as they cannot have the fine early ones they have to be satisfied with the late ones, very few of which I consider good enough to buy!!!" (March 29, 1945).

Just as Renoir was popular with collectors and museums, exhibitions of his work kept his name before the public. In 1937 the Metropolitan Museum of Art mounted a major exhibition of Renoir's work. In the period from May 19 through September 12, approximately half of all the visitors to the museum appear to have seen the show.[82] The Metropolitan Museum's annual report said that 171,942 people had visited "Renoir: A Special Exhibition of His Paintings" and it also reported what was perhaps the most striking aspect of the success of the exhibition: the sale of three thousand copies of the catalogue.[83] Predictably, critical appraisal of the exhibition was favorable, with the writer for *Artnews* calling it "the happiest inspiration and act of the Metropolitan within recent years."[84] Renoir was a phenomenon,

and a deeper look at the review of the Metropolitan exhibition shows the reason for the tremendous enthusiasm for the painter. Renoir, along with Cézanne, was placed above all the other Impressionists. The critic contended that the exhibition encouraged comparisons among the Impressionists and their work. "This Renoir exhibition . . . makes the brilliant journalism of Degas, the courageous and virtuoso technique of Manet, the bold, vigorous stylistic rebellion of Courbet, all seem pale beside the easily triumphant realization of life in terms of paint which, in the last analysis, gives Renoir an immortality like that of Titian, Tintoretto, Rubens, Poussin, and Watteau."[85] The critic then went on to praise Renoir's late work, "the most completely misunderstood of all modern painting."[86] This extra attention was certainly due, in part, to the increased visibility of paintings from that period in New York galleries in the late 1930s as well as to the publication in 1935 of *The Art of Renoir* by Dr. Albert Barnes and Violette de Mazia. A review, again in *Artnews,* of a 1935 exhibition of Renoir's late paintings at the Durand-Ruel Galleries refers to the pictures in such gushing terms as "reverberation of joy," "splendor of color," and "joyous affirmations of the visible world."[87]

These reviews also provide insight into the manipulation of the public that helped establish Renoir's favored position in the late 1930s and early 1940s. In these difficult times, between the Great Depression and a world at war, Renoir's personal life was presented as an example of the fortitude and endurance necessary to overcome adversity. "Eleven pictures at the Durand-Ruel Galleries give an account of Renoir's art since 1900," read a review of a 1936 exhibition at the New York gallery. "They leave little question about the unwavering ability and courage of an artist, who, in his sixties and seventies, tormented by rheumatism, worked with stiff fingers and arm, and with his brush tied to his wrist."[88]

This review was not the only one constructed to plumb the emotions of the reader. The *Artnews* review of the 1937 exhibition at the Metropolitan clearly appealed not to the sentimentality of the reading audience but to its honor, morals, and even patriotism. "[Renoir] painted life, not as a sniveling proletarian nor a caustic, misanthropic aristocrat, not as a bombastic rebel nor as a smug bigot, but as a man alive to the richest human experience . . . in this fine sense, in the best of living and its

fitness to be painted, Renoir furnishes the eternally valid proof of the ineffectuality of *tendence* [trendiness] in art. Artistically, the conscious social commentary, the Marxist point of view, the *nationalsozialistische Weltanschauung,* however sensational momentarily, are certain to become as flat as last night's champagne when stood alongside the clear, fragrant vintage of an art which sees as heroic those things which are best in life."[89] Renoir is obviously being presented as the antithesis of forces that, by 1937, were worrying much of America: the rise of the Nazis in western Europe and the spread of Communism in eastern Europe.

In fact, certain dealers organized exhibitions of Renoir's work specifically to emphasize its political and philosophical connections to events in Europe in the late 1930s and through World War II as well as to heighten the emotional response of the public to the artist.[90] The two most notable examples are "Renoir: A Centennial Loan Exhibition," which was organized by Duveen in late 1941 for the benefit of the Free French Relief Committee, and Durand-Ruel's 1942 exhibition of late masterpieces for the benefit of the Children's Aid Society.

One aspect of Renoir's work was perhaps more appealing to the public than all else, particularly during the hardest times of World War II: in Clark's own words, "Renoir's popularity was due in part to his pictures being gay & cheerful in sentiment & color."[91] In the introductory essay to the catalogue of the Metropolitan Museum's 1937 exhibition, the artist's world was presented as an earthly paradise, populated with "happy folk, even joyous. . . . The girls are simple and warmhearted young creatures, their eyes wide apart like kittens'; the men are relaxed and contented."[92] Aside from its many possibilities for anti-Soviet or anti-Nazi rhetoric, or its use as an example of fortitude and endurance, Renoir's art was an antidote to the evils and woes of the Depression and, later, of wartime life.

Following the war, Clark's taste for Renoir's work did not wane. In 1946, with even less choice of major pictures, he purchased *Thérèse Berard*. By 1954, he commented in a letter, "Practically there are none or very few good pictures on the market . . . Renoir has disappeared."[93] But interest in the artist and his work had not. Museums and dealers continued to mount exhibitions, the most notable of which were at the California Palace of the Legion of Honor in San Francisco in 1944,

Wildenstein's in 1950, Paul Rosenberg in 1954, and the Los Angeles County Museum of Art in 1955.[94]

The opening of the Sterling and Francine Clark Art Institute in 1955 caused a bit of commotion in the art world. For the forty years the Clarks had been collecting, they had succeeded in maintaining virtual secrecy. In a letter to a friend in early 1955, Clark wrote, "Do not mention the opening of the Institute to anyone, as you will treat me to a cloud of newspapermen to the detriment of my health."[95] Even one year after the Institute had opened, the full extent of the Clark collection was not known. Reviewing the third exhibition at the Clark Art Institute, which presented fifty nineteenth-century French paintings, distinguished art historian and critic Alfred Frankfurter compared the new museum with the Barnes Foundation. "It begins to emerge that for most of this time [that people have tried to gain access to the Barnes] there has also been another American treasure-trove yet more secret and, if anything, richer still."[96]

In September 1956, three months before Clark's death, thirty-three Renoirs (and two Monets) were shown in Williamstown. "The greatness of Renoir, as one of the most individual personalities of the Impressionist group, stands out with freshness and power in the more than thirty canvases of the Clark Collection," wrote Helen Comstock in *Connoisseur*.[97] Elaine de Kooning's review of the event in *Artnews* describes Renoir as an artist loved by the public while viewed with a little more scepticism by artists and critics, a painter whose achievements were perhaps greater than his ambitions. Yet the Clark collection of Renoir's works was different from what would, by 1956, be expected as a result of the decades of attention his late paintings received. "There are few ruddy hues; the prevailing tones are cool greys and blues. The warmer tones are local, not atmospheric."[98] Above all, the Clark canvases were seen by de Kooning as a celebration of the physicality of paint. Alfred Frankfurter concurred, writing that "Mr. Clark's search seems always to have been for paint quality,"[99] an echo of Clark's own words three decades earlier about Renoir's *Sleeping Girl with a Cat*, "a magnificent piece of painting." Indeed, Clark's collection resonates still with the distinction and individuality of a very private collector driven by his own highly personal taste.

STEVEN KERN

CATALOGUE

INTRODUCTION

Robert Sterling Clark bought paintings by Pierre-Auguste Renoir for thirty-five years, from his initiation to the artist with *A Girl Crocheting* in 1916 to his last purchase in 1951, *Apples in a Dish*. A list of the paintings arranged by year of purchase follows. Clark was clearly attracted to specific subjects as he formed his collection, but he did not purposely concentrate on one subject at any given time. In 1933, for example, he acquired two cityscapes, one landscape, one still life, and two depictions of women.

Clark was a collector who had favorites: favorite artists, favorite periods within an artist's work, favorite dealers.

Most of the Renoir works acquired by him—twenty-eight out of a total of thirty-eight paintings—came from the Durand-Ruel Galleries. This record of purchases is clear evidence of a remarkable relationship between Clark and the New York branch of the distinguished Parisian dealers. Clark's preference for Renoir's early work is evident in the collection itself, as can be seen from the list of paintings arranged by year of execution that follows. All but seven of the Renoir paintings in the original collection were painted in 1885 or earlier; 1881, which Clark considered to be Renoir's very best year, is represented by six paintings.

LIST OF PAINTINGS ARRANGED BY YEAR OF PURCHASE

1916 *A Girl Crocheting*

1922 *The Onions*

 Young Girl Seated in a Garden

1925 *Bridge at Chatou*

1926 *Sleeping Girl with a Cat*

 Blonde Bather

1928 *At the Concert*

1930 *Tama, the Japanese Dog*

1933 *The Bay of Naples, with Vesuvius in the Background*

 A Girl Gathering Flowers

 Madame Claude Monet Reading

 Venice, the Doges' Palace

 View at Guernsey

 A Bouquet of Roses

1934 *Rowers at Argenteuil*

1935 *Marie-Thérèse Durand-Ruel Sewing*

1937 *Mademoiselle Fleury in Algerian Costume*

 The Letter

 Self-Portrait (1899)

 Bather Arranging Her Hair

 Washhouse at Lower Meudon

1938 *Standing Bather*

 Studies of the Berard Children

1939 *A Girl with a Fan*

 Monsieur Fournaise

 Self-Portrait (c. 1875)

 A Girl Reading

1940 *The Ingenue*

 Jacques Fray

 Flowers in a Blue Vase

1941 *Seascape*

 Still Life with Peach and Tomato

1942 *Sunset at Sea*

 Peonies

 Sunset at the Seashore

1946 *Thérèse Berard*

1950 *Study for "Scene from Tannhäuser—Third Act"*

1951 *Apples in a Dish*

LIST OF PAINTINGS ARRANGED BY YEAR OF EXECUTION

c. 1872 *Madame Claude Monet Reading*

 A Girl Gathering Flowers

1873 *Rowers at Argenteuil*

1875 *Washhouse at Lower Meudon*

 Monsieur Fournaise

c. 1875 *A Girl Crocheting*

 Self-Portrait

 Bridge at Chatou

 Young Girl Seated in a Garden

c. 1876 *Tama, the Japanese Dog*

 The Ingenue

1878 *Still Life with Peach and Tomato*

1879 *Thérèse Berard*

 A Bouquet of Roses

 Sunset at Sea

c. 1879 *Study for "Scene from Tannhäuser—Third Act"*

1880 *Sleeping Girl with a Cat*

 At the Concert

c. 1880 *Peonies*

1881 *Venice, the Doges' Palace*

 The Onions

 Studies of the Berard Children

 The Bay of Naples, with Vesuvius in the Background

 Blonde Bather

c. 1881 *A Girl with a Fan*

1882 *Marie-Thérèse Durand-Ruel Sewing*

 Mademoiselle Fleury in Algerian Costume

1883 *Seascape*

 Apples in a Dish

 View at Guernsey

1885 *Bather Arranging Her Hair*

1887 *Standing Bather*

1889 *Flowers in a Blue Vase*

1891 *A Girl Reading*

1895 *Sunset at the Seashore*

c. 1895–1900 *The Letter*

1899 *Self-Portrait*

1904 *Jacques Fray*

NOTES TO THE READER

The catalogue that follows includes thirty-eight paintings by Renoir that were acquired by Robert Sterling Clark. Thirty-three of these are now in the collection of the Clark Art Institute, the other five having been deaccessioned and sold between 1970 and 1988. The paintings have been grouped by subject, reflecting Clark's own preference as he collected.

In the catalogue, each reproduction is accompanied by technical information on the paintings discussed:

TITLE: All titles are given in English. Variants and alternative titles, which have appeared in art-historical literature or in early records on the painting but which are not used by the Clark Art Institute, appear in parentheses.

DATE: The date of the painting follows the title. The letter *c.* (circa) before a single year indicates a leeway of five years before and after that date; one before a span of years indicates execution sometime between the two dates.

MEDIUM: All paintings are oil on canvas with the exception of *A Bouquet of Roses.*

DIMENSIONS: Dimensions are given in inches and centimeters; height precedes width.

INSCRIPTIONS: All visible signatures, dates, and other inscriptions, as written by the artist, are included. The use of upper- and lowercase letters reflects the actual appearance of the inscription. Line division is indicated by a slash.

NUMBERING AND CREDIT LINES: All paintings in the permanent collection of the Clark Art Institute have been assigned an accession number. Its first element, "1955," designates the year the painting entered the collection of the Sterling and Francine Clark Art Institute. The other element, either two or three digits, was originally an inventory number.

ACQUISITION HISTORY: The date and place of purchase are included for each of the paintings.

AUTHOR: All essays end with the initials of the author: KE, Karyn Esielonis; PRI, Patricia R. Ivinski; SK, Steven Kern; or RM, Rebecca Molholt. Kate Burke (KB) compiled the chronology.

IMAGES OF WOMEN

SOCIETY PORTRAITURE

Renoir began painting the spaces, people, and activities of modern Paris in the late 1860s, depicting theater and opera loges on several occasions. In the Clark picture, he juxtaposes an older woman with an adolescent girl, traditionally identified as Madame Turquet, the wife of the undersecretary of state for the fine arts, and her daughter.[1] Although there is no firm evidence for its identification, the setting is easily recognized. The expensive evening dress of the woman and the plush red interior of the box suggest Charles Garnier's opulent Opéra, which opened in 1874 and became for many the symbol of Baron Haussmann's newly rebuilt Paris.[2]

Views of theater and opera boxes had been a popular subject among illustrators since the midcentury,[3] and among Renoir's contemporaries they were painted by Edgar Degas, Mary Cassatt, Eva Gonzalez, and Berthe Morisot.[4] It seems curious, perhaps, that painters and illustrators focused on the audience attending the theater or opera rather than on the performers on stage. However, contemporary chroniclers often observed that many visited the Opéra not so much for the performance but for the audience—to see who else was there, to chart the newest fashions, and to keep abreast of the latest political, social, and romantic liaisons. In a typical comment, F. Adolphus wrote, "Like others, I have gone habitually to the Opera as a mere social act, just as I should go to a drawing room, and have sought for my diversion there in the boxes rather than the performance. To the people who constitute society (or who think they do) the Opera has always and still means the house rather than the stage."[5] As Degas's painting *The Ballet of Robert le Diable* (1871; The Metropolitan Museum of Art, New York)

Figure 18. Pierre-Auguste Renoir
The Loge
1874
Oil on canvas, 31½ x 25 in. (80.x 63 cm)
Courtauld Institute Galleries, Somerset House,
London. Samuel Courtauld Collection

At the Concert (*Dans la loge; In the Box; A Private Box*)

1880

39¹⁄₁₆ x 31¼ in. (99.2 x 80.6 cm)

Signed and dated upper left: *Renoir. 80.;* signed center left: *Renoir.*

1955.594

Purchased from Durand-Ruel through William H. Holston Galleries, May 28, 1928

indicates, audience members, aided by the nineteenth-century practice of keeping the house lights on at all times, surveyed each other even during the performance.

Renoir exhibited the first major Impressionist picture of an opera box, *The Loge* (1874; Courtauld Institute, London; fig. 18), in the group's inaugural show in 1874. The Courtauld painting features a lavishly dressed woman, her face heavily made up, leaning on the edge of the box, while her male companion scans the crowd with his binoculars. At least one critic questioned the morals, intentions, and identity of the woman, who unabashedly presents herself for public view, and described her as a "cocotte in black and white [who] will attract people with her wicked charms and [the] sensuous luxury of her clothes."[6] Whether Renoir intended *The Loge* to evoke such words is not known, but his subsequent treatments of the subject, including the Clark canvas, seem to have had no such aims—the figures are comparatively reserved in manner and restrained in dress.

Though X rays reveal that Renoir originally included a male figure in *At the Concert*, the final image shows only two female figures. Their proximity, poses, and difference in age suggest a mother and daughter, chaperone and charge, or older and younger sister. Unlike the woman in the Courtauld's *Loge*, the two here sit in the recesses of the box, shielding themselves from the gazes of other members of the audience. Renoir includes a bouquet of flowers, a standard detail in pictures of theater and opera loges. Yet, to prevent critics reading it as a sign of a demimondaine, as they sometimes did, he places it in the lap of the young girl, its red flowers matching those that decorate her chaste white dress.

The relationship between the figures in the box and the viewer of the picture involves a curious combination of intimacy and distance. While many pictures of the Opéra's loges, including the Courtauld painting, position the viewer as a member of the audience seated in another box or on the orchestra floor, the viewer of the Clark picture appears to stand in the box itself. The older woman sits facing the viewer, her low-cut dress framing her bare chest with a border of dark tulle. Her hand resting against her cheek, her red lips, and the deeper red curtain behind her head draw attention to her face, but her glassy, dreamy expression—her mouth forms a slight smile and her eyes look off into the distance—suggests she is completely unaware of someone else in her immediate vicinity. Her passivity enables the viewer to look at her without interruption and reinforces period conventions that cast the woman as someone to be looked at rather than someone who actively looks. The same combination of intimacy and distance characterizes the relationship between the two figures. On the one hand, Renoir binds the two together physically: the young girl leans toward the woman, and their bodies are connected by their arms, which form a circle, and the score lying across their knees. The woman, however, pays no attention either to her companion or the music, while the young girl stares downward. Assuming the pair represents a mother and

daughter, the absence of any sign of psychological connection between them seems out of character for Renoir, for whom family bonds were a favorite, even sacred subject.

More than representing a parent and child, the picture is perhaps better understood as presenting a contrast between mature woman and adolescent girl, played out in terms of straightforward, easily identified oppositions. Where the older woman dresses in sophisticated black, the girl wears innocent white, the high neckline of her simple dress countering the other's décolletage. Her long hair hangs down her back, while her companion's is fashionably styled, her bangs emphasizing her large eyes and undirected gaze. Unlike the older woman, whom Renoir presents sinking back into the plush, sensuously red material of the loge, so that she may be perused, the girl turns demurely away from the viewer. Presumably when she reaches sexual maturity, her behavior will change accordingly, and she, too, will become the object of the gaze.

At the Concert, along with twenty-four other figure and landscape paintings by Renoir, was shown in 1882 at the seventh Impressionist exhibition. Renoir had not exhibited with the other Impressionists since 1877, but his dealer, Paul Durand-Ruel, had suffered business losses during the economic depression of the early 1880s and entreated him to submit work to the 1882 exhibition. Renoir initially refused.[7] Though he had been one of the group's founding members and had participated in their first three independent shows, he felt that some of the artists included in later exhibitions—particularly Degas's protégés—had diluted their quality. He also feared that the leftist politics of Camille Pissarro, Paul Gauguin, and Armand Guillaumin might taint his own reputation. Moreover, his plan to submit works to the Salon would, according to the Impressionists' own rules, prohibit him from exhibiting with them. After defending his position in several firm letters, Renoir eventually relented. He would not personally submit works but would not prevent Durand-Ruel from showing the Renoir canvases that belonged to him.

Renoir's fears proved unfounded. His figure paintings drew some of the most favorable notices of the show. Joel Isaacson has contended that the painter's popularity at the 1882 exhibition arose largely from the conventional aspects of his works—the clarity of form, controlled brushwork, and attention to detail—which he had been cultivating in the hope of succeeding at the Salon and making inroads with more conservative collectors.[8] Five critics praised *At the Concert*, including the often difficult Louis Leroy, who took note of and supported the new direction Renoir had taken: "The faces of the two young women, their dress, the color of the ensemble have bourgeois qualities that Impressionism execrates."[9] There is some validity to Leroy's comments. While the loge itself is composed of loose, long strokes that suggest its shape but do not describe it in detail, the two figures are more firmly modeled, drawn, and outlined.

KE

BOURGEOIS PASTIMES

Beginning with the criticism of his contemporaries, much of the Renoir literature casts the artist as the painter of woman, who captured her essential character.[1] That way of framing the artist remained standard until the mid-1980s, when a retrospective of the artist's work and the emergence of a feminist consciousness in art history led to a reevaluation of his images of women.[2] That Renoir loved painting women was not in dispute—the lion's share of his paintings are devoted to them— and as he grew older, men all but disappeared from his canvases. At issue was how he painted women and the critical tendency to posit those images as factual and authentic. As feminist scholars correctly argued, these pictures did not "truthfully" portray some eternal feminine or some kind of inherent, biologically determined "reality" of women. Instead, they were the fabrications of a particular man of a particular background and beliefs, which were shaped by, and operated within, the larger structures and categories that governed the way people thought about women in late-nineteenth-century France.[3] Renoir's pictures were described as natural and truthful, not because they were but because the ideas they espoused corresponded with those of society at large and of the critics who considered them. In addition, his smooth, seemingly effortless way of putting paint on the canvas and his own characterization of his painting as instinctual rather than intellectual—taken by commentators at face value—made his women appear simple recapitulations of fact rather than calculated formulations. To understand Renoir's images of women fully entails looking beyond the beauty of their facture and their pleasant subjects to recognize them as components of a larger visual culture that performed certain kinds of political, social, and economic work. That work consisted largely of reproducing and reinforcing mainstream notions of a woman's proper place and behavior. She was a beautiful, decorative, and often passive object, a creature of instinct rather than intellect, of reproduction rather than production. Her customary domains were the home and nature. Her sexuality was usually safe rather than suspect. And, with the advent of *la nouvelle femme* in the 1880s, Renoir's paintings pressed these views of women even more insistently.[4]

The Clark collection offers a representative selection of Renoir's female types. The particular group discussed here involves women who are shown fully clothed and in largely decorous poses, in contrast with the next group, where in dress and manner, the women are meant to be sexually provocative, or the last, which depicts nudes. His images of women not only insist on certain ideas about gender roles but also show a decided, though not absolute, tendency to correlate certain kinds of behavior and dress with a woman's class.[5] Thus, the pictures in this group, which come predominantly from the 1870s and 1880s, portray fashionably dressed bourgeois women situated in places and engaged in activities considered appropriate to women of their station: in nature, in the home, and in the garden, picking flowers, sewing, writing letters. In keeping with his sense of propriety, Renoir rarely showed bourgeois women in public places, save the Opéra, where they were allowed by period mores to go unaccompanied without harm to their reputations. Nor did he show them consorting as freely with men or acting as casually as do the working-class women in such pictures as *Ball at the Moulin de la Galette* (1876; Musée d'Orsay, Paris) or *Luncheon of the Boating Party* (1880–81; The Phillips Collection, Washington, D.C.; see fig. 11).[6]

The woman in nature was one of Renoir's favorite themes throughout his career. While most of his canvases advance the time-honored theme of woman as the embodiment of nature, *A Girl Gathering Flowers* slyly pits nature against fashion and country

A Girl Gathering Flowers (*Femme cueillant des fleurs; L'Ombrelle renversée; Woman Gathering Flowers; Jeune fille cueillant des fleurs*)

c. 1872

25¼ x 21⅞₆ in. (65.5 x 54.4 cm)

Signed lower right: *Renoir.*

1955.907

Purchased from Durand-Ruel Galleries, June 13, 1933

against city. On the one hand, Renoir unifies the woman with her natural surround. Short, quick brushstrokes merge the bottom of her dress and the grassy field which grows up around her, making it seem as if she herself is sprouting from the meadow. Her face and hair become one with the bank of trees behind her, and the blue and dashes of purple in her dress match the hues of the sky and the lavender specks indicating flowers in the grass. At the same time, her pose seems frozen and rigid and her face appears an impassive mask as she stands stiffly gripping her bouquet in a mannequin-like posture at odds with the painter's improvisatory, spontaneous brushwork and the setting, which is not a neatly kept private garden but an untamed field.[7] As the cluster of buildings on the horizon indicates, she is gathering flowers not in some far-flung rural area but in a suburban one, and her formal dress, complete with bustle, hat, and parasol, suggests she is probably a woman from the city, certainly not from the country. Renoir paints the figure in profile, the better to emphasize the way her dress reconstitutes her natural body as a stylized one. A corset reins in her waist, while the bustle, which became fashionable in the early 1870s, exaggerates her rear, and the narrower skirts, which also came into vogue at this time, probably make it difficult for her to walk easily.[8] A slave to fashion perhaps, but also a study in decorum, she is hatted and, though it is presumably warm, fully covered. While *Young Girl Seated in a Garden* also displays a stylishly—if demurely—dressed woman in nature, the opposition is not as pointed, for here a trellis orders and confines nature just as fashion shapes and defines the body.

Madame Claude Monet Reading presents a neat contrast with *A Girl Gathering Flowers*. Both pictures show the same short, quick brushstrokes and light palette. While the latter features a woman of some fashion posing in nature, the former depicts the wife of Renoir's friend and fellow painter Claude Monet in a quiet, private moment, apparently unaware that she is being watched. Renoir painted Camille Monet, the daughter of a wealthy businessman who began living with Claude Monet in 1866, on several occasions, both alone and with their son Jean. Renoir probably produced this picture in the couple's home in Argenteuil, which they moved to in 1870 and which Renoir frequently visited. Where her counterpart in the meadow dresses more formally for her public outing, Madame Monet relaxes in her loose, though elaborate, dressing gown, a garment that well-heeled women wore with half-corsets at home until midafternoon, when they donned less casual attire. She sinks into the furniture, and in contrast with the body of the woman in the meadow, which is exaggerated by fashion, her figure disappears beneath the voluminous robe into the soft pillows. Though her body is swallowed up in fabric and furniture, Madame Monet's face is

depicted in a touching and sympathetic way. With her dark eyes staring intently at her book and with her slightly upturned mouth, her expression conveys the sense of an engaged and active mind, something of a departure for Renoir, whose stock female face, with its large, often unfocused eyes, gives little indication of an individual personality or of a lively intellect.[9]

Compared with the portrait of Camille Monet, *A Girl with a Fan* is a somewhat odd picture, marked by incongruities and ambiguities of setting and dress. The figure is sitting—that is clear from the chair back which projects forward—but where remains a mystery. She is improbably placed below and close to an extraordinarily large bouquet of flowers which droops over her, and the space behind her is noticeably flat. There is no indication of a vase—the flowers appear to grow from the back of the picture. The green and bluish stripes might be read either as a window or as wallpaper. The greenish rectangle at the left might indicate a table, though the shape seems vertical, an effect enhanced by the painter's signature, which emphasizes its two-dimensional surface.

The figure's dress is also somewhat curious. She wears the round, unstructured hat that girls of all classes and locales usually wore in summer and a high-necked, chaste blue dress. Her long, loose hair provides another youthful note. The fan, by contrast, is an article more closely associated with sophisticated women, both young and old, who used it to navigate social, particularly amorous, situations: to signal to people, to accent their conversation, and, above all, to flirt. Moreover, women usually brought fans to places such as an evening salon, a dinner party, the opera, the theater, or a ball, yet the dress here indicates a daytime occasion rather than an evening event.

The flattened, ambiguous setting, the exaggeration and strange placement of various features of the picture, and the revision of the standard meanings or uses of various props and signs typify the maneuvers of avant-garde painting at this time. Renoir ostensibly uses these strategies and devices to mark the canvas as a modern one. Consistent with his general practice, however, he does not use them to disrupt the subject of the picture—an attractive, pleasant young woman—by calling her identity or class into question or by making her psychology a point of speculation, as Manet or Degas, for example, might have done.

Though the space is odd, the picture coheres by dint of the smooth, uniformly silky brushwork and the colors that complement, rather than unsettle, one another. Moreover, its incongruities and ambiguities become less perplexing once we realize that Renoir uses them for a purpose: to emphasize the figure's face and, more significantly, to set in motion a larger theme, the advent of sexual maturity in the adolescent girl. The

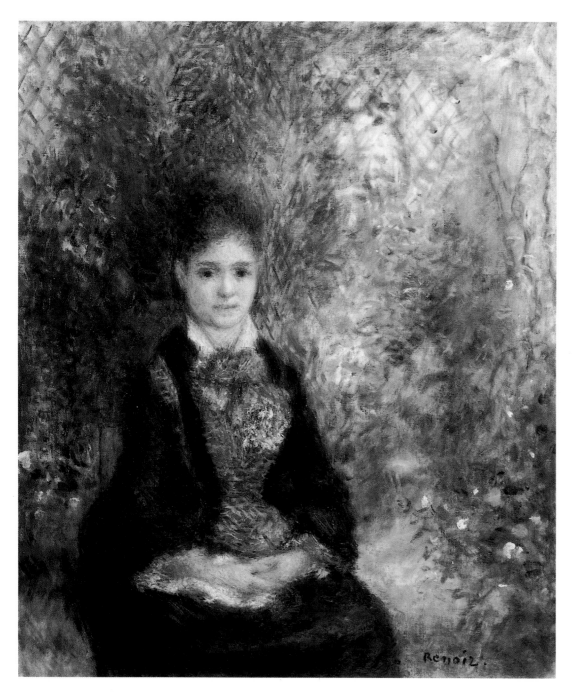

Young Girl Seated in a Garden

c. 1875

18¼ x 14¹⁵⁄₁₆ in. (46.4 x 37.8 cm)

Signed lower right: *Renoir.*

Purchased from Durand-Ruel Galleries, January 3, 1922;

deaccessioned from the Sterling and Francine Clark Art Institute, September 17, 1988

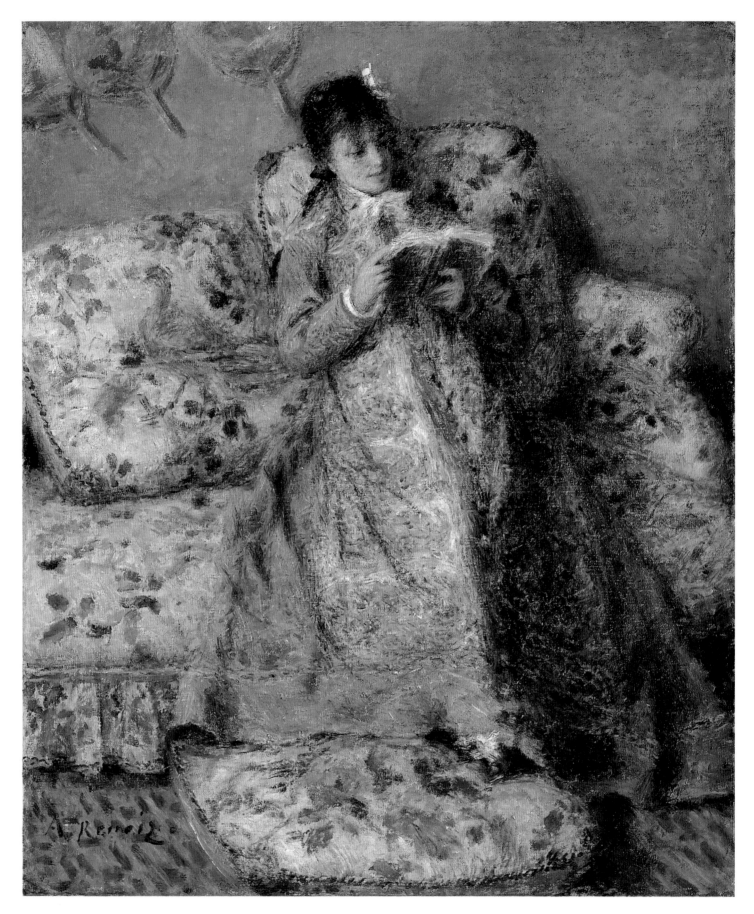

Madame Claude Monet Reading (*Portrait of Madame Monet; Madame Monet Reading a Book; Madame Claude Monet*)

c. 1872

24⅟₁₆ x 19¹³⁄₁₆ in. (61.2 x 50.3 cm)

Signed lower left: *A. Renoir*

1955.612

Purchased from Durand-Ruel Galleries, February 2, 1933

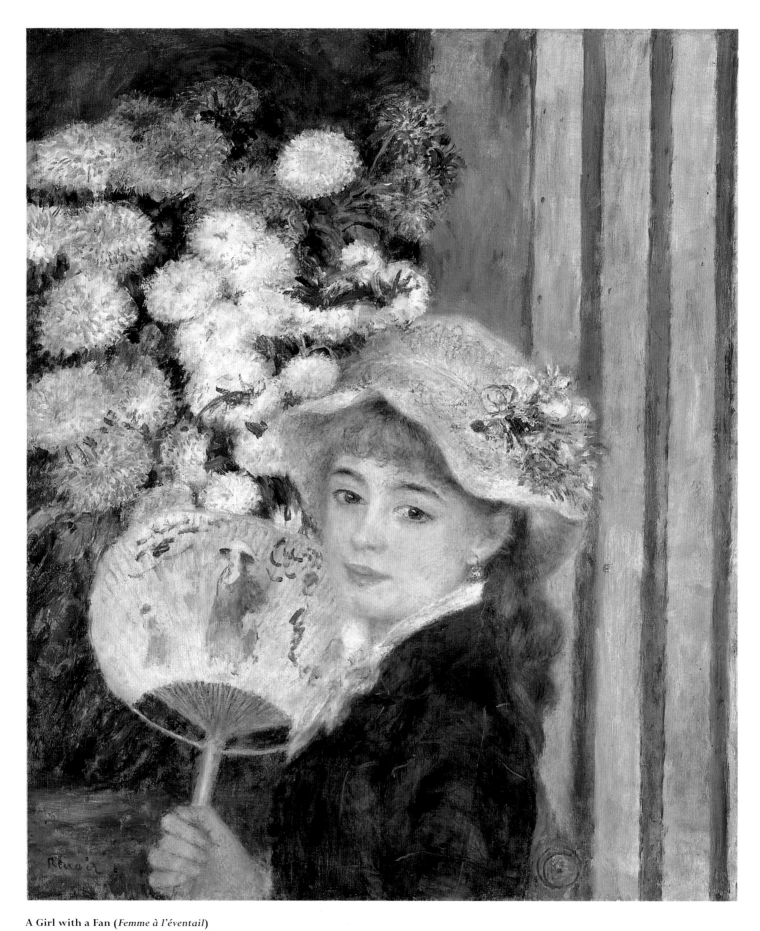

A Girl with a Fan (*Femme à l'éventail*)

c. 1881

25⁹⁄₁₆ x 21¼ in. (65 x 54 cm)

Signed lower left: *Renoir.*

1955.595

Purchased from Durand-Ruel Galleries, January 17, 1939

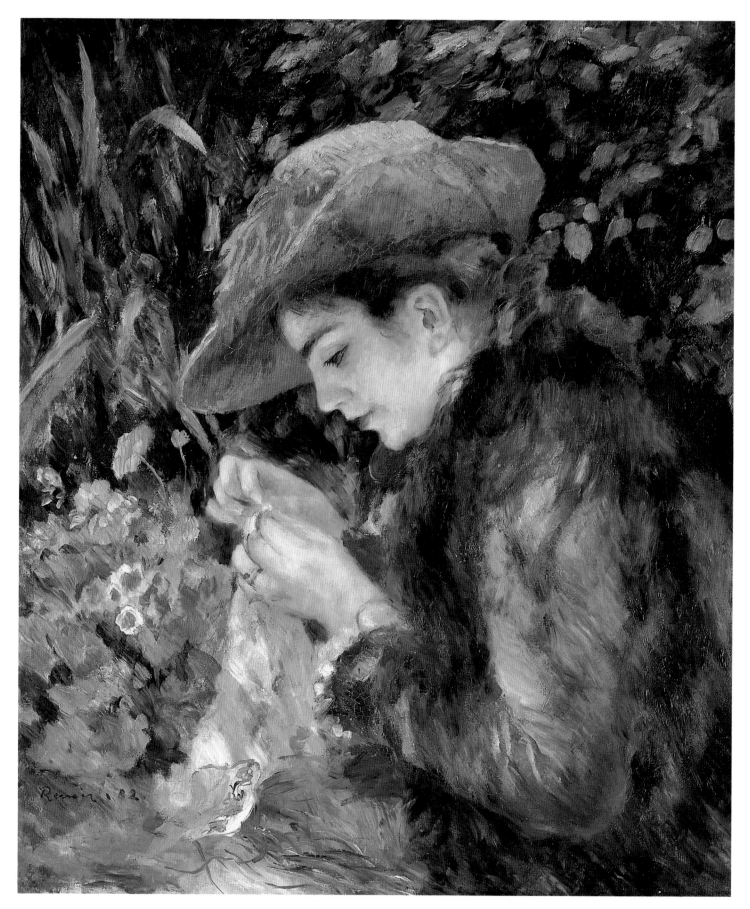

Marie-Thérèse Durand-Ruel Sewing (*Portrait of Mademoiselle Durand-Ruel, now Madame E. Aude, Sewing***)**
1882
25½ x 21⅛ in. (64.8 x 53.8 cm)
Signed and dated lower left: *Renoir. 82.*
1955.613
Purchased from M. Knoedler & Company, July 23, 1935

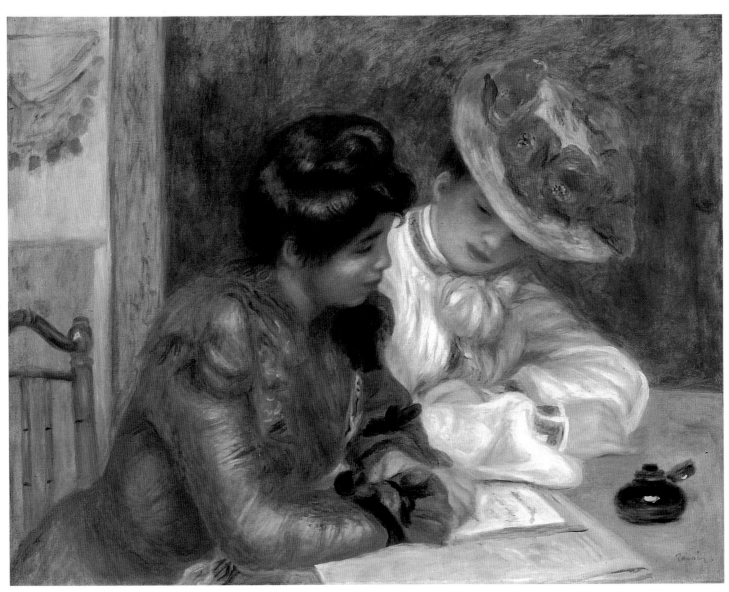

The Letter

c. 1895–1900

25⁹⁄₁₆ x 31¹⁵⁄₁₆ in. (65 x 81.2 cm)

Signed lower right: *Renoir.*

1955.583

Purchased from Durand-Ruel Galleries, May 6, 1937

apparent inconsistencies enable him to suggest the process of becoming, the transition from one stage to another. The compressed space pushes the figure closer to the viewer, and the fan, flowers, and hat frame, and thus focus attention on, her face. Though she skillfully positions her fan to set off her face, her hand—which tightly grips rather than gracefully manipulates the fan—suggests she is still a student, not a seasoned practitioner, of the art. Fan, flowers, and hair constitute a chain of signs. In certain contexts, flowers referred symbolically to a woman's sexuality generally or to her genitalia specifically. Such allusions seem plausible in this particular case, where the lush bouquet spills over onto, and touches, the figure and includes red blooms, which echo the color of her full lips, thus insinuating some symbolic connection between the two. The figure's hair can also be understood in two ways. Girls often wore their hair long and loose, and, read in conjunction with her youthful hat, her hair is a sign of her tender age. On the other hand, long, loose hair on a woman often involved sexual associations, and, considered in combination with the more womanly fan or lush bouquet, the hair might suggest such erotic connotations. At least one critic seems to have responded to the hints of the girl's blooming sexuality rather than her explicitly chaste dress, youthful hat, and girlish hair. Thus, Gustave Geffroy wrote of the picture, "But one always returns to the women who gaze out, their eyes moist with light, proffering the fruit of their mouths—*A Girl with a Fan*, with her luscious flesh."[10]

Though Marie-Thérèse Durand-Ruel was also an adolescent girl, Renoir intimates nothing in her portrait of the incipient sexuality that characterizes the figure in *A Girl with a Fan*. This picture serves a different purpose since it is a representation of a specific individual, the daughter of his dealer, Paul Durand-Ruel, rather than a fantasy of female sexual development played out on the generalized features of an anonymous young girl. Here, Marie-Thérèse Durand-Ruel scrutinizes her needlework, which all girls from good bourgeois families were expected to practice and perfect. The portrait displays the distinct outlines, concealed brushwork, and crisper forms of the so-called drier style that Renoir adopted in the 1880s. By showing Marie-Thérèse in a stylish red hat and surrounding her with thick foliage, Renoir employs the same terms of fashion and nature that shaped *A Girl Gathering Flowers*. Here, however, those terms work in concert, not in opposition. Marie-Thérèse shows movement in her body and facial expression, unlike the mannequin-like figure in the earlier picture. Moreover, the wall of greenery and flowers suggests a secluded, private garden, an intimate, focused space that complements her single-minded absorption in her work.

Like needlework, letter writing was a particularly feminine pursuit. Images of figures writing or reading letters emerged as a theme in genre painting in the seventeenth century. A letter in the hands of a woman identified her as a person of refinement and stature, no doubt because the ability to read or write was mainly the province of the upper, educated classes well into the late nineteenth century.[11] For women who were expected to remain in and maintain the home, letters were a means of communicating with and finding out about the outside world. It might be argued, however, that the activity of letter writing is not the main subject of *The Letter*, but merely a vehicle that enables Renoir to represent, and the viewer to savor, two attractive, fashionably dressed young women. The hands of the woman writing the letter give some credence to that claim. There, perhaps, Renoir's legendary antipathy for depicting a woman's intellect manifests itself since the hand holding the pen is summarily painted, almost to the point of illegibility. The abbreviated handling of that passage becomes more pronounced when the writer's hands are compared to those of her companion, which are painted in far more detail. Thus, at the very point where the women give form to their thoughts, ideas, and desires, the painting fails to cohere, and the viewer's eye "naturally" gravitates away from the pen and paper toward those aspects of the painting that are rendered more distinctly: the companion's huge flowered hat, her idle hands, the gold detailing on her white blouse, the figures' faces, even the back of the chair.
KE

PROVOCATIVE POSES

With the exception of *The Ingenue*, the pictures in this group show figures half-dressed in their undergarments—petticoats and skimpy chemises with wayward straps that reveal bare shoulders and chests, a conceit Renoir developed in the 1870s and returned to throughout his career. Projecting a sexual allure that appears innate rather than studied, the figures are unconscious of their state of dishabille and its erotic implications and unaware of a viewer, since they are otherwise engaged—whether in knitting, reading, or sleeping. Their activities and behaviors are neither personal nor intimate but naturalize their state of undress by situating it within the pedestrian tasks and diversions of everyday life. Period viewers would probably have identified these women as working class since their relaxed attitudes and apparent equanimity with their half-clothed states implied the loose morality and easy sexuality stereotypically associated with those on the lower rungs of the economic and educational ladder.

Renoir casts the viewer as a voyeur who surveys these unsuspecting women, but he attaches no sense of guilt, subterfuge, or shame to the role. He fashions an intimate viewpoint—placing the figures close to the picture plane and the canvas tightly around them to imply the spectator's physical proximity—but eschews the prying, keyhole view that Degas, for example, used with his nudes to suggest that the spectator is spying on the figures. And though he does not specify the figures' locations, he gives the viewer no reason to believe that he has invaded the distinctly private realms of the bedroom or bath.

Renoir painted three versions of *A Girl Crocheting* about 1875.[1] Nini de Lopez, one of his favorite models at the time, sat for the picture. Dressed in a simple chemise and seated in a chair, she conjures up images of the artist's model who could be found in various stages of undress while working for a painter.[2] Though the sight of Nini passing time between sessions may have inspired *A Girl Crocheting,* Renoir removes any evidence of the painter's studio or enterprise, the easels, brushes, and canvases,

which might detract attention from the beautiful figure. Where Renoir employs loose, sketchy brushwork in both the figure and the setting of the related canvases, he varies the handling in the Clark picture to create a visual hierarchy. A rapid, casual kind of notation describes the setting and the figure's lower body, while smoother, more blended strokes form her face and torso, the parts of her body that make her sexually enticing. Her cascade of brilliant golden hair spreading over her back, as well as her delicate shoulders and fine features, gives the figure an innocent, angelic presence, which tempers the sexual implications of her attire.

The female nude was a time-honored high-art subject, which visitors to exhibitions, whether the official government Salon or independent shows, were accustomed to seeing. By the late nineteenth century, the female nude had replaced history painting as the test of artistic talent and ambition and had become, as Linda Nochlin has written, "the topos that stood for art itself."[3] As long as the nude body was rendered in a sexually antiseptic manner, it was welcomed in official circles, and its commercial success suggests it was appreciated in private ones as well.[4]

In contrast with an unclothed body, a partially clothed one was potentially more titillating: it invited the viewer to guess what was underneath the garments and created erotic tension and excitement by masking and withholding. As Freud contended, "The progressive concealment of the body which goes along with civilization keeps sexual curiosity awake."[5] A woman's undergarments were a second skin of sorts and the final barrier between her flesh and the viewer's gaze—"screens against desire, which frustrated and exacerbated it simultaneously," in the words of one male historian of fashion.[6] Renoir trades on this idea in *A Girl Crocheting* and the other pictures in this group. He teasingly suggests the breasts swelling and shaping the chemise and indicates the lines of the thighs beneath the skirt, but does not expose the flesh.

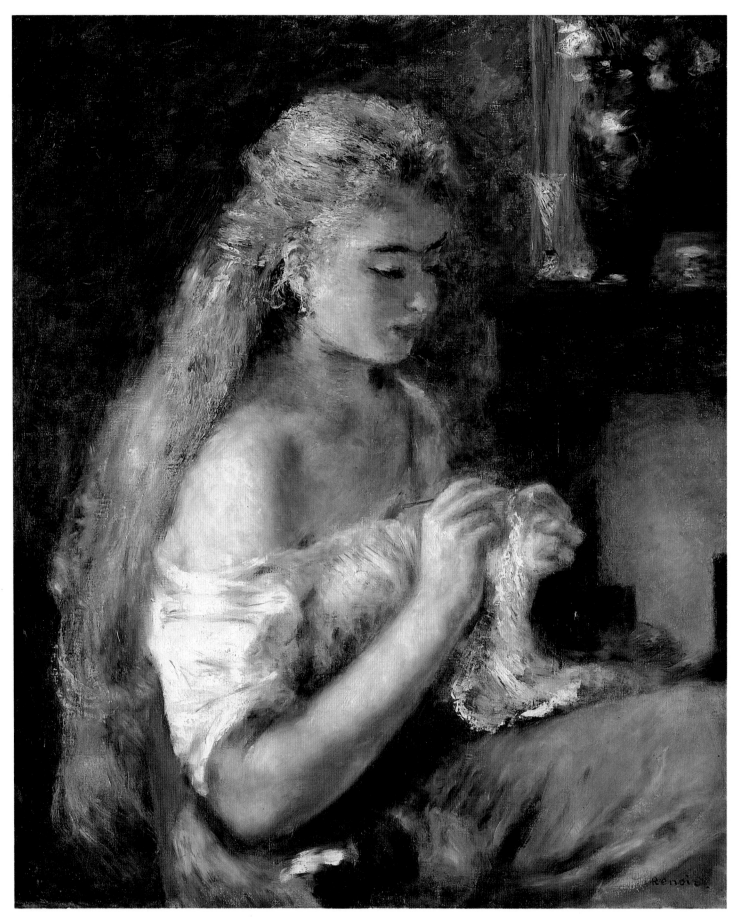

A Girl Crocheting (*Girl Knitting; Jeune femme cousant*)

c. 1875

28⅞ x 23¹¹⁄₁₆ in. (73.3 x 60.5 cm)

Signed lower right: *Renoir.*

1955.603

Purchased from Scott & Fowles, December 15, 1916

Covering and concealing the female body was a particularly resonant issue in Renoir's time, when women's dress usually involved numerous layers of clothing, including a chemise, pantaloons, stockings, a corset, and numerous petticoats, which were then completely hidden. Jean Renoir remembered his father mocking those multiple layers: "Hand lace pantalettes and a plethora of petticoats amused him, and he sometimes compared a woman undressing to one of those circus numbers in which the clown takes off half a dozen vests."[7] That undergarments were not customarily seen or discussed publicly added to their mystery and erotic appeal,[8] qualities that fueled Emile Zola's description of the annual white sale in his novel about a late-nineteenth-century department store, *Au bonheur des dames* (1883). In terms suggesting an erotic dream, he wrote, "And the underthings appeared, and fell one by one: white slips of all lengths, the slips that rein in the knees and the slip with a train that sweeps on the ground, a rising tide of slips in which legs were drowning; bloomers in which a man's hips would be lost; shifts, finally, buttoned to the neck for the night, uncovering the bust during the day, held up only by narrow straps, in simple calico, in Irish linen, in batiste, the last white veil that slipped from the breasts, down along the hips."[9] Almost twenty years later, women's undergarments had lost none of their cachet. Recalling a visit to a lingerie shop, Octave Uzanne wrote, "I thought that I was living in an edenic milieu where houris might have dropped their veils of light. . . . Oh! the divine belted and fitted chemises with hemstitched tops, trimmed with wide collerettes that plunged the soul into a disturbing obsession with the shapes that they would cover!"[10]

The half-dressed figure appears again in *Sleeping Girl with a Cat*, though in this instance Renoir offers a glimpse not only of her bare chest but also of her stockings, which were normally covered by long skirts. Renoir's model was a young woman from Montmartre, Angèle, whom Georges Rivière likened to the characters in the stories of Zola and Maupassant.[11] As he did in *A Girl Crocheting*, Renoir heightens the intensity of the picture by setting the illuminated figure against a darker background, but compared with the earlier work, this is a decidedly strange image. The young girl wears a hat and shoes but no blouse. Her unadorned skirt and striped stockings indicate her working-class origins, though she slumbers in a delicate chair covered in red velvet, a *fauteuil-crapaud*, which would most likely be found in a bourgeois home.[12] The setting, for its part, is neither bourgeois nor working class but distinctly indeterminate.

Renoir sent this picture to the Salon of 1880. Despite its vibrant contrasts of red and blue, dramatic lighting, and provocative subject, the canvas attracted little attention. Zola, who reviewed Renoir's and Monet's entries, reported that it was badly hung and therefore overlooked.[13] *Sleeping Girl with a Cat* did, however, pique the curiosity of the caricaturist Draner, whose rendering of the picture for readers of the humor magazine *Le Charivari* (fig. 19) validates the theory that the

imagination feeds on what is concealed, not on what is disclosed.[14] Where Renoir "naturalized" the picture's peculiarities by gluing its various parts together with smooth brushwork and complementary colors, Draner capitalized on the picture's perplexities and, moreover, spelled out what the artist only intimated. Thus he endowed Renoir's fairly flat-chested girl with large breasts, which bulge beneath her chemise, and exaggerated the chair and hat. The cat was a conventional symbol of female sexuality. Where Renoir perhaps alluded to that meaning, the caricaturist makes it explicit. Draner's feline is wide awake, not innocently sleeping, its tail stands bolt upright, paying symbolic homage to an erect penis, and its coat displays pronounced stripes that match those of the girl's stockings. Lest the viewer miss the point, the girl, who is also now awake and tapping her foot, suggestively scratches the cat, a sly, contented smile replacing the slightly downturned lips that Renoir depicts. No longer the object of someone else's erotic fantasy, in Draner's rendition she enjoys her own daydreams.

Figure 19. Jules-Renard Draner
A Visit to the Impressionists
From *Le Charivari,* March 9, 1882
General Research Division, The New York Public Library
Astor, Lenox and Tilden Foundations

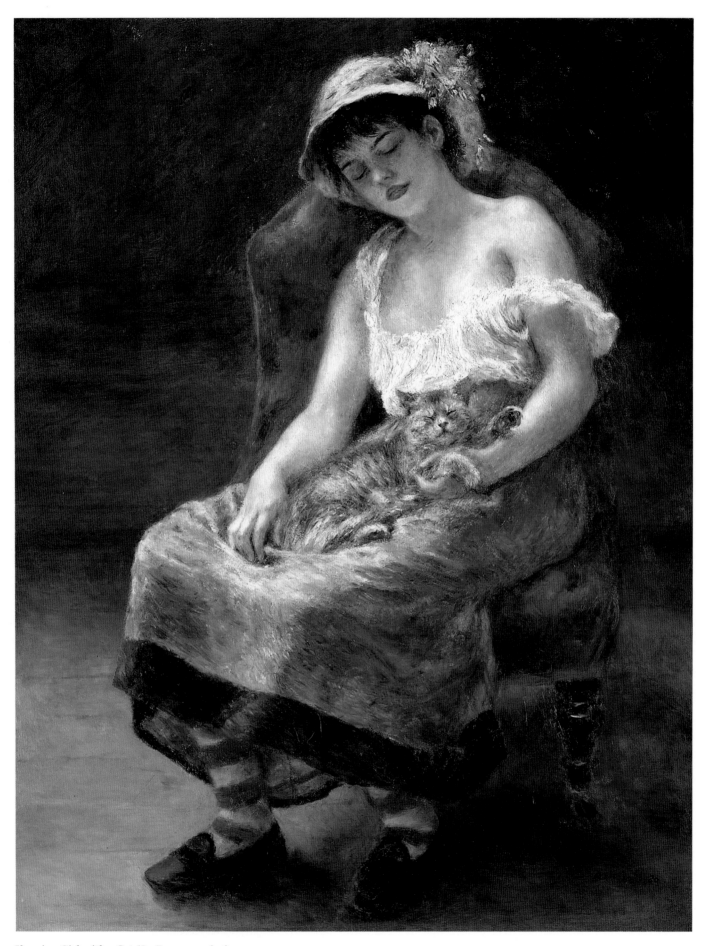

Sleeping Girl with a Cat (*La Femme au chat*)
1880
47¼ x 36⅜₆ in. (120.1 x 92.2 cm)
Signed and dated lower right: *Renoir. 80.*
1955.598
Purchased from Durand-Ruel Galleries, May 3, 1926

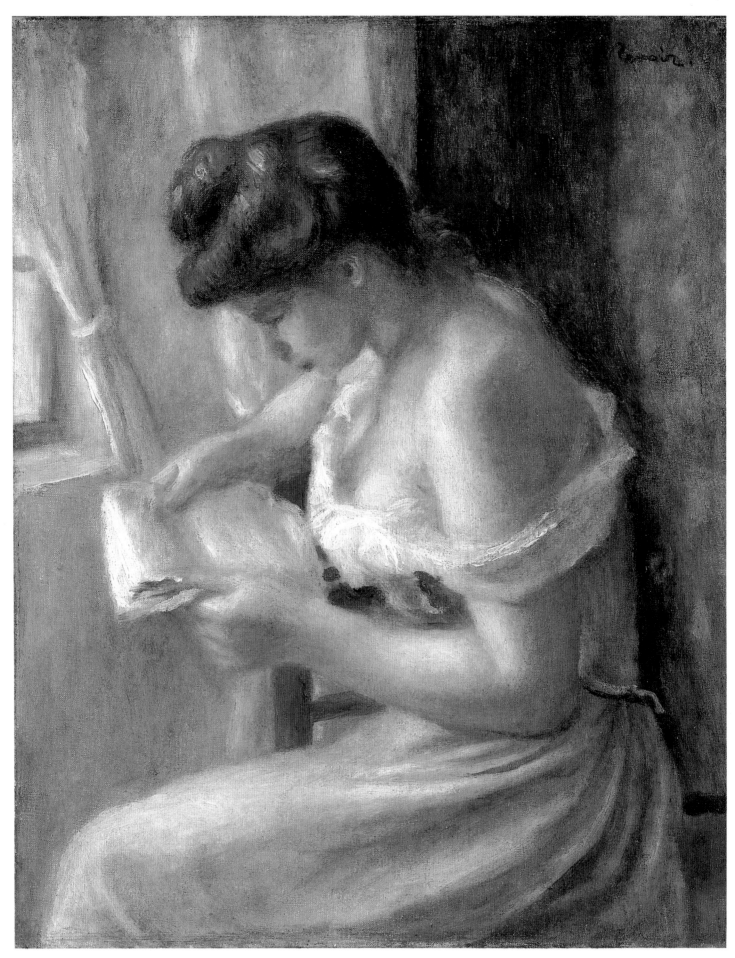

A Girl Reading

1891

16⅛ x 12¹¹⁄₁₆ in. (41.6 x 32.3 cm)

Signed upper right: *Renoir.*

1955.908

Purchased from Durand-Ruel Galleries, June 26, 1939

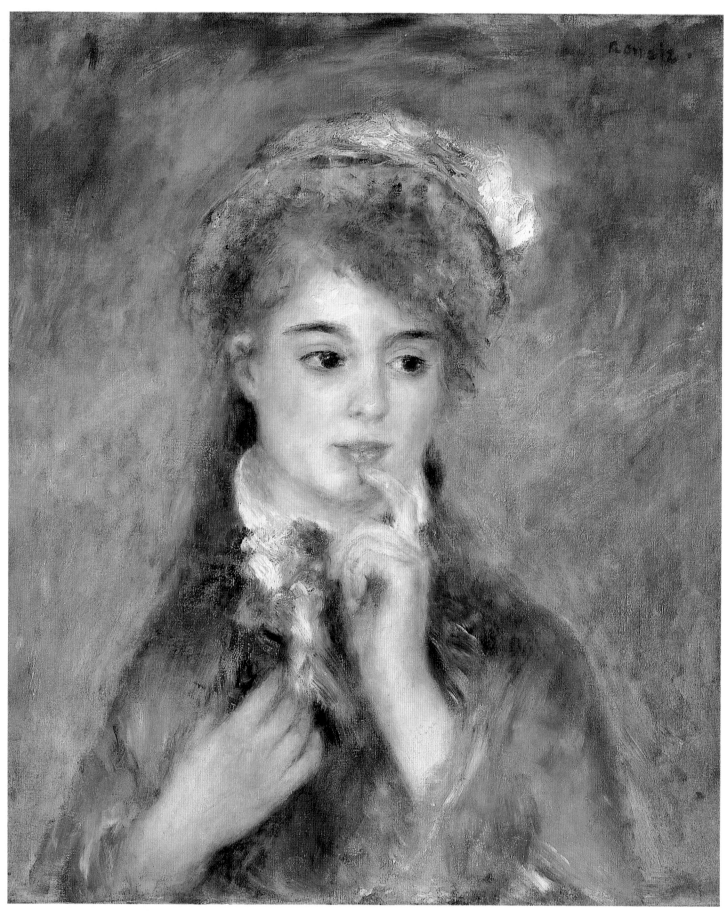

The Ingenue (*L'Ingénue*)
c. 1876
22 x 18⅛ in. (55.8 x 46.1 cm)
Signed upper right: *Renoir.*
1955.606
Purchased from Carroll Carstairs, November 28, 1940

Though his themes and subjects remained fairly consistent, Renoir's style of painting changed several times during his career. By the 1890s, he had begun to distill his motifs into large, simple shapes and masses, a product perhaps of the rheumatoid arthritis that made it difficult for him to handle a brush. With this change came gentler touches of paint, smoother, creamy surfaces, softer contour lines, restricted palettes usually composed of a few muted colors, and compositions organized around rolling, curving rhythms. In *A Girl Reading*, he articulates the figure and setting in terms of well-defined, elementary shapes—a sphere for the head, cylinders for the arms, and rectangles for the torso and lower body. Both the setting and the figure's clothing are spare and plain, and the colors are limited to subtle variations of pinks, grays, and greens. Though he had simplified his style, Renoir had not lost his taste for beauty and sensuality. A soft light, coming from the window, plays over the figure and emphasizes her shoulder blade, breast, and arm, but in contrast with the earlier pictures, Renoir does not highlight the figure against a darker ground. The edges of the forms are uniformly smooth and feathery, and the colors muted and subdued. The modeled volumes of the woman's body assume the shape of an easy, continuous curve, beginning with her slightly bent head with its large rolls of hair, moving through her back, and extending through her thigh. The picture strikes only one bewildering note—the page the woman scrutinizes is curiously blank.

In contrast with the other pictures in this group, *The Ingenue* shows a bust-length image of a fully dressed female in which Renoir gives visual form to a theme that fascinated him throughout his career, the stage between girlhood and womanhood. Nini de Lopez, the model for *A Girl Crocheting*, also sat for *The Ingenue*. The picture recalls *The Parisian* (1874; National Museum of Wales, Cardiff; fig. 20), a full-length study of a fashionably dressed girl-woman, which Renoir exhibited in the first Impressionist exhibition. Both figures wear similar blue hats and dresses with a white ruffle and large bow at the neck, and both have the same sloping shoulders. Though Renoir used a different model for *The Parisian,* the young actress Henriette Henriot, the faces of the figures have much in common: large brown eyes beneath delicately curved brows, prominent red lips, thin noses, and slightly pointed chins. The critic Jean Prouvaire's account of *The Parisian*, which he characterized as the middle stage in a female's journey from young girl to cocotte, could easily apply to the figure in *The Ingenue*: "Her hat is tilted over one ear and is daringly coquettish. . . . The smile is false, and the face is a strange mixture of the old and the childish. But there is still something naive about her. One gets the impression that this little lady is trying hard to look chaste."[15] While some might argue that the figure in *The Ingenue* is a chaste girl trying hard to look coquettish, Prouvaire's sentences convey the dualism that Renoir achieves in works like *The Parisian, The Ingenue*, and many

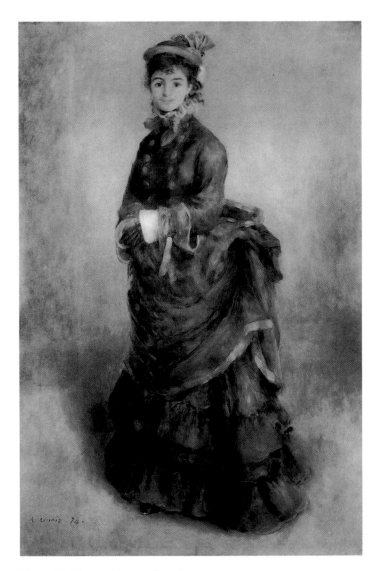

Figure 20. Pierre-Auguste Renoir
The Parisian
1874
Oil on canvas, 63 x 41½ in. (160 x 106 cm)
National Museum of Wales, Cardiff

other of his numerous pictures of the young girl approaching womanhood. While in *A Girl Crocheting* Nini de Lopez projects innocence and sweetness, in *The Ingenue* she seems slightly more knowing and coy. Her childlike face, composed of soft, rounded, smooth features, lacks the individuation and definition that come with age, but her glance, gesture, and fashionable attire suggest the more calculatedly sexual personality of an adult woman. Her dark eyes, which jump out from her pale skin, look intently off to the side, and she artfully directs the viewer's eyes to her red lips with a single finger—a child adopting the come-hither look of the practiced flirt. The loosely brushed, swirling background reinforces the dual qualities characterizing the figure—soft and unfixed like the child she is and sensuous like the woman Renoir apparently anticipates she will become.

KE

BATHERS

Though Renoir had painted the female nude before the 1880s, the subject had not been prominent in his oeuvre. Classical references in concert with Courbet's frank realism shaped the important nudes of his early career, *Diana the Huntress* (1867; National Gallery of Art, Washington, D.C.) and *Bather with a Griffon* (1870; Museu de Arte de São Paulo, Brazil), two full-length pictures of standing female figures. In the nudes that followed, he painted mainly seated figures in boudoirlike or arcadian settings composed of the looser brushwork that he favored in the 1870s. The figures themselves show varying degrees of modeling and finish. In the 1880s, however, he depicted the nude far more frequently, made it the subject of some of his most ambitious pictures, and painted the figures with a clarity and firmness that differ from his sketchier Impressionist style of the previous decade.

Renoir's new emphasis on and way of handling the female nude are bound up with the shift that occurred in his work in the early 1880s. If in the 1870s he painted modern-life subjects in a style suggesting ephemerality and transience, he now sought to modernize traditional subjects and to endow scenes of contemporary life with a sense of weight and solidity, permanence, and stability. His pictures would still involve observation of nature but would increasingly describe an ideal and imagined, rather than an actual, realm. The female nude, a time-honored theme whose roots lay in antiquity, provided an apposite vehicle for fashioning that combination of atemporality and contemporaneity.

Renoir devised his new approach to the nude in *Blonde Bather*. Statically posed before a generalized landscape that corresponds to no specific place and bereft of any clothing that might situate her in a particular period, the figure seems timeless. While Renoir composes the background seascape from the loose, sketchier strokes he used in the 1870s, he describes the figure with more blended, even marks, modeling and outlining her forms. The monumental bather dominates the landscape, in contrast with the nudes of the 1870s, which Renoir usually enclosed in their settings by using similar handling to merge figure and ground. Though the bather's body is large and fleshy rather than fashionably thin, the figure shows nothing of the realism of his earlier, Courbet-like nudes. Instead, Renoir idealizes the body by distilling the figure into large, simple, rounded sections and posing it so that her head forms the apex, and her thighs, back, and outstretched arm the legs, of a triangle. Painted in delicate, pinkish tones, her flesh exudes health and vigor and reveals no signs of age or gravity. Her youthful face, framed by her thick blonde hair, is unlined.

The idealized, monumental figure of the *Blonde Bather* shows its debt to the artists Renoir studied when he began to reorient his work—the eighteenth-century painters such as Fragonard and Watteau, whom he had always idolized, and Ingres.[1] He painted this bather in Italy, where he traveled in 1881 seeking classical models that would help him clarify his form, tighten his structure, and strengthen his drawing. There, he found useful examples in the works of Raphael, whom he praised for his dedication to "grandeur and eternal beauty,"[2] and the frescoes from Pompeii in the Museo Nazionale in Naples.

The bather sits before a generalized seascape. Renoir told friends that he conceived the picture on a boat in the Bay of Naples, but as John House observes, the background does not resemble that bay, and the figure, moreover, sits on the shore. It may be that Renoir reworked the background in the studio, since there is evidence of repainting.[3] When Renoir either sold or gave the painting to Henri Vever, a jeweler and collector of modern art, he erased his original signature, now partially visible, to

inscribe it to Vever. He painted a second version of *Blonde Bather* in 1882, probably at the request of his dealer, Paul Durand-Ruel.[4]

The *Bather Arranging Her Hair* and *Standing Bather*, both of which feature a large figure before a seascape, follow the format that Renoir established in *Blonde Bather*. Reflecting Renoir's stylistic experiments of the 1880s, however, the treatment of these later figures differs from that of the earlier one. In contrast with *Blonde Bather*, he smooths the brushwork in *Bather Arranging Her Hair*, and to a lesser degree in *Standing Bather*, so that it is barely visible, contours the bodies with crisp lines, and defines the forms of the landscape more clearly.[5] Renoir's way of applying paint in the seascapes of these pictures has been compared to that of his close friend Cézanne.[6] The regular, rectangular brushstrokes somewhat resemble Cézanne's so-called constructive stroke, but they also display a delicacy and fluidity that differ from the materiality and physicality of Cézanne's marks and the forms they described. Finally, these nudes are slightly more salacious than *Blonde Bather*. Instead of the classically sanctioned swath of drapery laid decorously across the figure's lap, these figures drop what appear to be their chemises, so that they become more titillatingly half-dressed than simply nude.

The challenge of modernizing the female nude engaged a number of late-nineteenth-century avant-garde artists, notably Manet and Degas. The particularity of Renoir's solution comes into focus when compared to each of theirs. Manet invoked Titian's *Venus of Urbino* in *Olympia* (1863; Musée d'Orsay, Paris), but used the pose, handling, and setting to challenge the nude's customary status as a passive object of male sexual desire. Critics saw a contemporary woman, a prostitute, in *Olympia*'s flatly painted forms and direct gaze and read the bouquet of flowers held by her maid as the offering of a recent client.[7] Degas, on the other hand, crafted images of modern, unidealized bodies engaged in the mundane tasks and often ungainly movements of everyday life—bathing themselves, toweling themselves dry, dressing themselves, and so on.

Renoir's modern nudes, however, are not rebarbative and sexually challenging as *Olympia* is or active, ordinary women as Degas's nudes are. The issue they address most forcibly is that of time—of preserving historical convention but transporting it to the present, of modernizing "grandeur and eternal beauty." Renoir remained committed to the conventions of the nude and showed no desire to fundamentally revise them. The static poses

and averted eyes of his bathers enable the presumably male viewer to consume their bodies freely without interruption,[8] and by placing these bodies in seascapes, Renoir underscored the age-old equation of woman as the product and embodiment of nature. Meant to reassure, the bathers combine ample proportions suggesting maternal plenitude and fertility with youthful faces epitomizing innocence, sweetness, and inexperience. They admit no signs of their own sexual desire and little consciousness of their own bodies.

Though tradition resonates in the setting, pose, and handling of the bathers, Renoir nonetheless intends them to be modern women, not historical figments. With their small noses, delicate mouths, and large, almond-shaped eyes, their faces resemble those of the women who populated his contemporary-life scenes of the 1870s. Describing Renoir's nudes, Georges Rivière wrote, "Venus as painted by him brings out the model's Parisian origins. She is one of us just as the beautiful princesses of Racine's tragedies belonged to Versailles not the palace of Theseus."[9]

While the backgrounds of these paintings are generalized, the loose brushwork nonetheless suggests the rapid execution of plein-air painting, that is, an image painted before the motif. In many of the nudes of the 1880s, the different handling of the figure and ground—the one studied and the other apparently spontaneous—seems disjunctive and dissonant, and the absence of any middle ground in the pictures makes the seascapes appear like stage sets or backdrops before which the bathers pose. This disjunction emerges in *Blonde Bather* and to some degree in *Bather Arranging Her Hair* and *Standing Bather*. Since so many of his bather images of the 1880s show this discordance, which a painter of Renoir's skill could easily have eliminated, he must have intended it to mean something. It might be argued that the quality of timeless contemporaneity which he sought rested, in part, on that peculiar combination of styles. In the bathers, figure and ground are not, in fact, completely at odds. For example, Renoir repeats the blues and pinks of the background in the flesh of *Blonde Bather*, and in the area closest to her body, the strokes lengthen and follow the curves of the figure. Her hair melts into the background, as does the drapery she holds on her lap; no edge separates one from the other.[10] To some degree, the figure seems to emerge from the background, for the strokes begin to coalesce and to register equivalences more exactly as they move from the background into the figure. Similar formal strategies

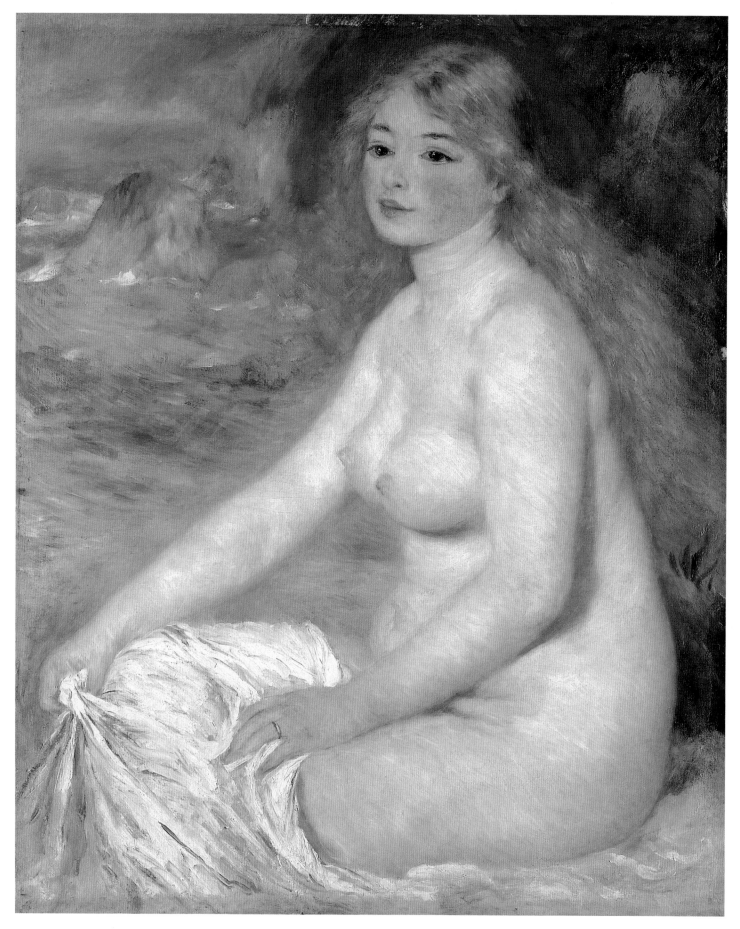

Blonde Bather (*Baigneuse au bord de la mer; Bather at the Seaside; Bather beside the Sea; Bather; Bathing Woman***)**
1881
32³⁄₁₆ x 25⅞ in. (81.8 x 65.7 cm)
Signed, dated, and inscribed upper right: *à Monsieur H. Vever / Renoir 81* [partially overpainted] / *Renoir. 81.*
1955.609
Purchased from Durand-Ruel Galleries, July 2, 1926

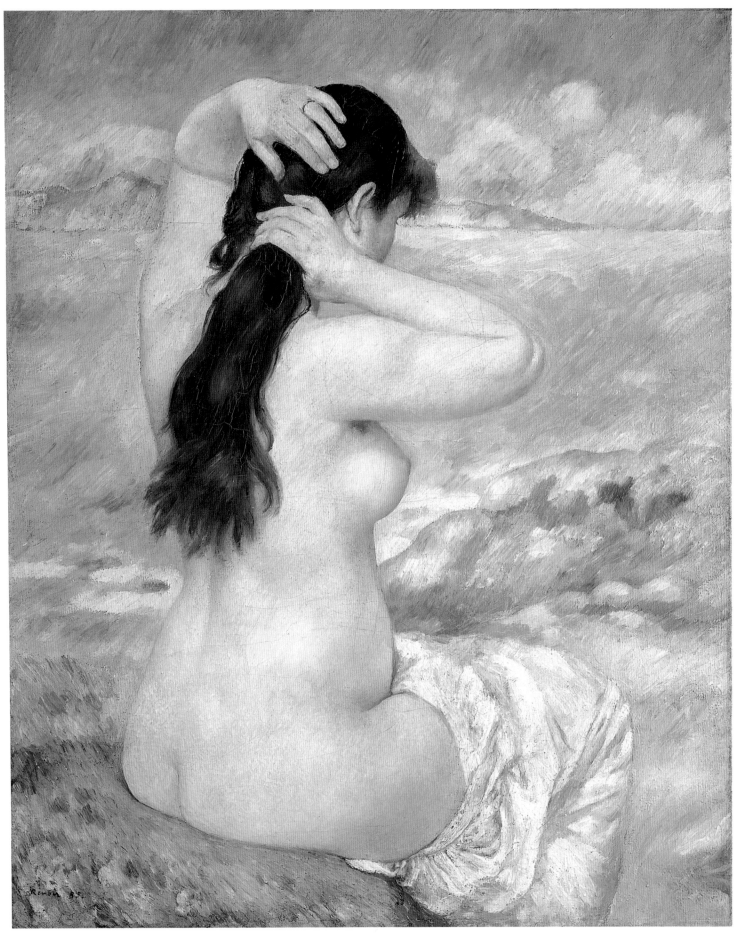

Bather Arranging Her Hair (*Bather; Baigneuse; La Brune; The Brunette; La Coiffure; The Hairstyle; Girl Fixing Her Hair; Bather Combing Her Hair*)
1885
36¹/₁₆ x 28¼ in. (91.9 x 73 cm)
Signed and dated lower left: *Renoir. 85.*
1955.589
Purchased from Durand-Ruel Galleries, April 26, 1937

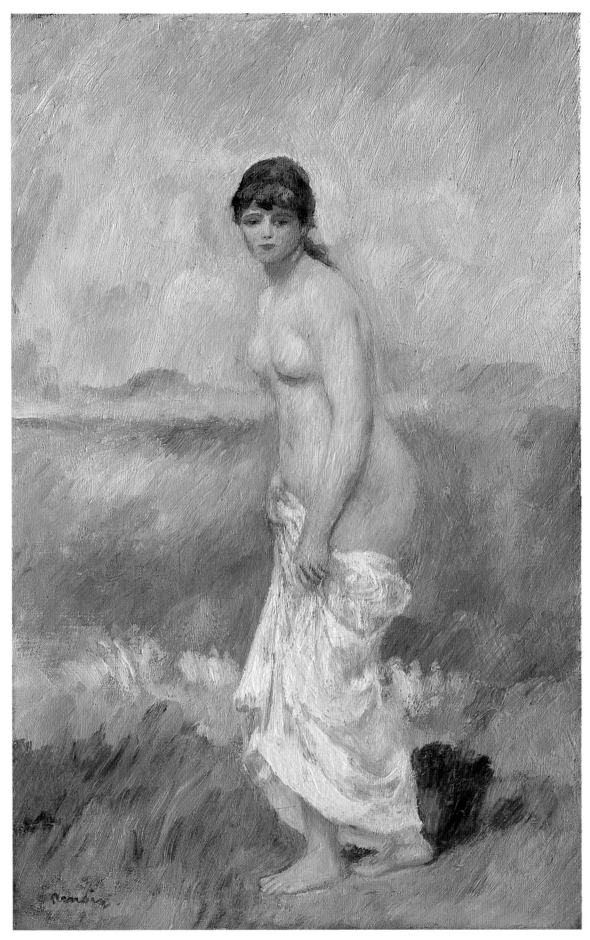

Standing Bather (*Baigneuse*)
1887
17 x 10⅝ in. (43.2 x 27.1 cm)
Signed lower left: *Renoir.*
1955.605
Purchased from Durand-Ruel Galleries, November 22, 1938

are used to connect figure and ground in *Bather Arranging Her Hair* and *Standing Bather*. By linking rather than merging figure and ground, Renoir establishes a dialogue between the two styles, so that one colors the reception of the other. Thus, the background animates the figure, and the bather stabilizes the background, with the result being a picture that produces a sense of the enduring present rather than a transitory moment.

The change in Renoir's work in the 1880s was the product of a complex array of personal and professional factors. Advancing age—he was now in his forties—and his recent liaison with Aline Charigot, the model for the *Blonde Bather* and his future wife, may well have been significant. He was, in addition, distancing himself from the Impressionists by this time. Recalling the shift in his art, he later told Ambroise Vollard that he felt he had "wrung Impressionism dry" and claimed that a painter who worked directly from nature eventually sought nothing but momentary effects and lost the ability to compose a picture.[11] The poor sales of his canvases also concerned him, and he hoped to succeed at the Salon, which, he contended in a letter to Durand-Ruel, was still the best place to attract buyers.[12] These monumental female bathers in generalized settings might more easily take their place alongside the smoothly painted, classical nudes of such leading academic artists as Bouguereau and Gérôme and might perhaps appeal to the collectors who bought their works.[13] It must also be noted that Renoir did not completely depart from his work of the 1870s, for even then he had tended to define his forms, rarely dissolving them in paint as completely as Monet or Pissarro often did. Nor was he alone in questioning the ephemerality and sketchiness of Impressionism. Though their work took different directions and involved different goals, Seurat and the other Neo-Impressionists, Cézanne, and Gauguin, among others, all sought, to varying degrees, to give their forms a sense of solidity, weight, and permanence.

Finally, and significantly, Renoir's approach to the female nude must be considered within the context of changes in the status of women in late-nineteenth-century Paris. Over the years, his nudes have been characterized as depictions of woman as she naturally is, as evocations of the beauty, truth, and essence of woman.[14] With the emergence of a feminist consciousness in art history, writers have rightly questioned those staple descriptions, which fail to acknowledge that the nudes were the constructions or fabrications of a particular man who had selected and combined various traits to create his version of ideal femininity.[15] Fictions, not facts, the nudes are products of Renoir's fantasy and imagination.

As Tamar Garb and others have observed, those fantasies take on a particularly reactionary cast when situated in the context of the 1880s. That decade saw the beginnings of an organized feminist movement, with increasing numbers of women entering the professions and more women assuming the public roles traditionally held by men. It was the era of *la nouvelle femme*, who sought to expand her world beyond the private realms of home and family.[16] Clearly aware of and disturbed by these changes, Renoir wrote Philippe Burty in April 1888, "I think of women who are writers, lawyers or politicians—George Sand, Mme. Adam and other bores—as monsters, mere freaks" and contended that "gracefulness is [woman's] domain and even a duty."[17] His son Jean remembered similar comments: "Why teach women such boring things as law, science, medicine, and journalism, which men excel in, when women are so fitted for a task men can never dream of attempting and that is to make life bearable."[18] Renoir contested the concept of *la nouvelle femme* not only in his words but also in his paintings. Insisting on the boundaries that had traditionally separated male and female realms, they posited woman as the embodiment of nature, decoration, and beauty rather than culture, action, and thought.

Renoir's assertion of a world in which women assumed the role of nature to men's culture, tended to matters of reproduction rather than production, and accepted their status as objects to be viewed rather than viewing subjects was part and parcel of his misgivings about changes in the modern world generally. At various times in his life, he inveighed against electricity, sewage pipes, all-night stores, railways, workers' rights, industrialization, and mass production (which had ended his career as a porcelain painter).[19] Renoir's nudes, then, are characters in the premodern, edenic world he invented, a world where experience is simple and straightforward rather than complex, shifting, and often contradictory.[20]

KE

Artists have been creating self-portraits since the days of ancient Egypt. On a practical level, painting oneself saves an artist model's fees; on a personal level, it affords an opportunity to produce an intimate image of self-reflection. The comparison of two nearly identically sized bust-length self-portraits by Renoir, one painted about 1875, when the artist was thirty-four years old, and the other in 1899, when he was fifty-eight, proves to be of interest in terms of technique, style, and artistic expression.

Renoir's portraits often do not provide a strong sense of personality or character. However, the early self-portrait in the Clark collection captures something more than a physical likeness of the artist and is by far one of the most expressionistic paintings Renoir ever created. The treatment of the pigment is incredibly animated when compared with that of most Renoir works from the period, paintings done with smooth, feathery brushstrokes, such as his *Bridge at Chatou* or *Monsieur Fournaise*. The thick, agitated brushwork and the multitude of colors with which he paints the face make the painting seem to come alive.

No color on the face is seen in its pure form; each is aggressively mixed with surrounding pigments on the canvas. The beard and hair are built up of a striking combination of black, mustard yellow, and green pigments. Deep blue brushstrokes represent the reflection of Renoir's dark hair against his warm, pink skin. The whites of the eyes are actually pale blue, and the area surrounding the eyes is painted in an olive green color that makes Renoir look worn and drawn out—an effect that is emphasized by the angular contours of his thin face. The strong contrast between the shadowy background and brilliantly lit face increases the intensity of the portrait.

Contemporary photographs of the artist bear a resemblance to the arresting image of the Clark's early self-portrait. In contrast to his self-portrait of 1876 (Fogg Art Museum, Cambridge), which has the even brushwork and gentle, nonexpressive face more typical of his work, the Clark's painting of one year earlier clearly mirrors Renoir's tense psychological state. The seemingly idyllic world generally depicted in his paintings is not reflected here. The year 1875 was a particularly difficult one for him. He was rejected at the Salon, and the failure of the painting auction that he helped to organize at the Hôtel Drouot was dismal, with his paintings bringing in the lowest prices offered.[1]

Renoir did manage to sell a few works in the 1870s, and this painting was one of them. It was purchased by an important early collector of the Impressionists, Dr. Georges de Bellio. A Romanian homeopathic physician who settled in Paris in the 1850s, de Bellio had a sizable collection of Impressionist paintings, which included another of the Clark collection's

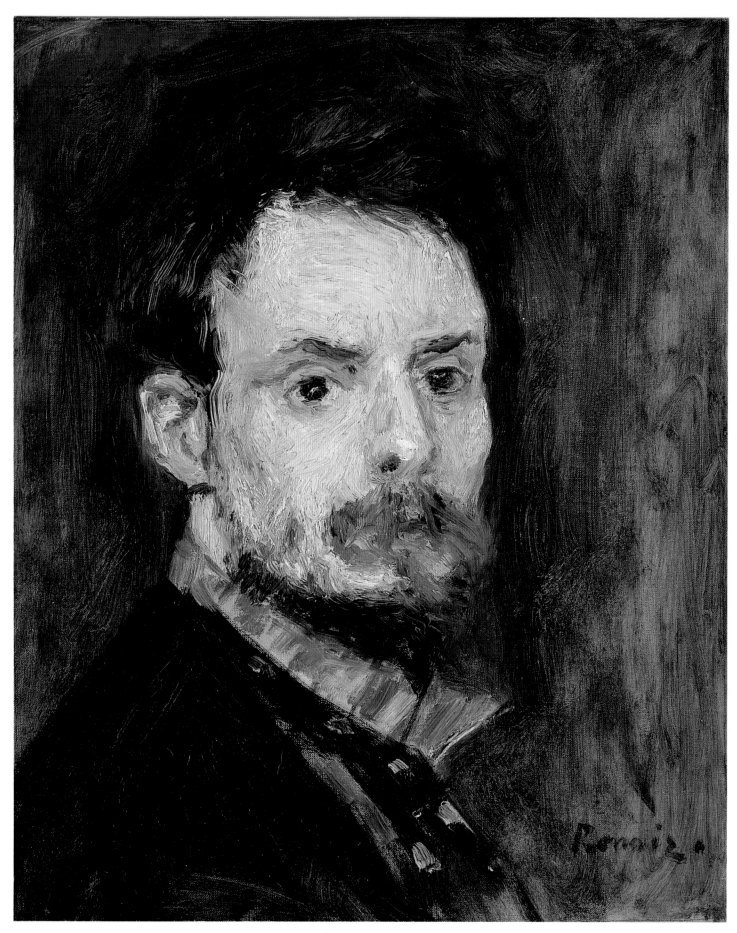

Self-Portrait

c. 1875

15⅛ x 12½ in. (39.1 x 31.7 cm)

Signed lower right: *Renoir.*

1955.584

Purchased from Durand-Ruel Galleries, February 14, 1939

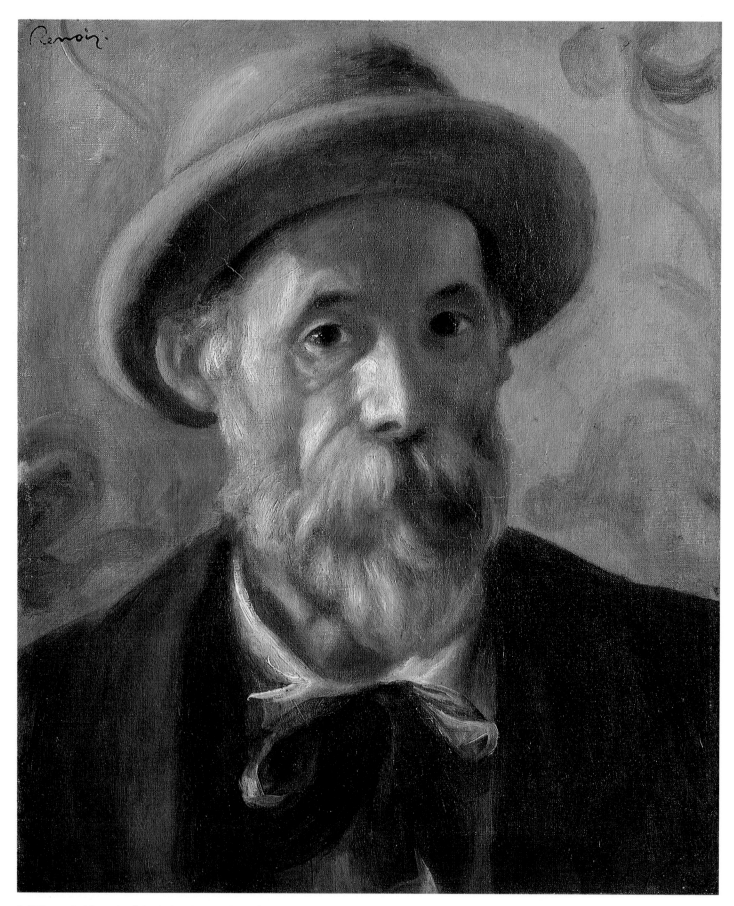

Self-Portrait (*Portrait of the Artist; Auguste Renoir*)
1899
16⅟₁₆ x 13 in. (41.1 x 33 cm)
Signed upper left: *Renoir.*
1955.611
Purchased from Durand-Ruel Galleries, April 10, 1937

Renoirs, *Bridge at Chatou*.[2] Victor Chocquet, another key supporter of the Impressionists, helped de Bellio acquire this self-portrait. He saw the painting in Renoir's studio and arranged for the artist to sell it to de Bellio for one thousand francs, a high price at the time for an Impressionist painting and a huge boost financially for Renoir. Renoir later questioned the enthusiasm of the public for this painting: "For some reason or other, everybody praises it nowadays. It's an unimportant little sketch. I had thrown it in the trash-basket at the time, but Monsieur Chocquet asked me to let him take it. I was ashamed that it wasn't better. But a few days later he brought me a thousand francs. Monsieur de Bellio had gone crazy over that bit of canvas, and it was he who had given the thousand for it."[3] Sixty-four years later, in 1939, Clark was quoted an asking price of $17,000 for the self-portrait. After close examination of the painting, he declared that it was a "very nice portrait of a particularly sensitive and agreeable face—It shows a man of genius and energy" (January 21, 1939).

Although Clark was not a great devotee of Renoir's late work, he admired the artist's self-portrait of 1899. Renoir's style had changed drastically in the intervening years between the two self-portraits in the Clark collection. By 1899 Renoir was a well-established artist and no longer desperate for commissions to pay the rent. The energetic and expressionistic brushwork of the more youthful self-portrait, which reflected his experiments with the then avant-garde tenets of Impressionism, has been replaced with traditional modeling in this mature image, and only a few areas of highlights are built up with impasto.

Renoir appears to have posed in front of flowered wallpaper, which provides a quite different background from the earlier portrait's nondescript space, created with very thin washes of pigment. Also, while his clothing had only been lightly sketched in in the earlier self-portrait, it is fully developed in the later work. The dramatic pink-and-blue-striped shirt collar and polka-dotted tie have been replaced in the later portrait with an ordinary white shirt and a plain scarf tied in a bow.

There is a softer, more genial look to this later self-portrait. Renoir's son Jean described his father's appearance in his later years: "His hair, which had once been light brown, had turned white, but was still quite thick at the back of his head. On top, however, he was completely bald, a feature which was not visible since he always wore a cap, even indoors. His nose was aquiline and gave him an air of authority. He had a beautiful white beard, and one of us always kept it trimmed to a point for him."[4]

Renoir's health had declined dramatically by 1899. His rheumatism had progressed to the point where it was difficult for him to control the movement of his hands—and yet he continued to paint. Julie Manet, daughter of the painter Berthe Morisot and Eugène Manet, was a close family friend and sometime informal pupil of Renoir's. In her diary entry of August 9, 1899, she gave the following account of the painter: "It is so painful to see him in the morning not having the strength to turn a doorknob. He is finishing a self-portrait that is very nice. At first he had made himself a little stern and too wrinkled; we absolutely insisted that he remove a few wrinkles and now it's more like him. 'It seems to me that those calf's eyes are enough,' he says."[5] Although the Clark's painting traditionally has been dated about 1897, it has been suggested that Mademoiselle Manet is referring to it here, an entirely plausible theory since the self-portraits next closest in date are those of 1910.[6]

Renoir's portraits of men are far less numerous than those of women. Many of these images are of fellow artists and friends rather than commissioned portraits. One such friend was Alphonse Fournaise, whose portrait he painted in 1875.[7] Fournaise, an astute entrepreneur, opened a restaurant and rented out boats for visitors in Chatou, a bucolic town on the Seine, only nine miles from the Gare Saint-Lazare in Paris.[8] Capitalizing on the desire of nineteenth-century Parisians to escape the city and enjoy the pleasures of the countryside, Fournaise played host to many of the most important French painters and writers of the day at his restaurant. It was on the balcony of this establishment that Renoir would paint his famous *Luncheon of the Boating Party* (1880–81; The Phillips Collection, Washington, D.C.; see fig. 11).[9]

Renoir had been frequenting this spot since the late 1860s and talked of it with delight: "I always stayed at Fournaise's. There were plenty of pretty girls to paint; and you were not reduced, as you are to-day, to chasing after a model for an hour only to be treated finally as if you were a disgusting old man."[10] Fournaise was kind to Renoir, who had very little money at the time, and according to Jean Renoir, Fournaise would often forgo giving Renoir a bill and would ask instead for a painting. Renoir reminded his friend that no one was interested in his work, but Fournaise was said to reply: "What difference does that make? It's pretty, isn't it? We have to put something up on the walls to hide those patches of damp."[11]

Renoir never forgot the public's initial disdain for his work, and for this portrait in particular. He later criticized those who changed their opinion of his paintings once they learned of their current market value: "That canvas, which was then considered the last word in vulgarity, has suddenly become very distinguished in its handling, now that my pictures are fetching large prices at the auctions. The people who prattle with such conviction to-day about the 'refined' manner of the portrait of Fournaise, would not even have parted with a hundred francs for a portrait, at the

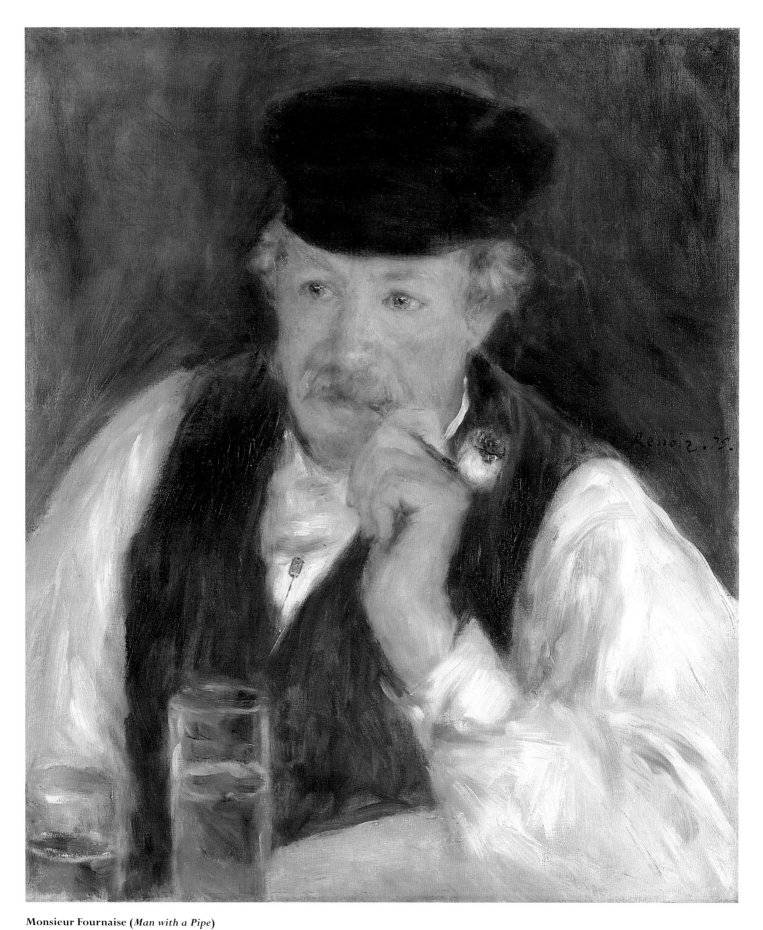

Monsieur Fournaise (*Man with a Pipe*)

1875

22 x 18½ in. (55.9 x 47 cm)

Signed and dated right center: *Renoir. 75.*

1955.55

Purchased from Durand-Ruel Galleries, June 26, 1939

time when that amount would have been a godsend to me."[12]

Renoir depicts Fournaise seated at a table with two beers in front of him, and the viewer can imagine the artist drinking from one as he paints.[13] Almost imperceptible wisps of smoke rise from the pipe. The painting is composed of broadly applied and smoothly blended brushstrokes—the only minutely detailed object is the small pin placed on Fournaise's shirt just above his vest. Renoir's portrait *Claude Monet Reading* (1872; Musée Marmottan, Paris) is composed in a similar manner; both are casually posed images of good friends enjoying a smoke. Manet also painted individuals in the same manner, as participating in scenes of contemporary life rather than posed for a formal portrait.[14] Renoir's brother Edmond, who wrote for the weekly publication *La Vie moderne*, remarked on his sibling's portraits: "Does he make a portrait? He begs his model to maintain a customary attitude, to seat herself the way she naturally does, to dress as she dresses, so that nothing smacks of constraint and preparation. Thus his work has, aside from its artistic value, all the charm *sui generis* of a faithful picture of modern life. What he paints, we see every day; it is our very existence that he has registered in the studies which are certain to remain among the most living and most harmonious of the epoch."[15] Rather than posing Fournaise for a more formal effect, Renoir has done just as his brother described and painted him in a natural stance and setting, thereby creating an image of *la vie moderne*.[16]

Not having the same attitude here as in his portraits of women, Renoir would presumably not have denied his male sitters an active and intellectual mind. However, generally speaking, the portraits of men seem to have no more depth of character than those of women, whose intellect he preferred to believe did not exist. Renoir obviously favored painting portraits of women, and Sterling and Francine Clark appear to have had no more interest in portraits of men than the artist did. When Clark was considering the purchase of *Monsieur Fournaise* in 1939, he told the staff at Durand-Ruel's "to telephone Francine & ask her to come in & pass on it whether she wanted it or not—no question about its quality—only subject" (January 13, 1939).
PRI

IMAGES OF CHILDHOOD

PORTRAITS OF CHILDREN

Over the course of his long and prolific career, Renoir painted many sensitive and engaging portraits of children. His four portraits of children in the Clark collection are stylistically all quite different and present a fascinating range of working methods, influences, and composition. The assertive impasto of *Mademoiselle Fleury in Algerian Costume* establishes an emphatic counterpart to the gently handled brushwork and tonal harmonies of *Thérèse Berard*. The loose, spontaneous feel of *Jacques Fray* provides an interesting comparison with the more structured improvisation of the *Studies of the Berard Children*, a work that, despite its title, is in many ways more finished. The portraits span twenty-five years of the artist's career, and each of the children depicted was the son or daughter of a member of the French aristocracy whose parents were friends, students, or acquaintances of Renoir.

The boy and three girls in the *Studies* were the children of Paul Berard, one of Renoir's earliest and greatest patrons; Thérèse Berard was his niece. Renoir and Berard were introduced at one of the Charpentier salons in 1879, just at the start of the artist's career as a portrait painter. Although that year was something of a turning point for Renoir, he was far from established in the art world. Despite the favorable reception of his work at the 1879 Salon, most people continued to be put off by his art. Berard knew this, but he immediately offered the artist his patronage and friendship. He was aptly described as a man "whose tastes were sure and audacious, [an] enemy of all accepted opinions, [who] understood by instinct the talent of Auguste Renoir at a time when it required an undeniable courage to defend his oeuvre."[1]

Berard also collected the works of other Impressionists and provided them with much-needed support. Claude Monet described his generosity, "We owe to Paul Berard a great deal of gratitude. We would arrive at his house . . . with a canvas under our arms—Sisley, Pissarro, Renoir, and myself—around eleven in the morning. We would find him in his house-robe, spending the morning arranging his eighteenth-century porcelains . . . [and] he bought our works from us. . . . We were happy, and we were always grateful to him for daring to hang in his dining room works which those of his milieu did not fail to mock."[2]

Even as late as 1883 Berard was still distressed at the lack of public acceptance of Renoir's painting. To a mutual friend he wrote, "As for Renoir, he is in a crisis of discouragement. . . . I have not seen anything new and he has no commissions. . . . I am terrified of the difficulty that one meets in having his paintings accepted. . . . Alas for Renoir, the portrait [of Lucie, Berard's youngest daughter] scares people."[3]

Renoir was a guest at Wargemont, the Berards' country house in Normandy, nearly every summer between 1879 and 1885. Often staying for months at a time in this relaxed and informal atmosphere, the artist painted every member of the family at least once, and the children several times. Altogether, Renoir executed approximately forty paintings at Wargemont, most of them for Paul Berard and his family. These works include the decorative painting *A Bouquet of Roses*, also in the Clark collection.

It was probably during Renoir's first summer at Wargemont that Paul's brother Alfred, who owned the adjoining estate, commissioned a portrait of his daughter. Thérèse Berard was then thirteen. Adrift with her thoughts in a sea of violet, the girl is caught in a studied moment of contemplation. In the manner of Velázquez, Hals, and Manet, the unmediated background space provides no peripheral detail to distract from our perception of the individual: she seems to glow with a light of her own. The blues and violets are tinted with magenta and even

yellow, color so vibrant that the background is transformed from a neutral backdrop to a warm and enveloping atmosphere that enlivens the pensive Thérèse. Its colors shimmer on the surface of the canvas and refuse to recede into space; instead, they saturate the air itself with a hue that echoes, pure and condensed, in the blue trim of her blouse.

The portrait is more typical of the way in which Renoir painted women than of the energetic and lively way he painted children. Thérèse is sitting quietly, not engaging the viewer except by her beauty and her melancholy, thoughtful appearance. A solemn and formal portrait, such as this one, is itself an academic type, and it is a surprise to realize how far from Impressionism this portrait is, given that it is by a man known today as one of the founding fathers of that movement.[4] The very thin and flat paint surface is characteristic not of the Impressionists but of the academics, who worked to suppress the visible brushstroke in favor of an image that resembles a view from a window, presented in minute and perfect detail. The smooth surface of the painting is animated by color rather than by brushwork; the delicate blending of colors continues even in the artist's signature. The tight handling of paint makes it difficult to pick out any individual brushstroke; the only impasto is in the light splotches that glint on the buttons.

Years later, Thérèse—then Madame Albert Thurneyssen—said that she had never liked this portrait, largely because of the very blouse that Renoir depicted with such care. As her son later described it, "She was then in what we call the ungrateful age; she was wearing a blouse such as those that children wore on their vacations in the country and that she did not find elegant."[5] Nevertheless, she kept the painting "in a prominent place in her living room" for many years.[6]

In 1938, when an agent for Sterling's brother Stephen knocked on Madame Thurneyssen's door and offered to buy the painting, she refused. Several weeks later the agent came again to the house, with the news that the unnamed American collector had doubled his price. This time, with the threat of war and the very real possibility that Paris might be bombed, Madame Thurneyssen decided to sell the painting.[7] Sterling, who always watched Stephen's collection with a competitive eye, was so stunned by the portrait when he saw it in 1945 on consignment at Durand-Ruel's that he bought it on the spot.

In 1881 Renoir was again staying with the Berard family in Normandy. Because he was careful to continue working in the pseudoacademic manner he knew they appreciated, Renoir employed the same tight brushwork and controlled handling of paint for all his portraits of the Berard family, even the *Studies of the Berard Children*. Though the individual portraits on this canvas are finished in and of themselves, the multiple viewpoints and

informal poses of the children make for a lively and charming composition.

The bright faces of all four of Paul and Marguerite Berard's children crowd the canvas. At the center is the eldest daughter, Marthe, looking up from her big red book. She appears again, dressed in pink, in profile at the lower right. (There is a marked family resemblance between Marthe and her first cousin Thérèse that is enhanced by the long brown hair tumbling over their shoulders in both portraits.) The baby is Lucie, who sleeps through two frames but is awake in the third sketch at the top, her bright eyes fixed in concentration. André, enclosed in a cloud of green, is reading diligently at the lower left. Five-year-old Marguerite is shown twice, at the top of the picture and seated along the right-hand edge.

Three of the four children are reading; Lucie, of course, was too young. The artist may have found this a useful way to keep the children quiet long enough to paint them, for a contemporary account of the Berard children describes them as noisy and rowdy, quite the opposite of the placid subjects of the painting: "The Berard girls, unruly savages who refused to learn to write or spell, their hair wind-tossed, slipped away into the fields to milk the cows."[8] The parents might indeed have been pleased to see their children represented as being so studious. As in the portrait of Thérèse, the Berards do not make eye contact with the viewer but remain quietly involved with their own activities.

Any one of these eight studies of the Berard children could have been transformed easily into a more finished portrait, like that of Thérèse, had the sections been cut apart. Indeed, a color for a solid background has already been selected and incorporated behind each child. Although the thin paint allows the weave of the canvas to be plainly seen in several sections, there is no doubt that the artist took considerable time with this canvas, adding many of the final touches with the same blue paint that he used to sign his name. Renoir considered this canvas to be finished as it was, and it was in fact exhibited only two years later as *Sketches of Heads*.

That Renoir was more than willing to work from photographs has been pointed out by François Daulte, who compiled a series of photographs of the Berards and paired them with some of Renoir's portraits of the family.[9] Details of clothing, posture, and expression match up too closely and too often for the connections to be purely coincidental. In each case, it seems obvious that the artist relied heavily on the photographs to work up to his final images, though he continued to work from life as well. Renoir embraced the new medium of photography as a tool in his work rather than trying to compete with it, as the Impressionists were accused of doing. Barbara

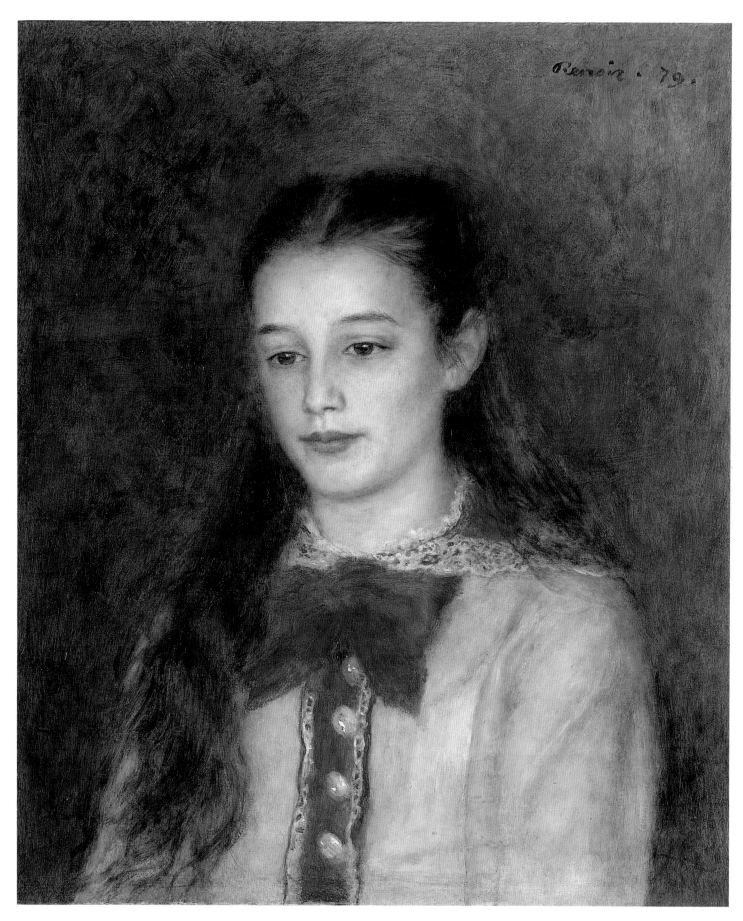

Thérèse Berard

1879

22 x 18⁷⁄₁₆ in. (55.9 x 46.8 cm)

Signed and dated upper right: *Renoir. 79.*

1955.593

Purchased from Durand-Ruel Galleries, January 2, 1946

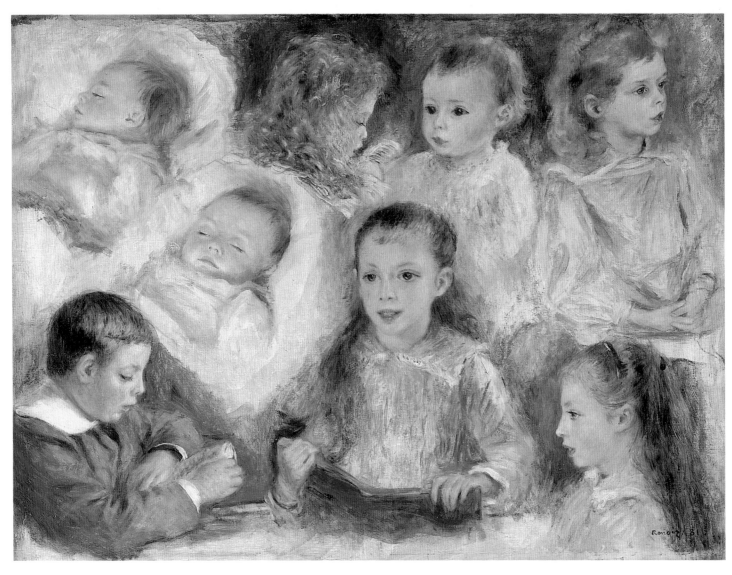

Studies of the Berard Children (*Têtes d'enfants; Enfants; Sketches of Heads*)
1881
24⅝ x 32¼ in. (62.6 x 82 cm)
Signed and dated lower right: *Renoir. 81*
1955.590
Purchased from M. Knoedler & Company, June 30, 1938

White has noted that some of his paintings even have the appearance of photographs, especially in their "firm facial structure and striking definition of the eyes."[10] This can be seen in *Thérèse Berard*, for example, where the face is the only clearly defined space in the composition.

Portraits were undoubtedly time-consuming efforts that did not allow the artist much room for innovation. Many painters, including Degas, Cassatt, and Ingres, endeavored to avoid commissioned portraits, which were regarded as "both artistically constricting and . . . less challenging."[11] Renoir also found it tiresome to do the intense work necessary to capture the features of an individual, saying, "If I rework a head the next day, I am lost; but it is a portrait, and a mother must be able to recognize her daughter."[12] A painting like *Madame Charpentier and Her Children* (1878; The Metropolitan Museum of Art, New York; see fig. 10) could take up to forty sittings to complete.[13] One of the Cahen d'Anvers girls, whose portrait Renoir painted in 1881, recalled the endless tedium of posing again and again, saying that the only thing that kept them entertained was the pleasure of having such lovely lacy dresses to wear.[14] In cases such as these, the medium of photography could save Renoir both time and annoyance and, at the same time, lift some of the burden from his often restless models.

Whereas *Studies of the Berard Children* contains quick and simple images of faces he had painted before, *Mademoiselle Fleury in Algerian Costume* presents a much more formal attitude, redolent of the contemporary image of the Orient. The closest outpost of the East, Algeria was still a French colony in the nineteenth century and was not brought entirely under French control until 1880. There had been a very strong French colonial presence in the country since the turn of the century, and orientalism had had a hold on French artists for decades. Unlike Monet, Whistler, and van Gogh, and many other painters whose orientalist motifs were drawn from study of the art of Japan, the orientalism of the academic painters was not directly inspired by the art of another country. In large part, it was an entirely contrived result of the artists' sojourns to the "exotic" locale of North Africa. And, in this regard, Renoir's alliance with the academic painters is announced with great clarity. North Africa was an extremely popular place for romantic and academic artists to visit; the trip was actually de rigueur for those who could afford it. The Paris Universal Exposition of 1867 has been described as having an orientalist theme,[15] and certainly there was a lively market in the nineteenth century for anything *orientaliste,* still considered a "modern" subject matter for painters.

Charles Gleyre, the teacher of both Renoir and the academic painter Jean-Léon Gérôme, was so inspired by North Africa that he traveled there several times from 1835 to 1838. Gérôme himself held on to the subject matter of the East for many years: his three paintings in the Sterling and Francine Clark Art Institute, *The Snake Charmer* (c. 1870), *The Slave Market* (c. 1867), and *Fellah Women Drawing Water* (c. 1870), are all orientalist works. John Singer Sargent was in North Africa working up his composition for *Smoke of Ambergris* (1880) at the same time as Renoir traveled there. Henri Matisse, entranced like Renoir by the color and light of Africa, also made the trip.

Renoir's own visits to Algeria were inspired largely by the

example of Eugène Delacroix, who was in North Africa in 1832 and who worked with oriental themes for much of his career. Renoir had painted Algerian themes as early as 1870; his *Woman of Algiers* (National Gallery of Art, Washington, D.C.), a studio painting of a favorite model dressed in oriental costume, was shown at the Salon that year. But it was not until March of 1881 that he could afford to go to Algeria. This first trip was followed by another the next year. As Renoir later told Vollard, "I caught the inevitable cold in my chest at Estaque, which decided me to make a second trip to Algeria. There I made a life-size portrait of a young girl named Mlle. Fleury, dressed in Algerian costume, in an Arab house, holding a bird."[16]

Painted in 1882, *Mademoiselle Fleury in Algerian Costume* shows a young European girl, presumably the daughter of the French governor-general of Algeria, crossing a courtyard with a small and restless falcon in her hand. Although falconry itself originated in North Africa, the bird painted here is a female European kestrel (*Falco tinnunculus*).[17] The girl's calm is unruffled despite the fact that the falcon appears to be screeching in her ear.

The overall effect of the painting is a single impression of scintillating, high-keyed color. Like Delacroix, Renoir perceived that "the light of North Africa contained a whiteness which cloaked all colors in a delicate gray film."[18] This luminosity, more than any particular subject he encountered on the voyage, had the most impact on his later working methods. Dr. Albert C. Barnes, like Clark a great collector of Renoir, criticized this painting for its "surface quality of tinsel which impairs solidity and plastic strength."[19] Indeed, the coherence of the shapes beneath the colors is hard to establish in certain passages, but the painting itself is done with great skill and attention to momentary, flashing detail. The wet-on-wet application of paint caused the colors to be dragged through one another to form thick surfaces, layers upon layers of high impasto, except in the face, where the paint is smoother, more delicate, and legible.

By depicting a Western model in the place of an Algerian girl, the painting becomes more specifically about the use of costume to render a subject exotic, apart, and available, a convention in painting that goes back to the odalisques of Ingres, or even the costume pieces of Rembrandt. The academic painter William Bouguereau, Renoir's contemporary, often "dressed and made up" his models to "play act *Orientale*."[20] Eroticized by means of orientalism and masquerading as a bejeweled young harem girl, Mademoiselle Fleury is posed to engage the male gaze as she pulls aside the veil.

The vague yet inviting half-smile on her face resembles that given to Renoir's *Blonde Bather*, a passive and objectified woman in a more overtly sexual context. *Mademoiselle Fleury in Algerian Costume* also resonates with *A Girl with a Fan*, Renoir's portrait of a young, coquettish girl. The two girls could be sisters, their individuality subsumed into Renoir's conception of beauty, so that only a general likeness of their features is presented. It is not known whether *Mademoiselle Fleury* was a commissioned portrait,[21] but it is obviously a painting of the size and type that would have been appropriate for submission to the Salon. Portraiture here has been superseded by the trappings of the Orient and the artist's desire to create a genre piece.

Only a small number of Renoir's orientalist works were actually inspired by his trips to Algeria, and it is generally accepted that the most successful of these were in fact done with costumes and props in the studio before his first trip; these paintings "correspond more to a conventional imagery of the East than do those painted after his trips to Algeria."[22] Having no original, personal vision regarding a country he had not yet visited, Renoir could only, in the 1870s, copy the conventional imagery.

That most of the few paintings surviving from Renoir's two sojourns in Algeria are loose, sketchy, and unfinished suggests that he had already tired of the motifs by the time he made the first trip, that he did not paint well en plein air and preferred to have time to work out his compositions in the studio, and that his interests lay more in the light and color of North Africa than in its specific subject matter. "Renoir was not an *orientaliste* by conviction[;] once he had left Algeria he never returned to those types" of paintings.[23] Renoir took part in the first few salons of the Société des Peintres Orientalists Français, but his orientalist works seem to lack the requisite mystery and intrigue that pervade paintings of similar subjects by Delacroix or Gérôme. Any exoticism in Renoir's paintings is negated by his repeated use of Western models in costume and by his lack of engagement with the theme.

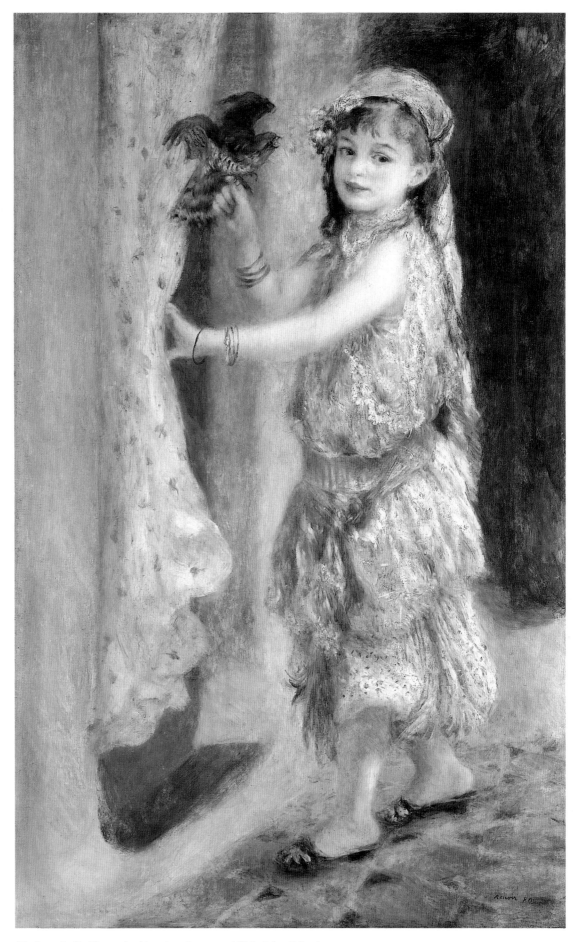

Mademoiselle Fleury in Algerian Costume (*Girl with a Falcon*)
1882
49¹³⁄₁₆ x 30¼ in. (126.5 x 78.2 cm)
Signed and dated lower right: *Renoir [8]2.*
1955.586
Purchased from Durand-Ruel Galleries, May 6, 1937

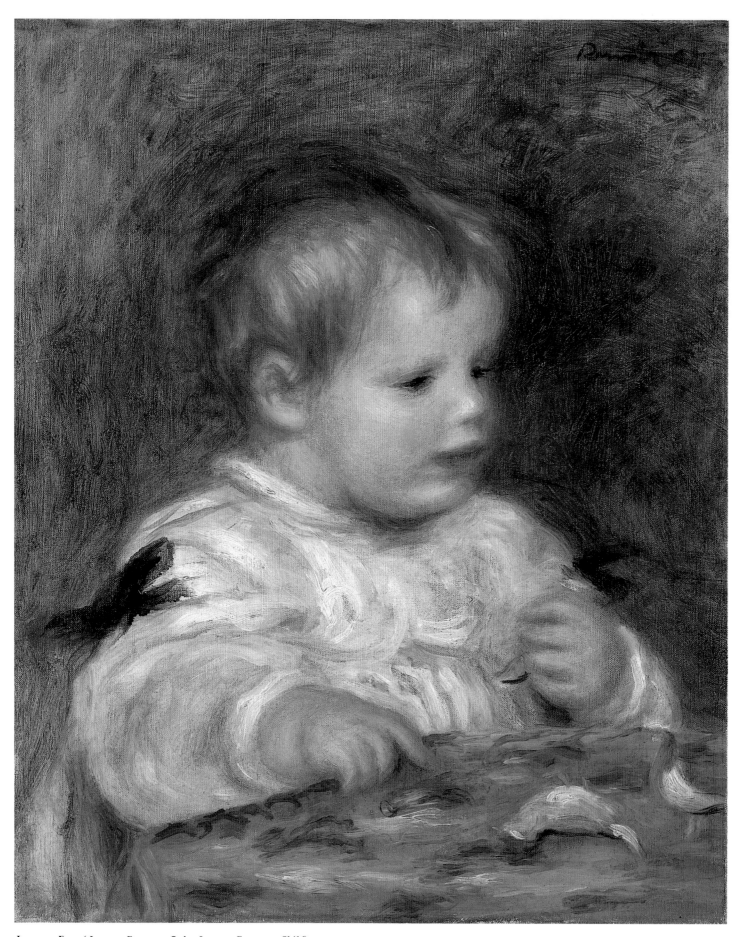

Jacques Fray (*Jacques Fray as a Baby; Jacques Fray as a Child***)**
1904
16⅝ x 13⁵⁄₁₆ in. (42.2 x 33.8 cm)
Signed and dated upper right: *Renoir 04.*
1955.600
Purchased from Durand-Ruel Galleries, May 28, 1940

By 1900 Renoir's paintings were fetching large sums of money, and his prices were well above those of his contemporaries. That year he was awarded a medal of the French Légion d'Honneur, which was presented to him by his friend Paul Berard. The 1904 Salon d'Automne included a retrospective of his work, and the artist's financial situation was such that he could finally begin to turn down many of the portrait commissions that had provided his income for so long.

Renoir's wife, Aline, gave birth to their third son, Claude, on August 4, 1901, in Essoyes, and "becoming a father again in his old age and sickness brought him tremendous joy."[24] In September of that same year Renoir went to the artists' colony at Fontainebleau, where he met the student Valentine Fray; he eventually became a friend of the entire Fray family. Fray exhibited at the Paris Salon and was known for her flower paintings.[25] In 1904, Renoir painted a portrait of Valentine's young son at her request, for a commission of only three hundred francs.[26] Her son, Jacques, was probably only a year old at this time.[27]

The little canvas gives us a glimpse of the child at play, his toy chickens nearly indistinguishable from the patterned tablecloth. The paint itself is very thinly and loosely handled; probably the entire portrait was sketched out in a half hour or so as the child played. The figure exists in a sfumato of paint, through which lines are indistinct and features blurred.

Renoir used a heavily loaded brush to paint the white of the child's blouse, and the rolling brushstroke carries over into the detailing of the black ribbons tied on the puffy white sleeves. The toy chickens set on the tablecloth and gripped in Jacques's chubby hand are painted with the same series of curving individual brushstrokes as the blouse. Volume here is realized through thick lines of paint rather than through modeling or color; there are almost no palpable forms except for the lines of paint themselves.

Clark liked *Jacques Fray* immediately when he saw it at Durand-Ruel's in 1940. Like the other Renoir portraits of children, this little work added a new dimension to the collection. *Jacques Fray* serves as an example of the countless other small portraits of children, including many of his own son Claude, that the artist painted in his later years. These paintings are each characterized by a loosely brushed, rhythmic surface and a spontaneously chosen moment giving the effect of a blurred snapshot, a quiet moment of childhood caught by the brushes of Renoir.

RM

PORTRAIT OF A PET

In the 1870s, when Renoir was particularly hard-pressed for funds, Théodore Duret, an art critic and champion of the Impressionists, helped to support him financially.[1] Duret also introduced Renoir to prospective patrons, and in 1875 he saw to it that Renoir met Enrique Cernuschi. An early advocate and collector of Japanese art, Cernuschi amassed a collection that eventually formed the core of the Musée Cernuschi in Paris. When Duret and Cernuschi had traveled together in Japan between 1871 and 1873, Cernuschi had returned with Tama, a Japanese *chin*. This breed of dog had been introduced to the West only in 1853[2] and was no doubt still considered exotic in the 1870s. Tama, which means "jewel" in Japanese, was painted by both Renoir and Manet (c. 1875; Collection Mr. and Mrs. Paul Mellon; fig. 21). Portraits of dogs were not unusual at the time; the two artists each painted several.[3]

The Clark's work shows Tama resting on its hind legs with one paw lifted in the air. *TAMA* is inscribed in the upper left corner, as it is in Manet's painting, but it is now barely visible.[4] The red stripe that juts out from the dog's fur, just below its chin, is presumably meant to represent the end of a ribbon collar.[5] The setting is almost indecipherable and, as in many of Renoir's portraits, simply consists of a mass of fluid brushstrokes. Renoir's soft, loose brushwork is especially well suited to the rendering of the delicate fur of the *chin*. Tama's white-and-black coat reflects the enormous variety of background colors, which range from deep blue to purple to red.

PRI

Figure 21. Edouard Manet
Tama, the Japanese Dog
c. 1875
Oil on canvas, 24 x 19⅛ in. (61 x 49.5 cm)
Collection Mr. and Mrs. Paul Mellon, Upperville, Virginia

Tama, the Japanese Dog (*A Dog*)

c. 1876

15 1/16 x 18 1/8 in. (38.3 x 46 cm)

Signed lower right: *Renoir.*

1955.597

Purchased from M. Knoedler & Company, May 1, 1930

LANDSCAPES

SUBURBAN VIEWS

Though known primarily for his figure paintings,[1] Renoir painted landscapes throughout his life. He conceived many of his earliest examples in the Forest of Fontainebleau, a spot outside Paris that had been popular among painters for some time and which he frequently visited to paint en plein air. His landscapes of the 1860s show the varied styles of the Barbizon and Realist painters—the rich, jewel-like tones and delicate strokes of Diaz, the feathery brushwork and silvery palette of Corot, and the darker colors and broader application of paint favored by Courbet. By the end of the decade, the characteristics that mark Renoir's early Impressionist style—the broader touch, flattened forms, and brighter colors—began to emerge, particularly in his pictures of La Grenouillère, a restaurant and bathing establishment on the Seine at Croissy, where he painted in the summer of 1869 with Monet.[2] Those pictures are significant not only for their style but also for their subject, a suburban area along the river near Paris. Such places would become the focus of avant-garde landscape painting in the 1870s and change the character of that genre.

Traditionally, the coherency of landscape painting as a genre had depended on the separation of nature and culture and of city and country. When painters included people or man-made features in the landscape, they painted them as incidental or complementary motifs rather than conspicuous or obtrusive ones that disrupted or supplanted the natural forms. Offering escape from the complications of urban life, images of unspoiled nature and the rural surround sold well among city dwellers. The suburbs, however, posed new issues for those who painted and marketed landscapes, since they were areas of mixed use and competing identities, which conflated the categories landscape painting had historically held separate. Partly rural, residential, and agricultural and partly urban, industrial, and touristic, they

were places where nature had been transformed with buildings, houses, bridges, restaurants, boating facilities, factories, and the like.[3] Those forms forced painters to rethink the bases of landscape painting. Would they deliberately seek spots free of any traces of people? Would they depict nature and culture harmoniously coexisting, or would they show these forces interfering with and unsettling one another? Would the landscape remind the urbanite of the city or release him or her from it?

Such questions go to the heart of the views presented in *Bridge at Chatou* and *Washhouse at Lower Meudon*: both pictures incorporate man-made structures, ones that, moreover, suggest the mundanities of everyday life rather than an escape from them.[4] That focus not only differentiates them from Renoir's landscapes of the 1860s but also gives them a distinctive place in his art as a whole, which, by and large, insists on pleasure and the existence of a simple, unspoiled world, an art of "safe places," in Gustave Geffroy's words.[5] Renoir's images of the Parisian suburbs along the Seine—*Rowers at Argenteuil* is typical[6]— generally assert that view, with their stretches of unsullied nature or individuals at leisure launching boats, rowing on the river, or lunching at places like the Restaurant Fournaise in Chatou.

Given Renoir's proclivities, it is unsurprising that of all the places he painted, he preferred Chatou, which he depicted in some nine figure paintings and seven riverscapes. Located about nine miles from the capital and easily accessible by train from the Gare Saint-Lazare, it was a haven for rowers and a favorite summer retreat for wealthy Parisians who built vacation homes there. Unlike Monet's Argenteuil or Pissarro's Pontoise, Chatou had not been affected by industry and had remained comparatively rural.[7] Meudon, though closer to Paris and more densely settled and industrialized, offered a celebrated forest and a spectacular view of Paris from the terrace above the town.

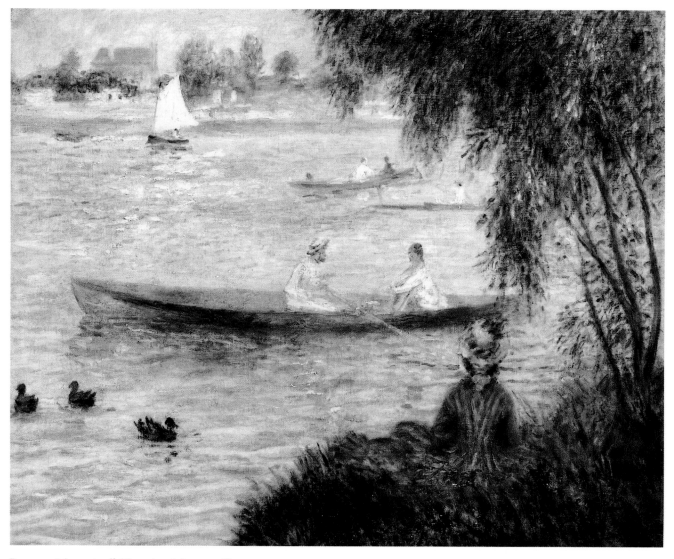

Rowers at Argenteuil (*Canotiers à Argenteuil***)**
1873
19¾ x 24 in. (50.2 x 61 cm)
Signed lower right: *Renoir*
Purchased from Durand-Ruel Galleries, April 5, 1934;
deaccessioned from the Sterling and Francine Clark Art Institute, December 15, 1970

Bridge at Chatou (*The Argenteuil Bridge*)

c. 1875

20¹⁄₁₆ x 25¹¹⁄₁₆ in. (51 x 65.2 cm)

Signed lower right: *Renoir.*

1955.591

Purchased from M. Knoedler & Company, October 13, 1925

Washhouse at Lower Meudon (*Wash-House on the Lower Meudon; Le Lavoir, Bas-Meudon; Le Bateau-lavoir***)**

1875

19⅟₁₆ x 24¼ in. (50 x 61.3 cm)

Signed lower left: *Renoir.*

1955.610

Purchased from Durand-Ruel Galleries, October 4, 1937

Critically, however, neither picture depicts the views, qualities, or activities that drew city dwellers, like Renoir, to those suburbs; instead they both focus on the human imprint on nature. Yet Renoir approaches the relation between people and the landscape in a different way in each painting.

In the picture of Chatou, Renoir focuses on the bridge that linked the town with a small island in the middle of the Seine. A houseboat and barge are moored near the riverbank, which gives way to a view of the densely packed buildings of the town and a road enlivened by carriages and pedestrians. The identity of the town as a leisure site is a marginal feature, noted only in the small rowboat which all but disappears in the sea of strokes composing the river.

Here, Renoir decides to harmonize natural and man-made forms and to focus on those aspects of the town that stamp it as more traditional and rural than modern and urban. The constructed forms ring the water and patch of grass in the foreground, so that they seem to cradle and envelop the natural ones. He depicts the buildings but none of the activities of the town: narrow and perhaps crowded streets, the jostle of people and carriages, residents carrying out their business, shopkeepers selling their wares, and the like. Instead, he enjoys the neat geometric shapes of the structures, which are the small buildings of an essentially rural area, and reduces the figures to tiny specks of paint, so that they do not affect the reading of the scene in any substantive way. Significantly, Renoir does not paint Chatou's railroad bridge, which might to different minds signify either modern progress and technology or the destructive tendencies of industry and the desecration of the country at the hands of the city. He depicts instead the bridge for pedestrians and carriages, older and traditional forms of transportation.[8]

Moreover, Renoir uses paint to further unify the different structures. The transitions between earth and buildings, water and bridge, are smooth, the one almost invisibly becoming the other. Thus the brushwork describing the water laps up against the piers of the bridge, and the strokes between the barges and banks gracefully merge one with the other. The colors are bright and sunny, and Renoir does not distinguish between the hues of nature and those of man-made forms—the greens, blues, and whites of the water, sky, and riverbank describe the barges, bridges, and buildings as well. This repetition of colors, in concert with the silky, fluid brushwork, encourages the viewer's eye to glide smoothly across the painting, from the riverbank to the river, to the barges and bridge, and finally to the town. No

difficult passages, sharp contrasts of color, or changes in brushwork impede the eye's progress. Situated across the river, the spectator takes in the view with the intellectual and emotional distance of a tourist or sometime visitor rather than the intimate knowledge or vested interest of a resident.

The way that the painter positions himself, and the viewer, in relation to the scene in *Washhouse at Lower Meudon* is more ambiguous, owing in part to the kind of subject represented and to his closer physical proximity to the scene. Washhouses, associated with labor, poverty, and the lower classes, were obviously at odds with Renoir's preferred themes of pleasure, beauty, and sensuality as well as with the silky, fluid brushstrokes and bright colors he developed to convey such themes. On the one hand, he tries to transform this antipicturesque scene into a picturesque one with lush, textured brushwork and pastel colors. He also situates himself, and by extension the viewer, above the scene, so that he looks at it from a physically, and perhaps socially, superior position. Nonetheless, a sense of desolation permeates the view. Some passages suggest that the scene eludes him and, try as he might, he cannot completely camouflage the strangeness of this inlet with paint and color. While he describes some areas with a degree of clarity consistent with his nearness to the washhouse, other areas, though equally close, border on illegibility. A tangle of strokes, for example, sits near the left corner of the front of the washhouse, but the adjacent boat is a firmly rendered geometric shape, painted with long strokes that suggest its weight and solidity. Similarly, Renoir indicates the railing of the washhouse with a thin, though clear, red line, but that line suddenly and inexplicably dissolves into a jumble of paint strokes that just barely describe the rear of the washhouse and the river behind it. Though the figures and the boats in the foreground are the same distance from the painter, he renders the one in a painterly shorthand of quick telegraphic marks and the other with firmer, longer strokes. Something of the drudgery and anonymity of the work being performed invades the picture itself. The six figures, reduced to mere dabs of paint, pursue their activities in an isolated, rather than communal, fashion. That four of the six wear the same yellow hats and blue shirts prompts the viewer's eye to move, almost mechanically, from one to the next, landing eventually on the deck of the washhouse. From the washhouse, the eye drifts to a formless, meandering landscape, a stretch of endless marshland, devoid of features that might delight or enchant it.

KE

ITALIAN SCENES

"I've suddenly become a traveler," Renoir wrote to his patron Madame Georges Charpentier from Italy in late 1881.[1] Indeed, following his success at the Paris Salon of 1879 and the resultant increase in popularity and income, the artist began to expand his artistic and intellectual horizons quite aggressively. Prior to 1881 Renoir had not ventured far from Paris; between 1881 and 1883, however, he traveled a great deal. An abundance of correspondence—along with many paintings—documents his trips to northern France, the Channel Islands, Provence, the Côte d'Azur, North Africa, and Italy. These travels offered Renoir the opportunity to experience aspects of sunlight and scenery not available in the city.

Renoir left for Italy in October 1881. His goals for the trip were quite modest. On the one hand, he hoped to experiment with figure painting, the genre with which he was currently having the greatest success; on the other, he planned his itinerary around a search for popular scenic spots with water and sunlight. His first stop was therefore Venice, the once powerful city at the head of the Adriatic Sea that was a popular destination for artists because of its picturesque canals, grand architecture, colorful crowds, and sparkling, limpid light.

In Italy, figure painting proved difficult, for Renoir was unable to communicate with his models. "I am reminded of Venice," he later wrote in a letter. "Following a girl carrying water, beautiful as a Madonna. My gondolier tells me he knows her. . . . Once on the chair, a three-quarter pose, she was disgusting. To get someone to pose, you have to be very good friends and above all speak the language."[2] Turning to the landscape as a subject, Renoir immediately set out to paint the most touristic views. He captured Saint Mark's Square and basilica, the Doges' Palace, and the lagoon on a number of occasions. While he recognized a certain lack of originality in these scenes, he certainly was aware of participating in the long tradition of painting Venetian *vedute*, and he trusted that such familiar scenes would be suitable for the market. "I did the Doges' Palace as seen from San Giorgio across the canal; it had never been done before, I think. We were at least six in line," he wrote somewhat jokingly from Venice.[3]

Venice, the Doges' Palace, Renoir's view from the church of San Giorgio, is clearly a mature Impressionist work. It is executed with marvelous spontaneity, the result of Renoir's working out-of-doors before his subject (though alterations to the canvas are evident).[4] This is witnessed in the rich surface texture, ranging from thick impasto to bare canvas, and in the bravura of the brushstrokes in the water, where blue and green dabs merge with lively reflections of salmon, orange, and yellow. The excitement of Renoir's brushwork describes the activity of the scene itself: the choppiness of the water, the surging crowds on the opposite shore represented as a riot of color. In contrast with this freedom, Renoir carefully describes the architecture of the Doges' Palace, where each niche is rendered, as well as Saint Mark's Square, where the bold vertical and hard contour of the campanile dominate.

"Goodbye Venice . . . I leave for Rome and then on to Naples. I want to see the Raphaels,"[5] Renoir wrote to his patron Charles Deudon. Indeed, from Venice, Renoir continued south to Florence, Rome, and Naples, where he saw masterpieces from antiquity and from the Renaissance. "I went to see the Raphaels in Rome," Renoir wrote to his dealer Durand-Ruel. "They are very beautiful and I should have seen them earlier. They are full of knowledge and wisdom. He wasn't looking for impossible things like me. But they're beautiful . . . wonderful for simplicity and grandeur."[6] The Pompeiian frescoes also interested him tremendously, and he found in them the same qualities as in the

Venice, the Doges' Palace (*Venise, Palais des Doges*)
1881
21⅛ x 25¹¹⁄₁₆ in. (54.3 x 65.3 cm)
Signed and dated lower right: *Renoir. 81.*
1955.596
Purchased from Durand-Ruel Galleries, February 2, 1933

The Bay of Naples, with Vesuvius in the Background (*Vue de Naples; Quai with Vesuvius in the Background; Naples; Naples Landscape;*
Vesuvius, Morning; Bay of Naples, Morning; The Port of Naples)

1881

22¹⁵⁄₁₆ x 31¹⁵⁄₁₆ in. (57.9 x 80.8 cm)

Signed and dated lower left: *Renoir. 81.*

1955.587

Purchased from Durand-Ruel Galleries, February 2, 1933

Renaissance frescoes. This so struck Renoir that he sought to incorporate similar characteristics into his own work through the introduction of solidity and stability of form. The frescoes also affected his sense of and approach to color: his palette lightened significantly, and he strove for harmony rather than brilliance. While perhaps best seen in the bathers of the 1880s—in *Blonde Bather*, for example—the lessons he learned regarding solid form, balanced composition, harmonious color, and pervasive light are also apparent in still lifes, such as *The Onions*, and in *Bay of Naples, with Vesuvius in the Background*, all of which date from his 1881 trip to Italy.

Although painted only weeks after *Venice, the Doges' Palace*, Renoir's depiction of the Bay of Naples is entirely different stylistically. In fact, the artist exploited different styles for much of his career. As in his student days during the 1860s, experimentation drove Renoir while on his Italian trip. In the 1860s, for example, Impressionism was the mode selected for *La Grenouillère* (1869; Nationalmuseum, Stockholm), while the enigmatic *Young Boy with a Cat* (1868–69; Musée d'Orsay, Paris) looks more to Realism for inspiration. It seems that experimentation preoccupied Renoir as he tried, in these early years, to focus on developing a stylistic vocabulary of his own.

By the 1880s, Renoir painted canvases that were meant to be sketches or studies in addition to those he considered salable and market bound. This can be seen, for example, in two landscapes in the Clark collection, the fully worked *View at Guernsey* and the study- or sketchlike *Seascape*. Yet the differences between *Venice, the Doges' Palace* and *Bay of Naples, with Vesuvius in the Background* are not the result of differences in intent; each was fully worked up by Renoir for eventual sale. The radical change in appearance reflects the impact on Renoir of both the Pompeiian frescoes and the work of Raphael. The energetic

brushwork of the Venetian scene gives way to classically inspired calm in the Neapolitan view: the brushstrokes are thinly painted in carefully placed diagonals, built up with layers of wash to tone the canvas. Color is also quieted, reduced to pastels: bleached, chalky colors evoking the harmonies of the earlier masters. The raking light and warm orange and yellow hues describe the visual effects of morning in the ancient city. This interest in harmonies found expression in another canvas of the same view, *Vesuvius, Evening* (1881; The Metropolitan Museum of Art, New York), with its prevailing tones of blue and purple. Renoir's interest in developing a series of paintings, in this case a modest one of two canvases, mirrors a pursuit made famous by Claude Monet, first with views such as those of the Gare Saint-Lazare in Paris during the 1880s and later with such magnificent series as Rouen Cathedral and the Grain Stacks.

Like the Venetian scene, *The Bay of Naples, with Vesuvius in the Background* is a fully articulated picturesque subject, but here Renoir supplements his interest in the shimmering effects of light and water with a keen attention to genre details like the boys on the wall and the woman balancing a basket on her head in the crowds in the foreground. The hustle and bustle of early morning life in the city strikes an interesting contrast with the graceful simplicity of the application of paint.

These two cityscapes, painted in such a short timespan on his first trip to Italy, are surprising documentation of Renoir's drive to learn, experiment, and ultimately incorporate once shunned lessons of past eras—antiquity and the Renaissance— into his art. Even in the subject matter he chooses, Renoir betrays an eagerness to create paintings that would prove successful with the patrons he had only so recently succeeded in cultivating.

SK

SEASCAPES

Though Renoir lived in Paris and the surrounding suburbs in the early decades of his career, he began to travel farther afield during the late 1870s. In doing so, he followed in the footsteps of many eighteenth- and nineteenth-century painters who spent part of the year, usually the winter, in their Paris studios, and the other part traveling to make sketches and studies of landscape subjects. Renoir painted three of the pictures discussed here on or near the Channel coast in the north of France—the sea and beaches of Normandy and the shores of the island of Guernsey. The canvases display different kinds of handling that reflect their different purposes: the quick, freely brushed strokes and loose structure of *Sunset at Sea* and *Seascape*, one certainly and the other probably a sketch, and the more controlled brushwork and tighter composition of *View at Guernsey*, a finished painting intended for the market. The fourth, *Sunset at the Seashore*, traditionally identified as a view at Douarnenez, was probably painted in the early 1890s, when Renoir spent several summers in Brittany.

The Channel coast attracted some of the most prominent painters of the nineteenth century, including Courbet, Daubigny, Boudin, Monet, and later Seurat and Signac. During the Second Empire, the area also became popular among tourists, many from Paris, who boarded the daily trains to escape the pressures of the city and take advantage of the salubrious effects of sun and sea. In the 1860s and 1870s, artists painted aspects of touristic Normandy—the well-heeled vacationers, the bathing spots, the busy ports, and the towns and villages, which were being increasingly developed to meet the needs of the summer population. By the late 1870s, however, painters began to turn their backs on commercial Normandy to focus instead on the region's varied light effects, its grayish blue sea, and the spectacular rock formations along its coast. Their landscapes and seascapes celebrated raw, uncultivated nature and denied the presence of man and the modern world.[1]

Renoir first visited the Channel coast in the summer of 1879 to stay with the banker Paul Berard, one of his principal patrons at that time, in his country house near Dieppe. During that trip, he painted both land- and seascapes, including *Sunset at Sea*, one of three images of the ocean off Normandy.[2] Though *Sunset at Sea* is not dated, it is similar in handling and subject—a panoramic expanse of sea and sky—to two canvases, both entitled *The Wave*, that date to the 1879 excursion.[3] Certainly these three canvases are less finished than market-bound landscapes, but whether Renoir conceived them as sketches for more finished landscape paintings or as the backgrounds of figure paintings to be executed in Paris is not known. It is, perhaps, precisely because *Sunset at Sea* is a sketch or study that it conveys a spontaneity, an ebullience, even a passion, that makes it a satisfying and striking image in its own right, one that reveals a side of Renoir that he restrained in his work for the market. Even Renoir's loosest, most freely brushed canvases of the 1870s evidence his need to define forms, to order random strokes, and to clarify structure. The casual is usually highly studied,[4] and as his concern for cultivating more conservative clients grew, restraint and control became the operative principles of his practice. In *Sunset at Sea*, however, Renoir puts the market and critics aside and aims quite simply to look and to paint, to set down the broad outlines of the sea and the effects of light. Savoring the wondrous effects of the spectacle before him, he registers them on the canvas with telegraphic, languid, and even smeared marks of paint that supply only the minimum amount of information needed to connect the image with a corresponding one in the material world. The picture bears the imprint of the hand and body that produced it. In the sky, larger, looser, almost

Sunset at Sea (*Coucher de soleil*)
1879
18 x 24 in. (45.7 x 61 cm)
Signed lower right: *Renoir*
1955.602
Purchased from Durand-Ruel Galleries, September 22, 1942

messy streaks, some still revealing the lines left by the bristles of the brush, capture the clouds and the pinkish orange sunlight breaking through them. In the foreground, short, thick rectangular marks, moving in a diagonal direction, suggest the rush of the sea and the movement of the waves, while in the middle ground, slower, more blended strokes embody the sense of calmer waters broken only by the image of a sailboat rendered with a few quick lines. There is a sense of immediacy not only in the application of paint but in the colors themselves, the brilliant blues, oranges, and pinks which are transferred straight from the palette to the canvas.

Between his 1879 trip to Normandy and his 1883 excursion to Guernsey, Renoir traveled regularly, visiting the south of France, Algeria, and Italy and returning to Normandy on several occasions. With an eye to the market, he painted some of the best-known sites in the areas he visited—Vesuvius, the Doges' Palace in Venice, and the exotic landscapes of the Near East—hoping their familiarity would increase the salability of the works. In September 1883 he traveled with Aline Charigot and Paul Lhote first to Jersey and then to Guernsey, two of the Channel Islands off the coast of Normandy. Though it had long been popular among English tourists, Guernsey was only beginning to gain a reputation among French travelers when Renoir visited the island. He settled in the area around Moulin Huet Bay, a rocky cove that period guidebooks billed as the island's most scenic spot. There he made about fifteen finished paintings and sketches or, as he described them in a letter to Durand-Ruel, "documents for making pictures in Paris."[5] His subjects included views of the landscape, the sea, and groups of figures bathing and relaxing among the rocks on the beach. Though the island had been developed to accommodate the tourist trade, Renoir eschewed images of pleasure boats, hotels, and bathing establishments in favor of presenting Guernsey as a retreat from the modern commercial world.[6]

View at Guernsey is one of four finished views of Moulin Huet Bay, seen from the road leading to the beach. Despite its loose Impressionist brushwork and heightened colors, the picture reveals a traditional landscape structure. The road and tree invite the viewer into the painting, which Renoir divides into distinct zones—the bluff in the foreground, the water and rocks in the middle ground, and the sky in the distance. He probably began the painting in front of the motif, but the elaboration of brushwork and degree of finish suggest he completed it in the studio, a common practice among plein-air painters. Renoir signed and dated this and the related paintings and sold them to Durand-Ruel when he returned to Paris. Though the pictures were ready for the market, displayed a well-known view, and had a conventional landscape structure, they apparently found no buyers, for they still belonged to Durand-Ruel in 1891.[7] Despite Durand-Ruel's attempts to market the

Figure 22. Pierre-Auguste Renoir
Sailor Boy
1883
Oil on canvas, 51¼ x 31½ in. (130.2 x 80 cm)
The Barnes Foundation, Merion, Pennsylvania

work, *View at Guernsey* seems to have remained unsold until 1933, when Clark purchased it. Evidence suggests that the dealer included it in his exhibition of Impressionist painting held in New York in 1886,[8] and he certainly hung it in 1905 in the first exhibition of Impressionist painting in London, where he perhaps felt its English subject would have greater appeal.[9]

Seascape, also dating to 1883, was originally identified as a view of Guernsey,[10] yet the stretch of rocks interspersed with pools of water, with cliffs in the distance, matches the famed tidal harbor of Yport,[11] which Renoir painted in the background of *Sailor Boy* (1883; The Barnes Foundation, Merion, Pennsylvania; fig. 22), a portrait of Robert Nunès, the son of the mayor of Yport. Renoir spent the latter part of August in Yport, where he

View at Guernsey (*Vue prise à Guernsey; Paysage à Guernsey***)**

1883

18⅛ x 22 in. (46 x 55.9 cm)

Signed and dated lower right: *Renoir. 83.*

1955.601

Purchased from Durand-Ruel Galleries, March 3, 1933

Seascape (*Guernsey Seascape; Marine à Guernsey*)
1883
21¼ x 25⁹⁄₁₆ in. (54 x 65 cm)
Signed and dated lower right: *Renoir. 83.*
1955.607
Purchased from Durand-Ruel Galleries, November 5, 1941

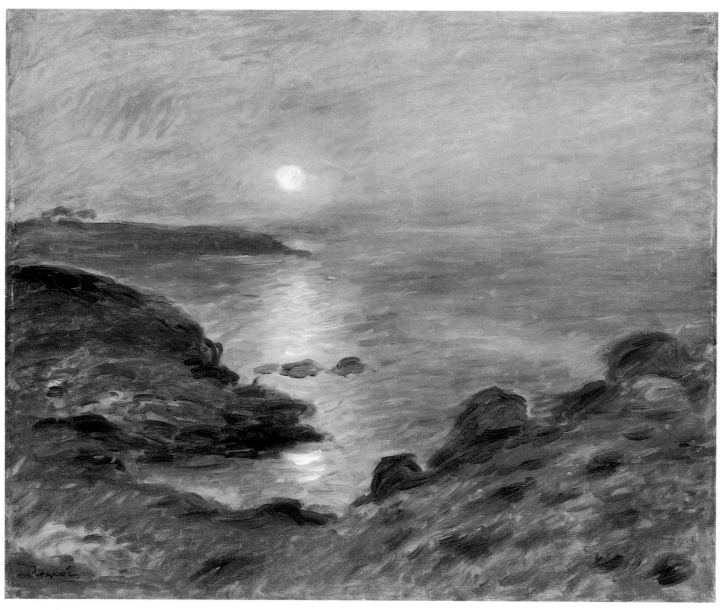

Sunset at the Seashore (*Sunset at Douarnenez; Sunset at Sea; Marine, soleil couchant*)
1895
21⅜ x 26 in. (54.3 x 66.1 cm)
Signed lower left: *Renoir*
Purchased from Durand-Ruel Galleries, November 19, 1942;
deaccessioned from the Sterling and Francine Clark Art Institute, September 17, 1988

executed the Barnes canvas along with a portrait of Aline Nunès, the mayor's daughter, before leaving for Jersey and Guernsey. The Clark's painting lies somewhere between a study and a finished painting, since it displays the informal, notational qualities of the Guernsey canvases that have been identified as sketches.[12] Renoir divided the composition into simple zones—a large area of rocks and pools of water in the foreground, a group of bathers who have set up camp in the middle ground, and an expanse of sea and sky with a promontory of land and a sailboat in the distance. The brushwork is casual and varied: diagonal, rectangular dabs in the rocks, quick dashes of paint for the figures, and longer, more disciplined strokes in the background. Because he was perhaps only making visual notes, Renoir left various areas of the canvas unresolved. In the background, for example, the forms evaporate into a mass of white to the left and there is no clear delineation between sea and sky. Moreover, the dark, boldly painted rocks seem to overwhelm, and even clash with, the pale areas in the distance, a kind of dissonance that seems odd for Renoir, who characteristically preferred smooth transitions between the various parts of the canvas. Whether a sketch or not, the image differs from the bather-and-beach

scenes from Guernsey. In those Renoir situated the viewer in or at the edge of the water, near the figures; here he reduces the beachgoers to mere specks of paint in the distance and dissuades the viewer from joining them with an imposing stretch of rocks.

Sunset at the Seashore has been traditionally dated to 1883, no doubt because its subject and its palette emphasizing oranges and browns resemble the scenes and colors Renoir favored in the Guernsey pictures. However, the picture's title and handling as well as the records of Renoir's travels suggest it was painted in 1895, when Renoir visited Douarnenez, near Quimper. Describing his stay in the town, Renoir wrote, "I'm working like a slave—Douarnenez is superb."[13] In contrast with *Seascape*, in which dabs, patches, and discrete strokes of paint describe the forms, this canvas displays the smoother application of paint—longer, more blended strokes—and the more muted, closely keyed colors that characterize Renoir's work in the 1890s. As a result, while *Seascape* and *View at Guernsey* both show clearly delineated zones and features, the transitions between the bank of land, the sea, and the distant sky in *Sunset at the Seashore* are softer and less distinct.

KE

STILL LIFES

Renoir's various remarks about still-life paintings indicate that he conceived them not only as finished, independent works but also as opportunities to rehearse and practice. He told Georges Rivière, "Painting flowers is a form of mental relaxation. I do not need the concentration that I need when I am faced with a model. When I am painting flowers I can experiment boldly with tones and values without worrying about destroying the whole painting. I would not dare to do that with a figure because I would be afraid of spoiling everything. The experience I gain from these experiments can then be applied to my paintings."[1] He described a still life of roses to his dealer Ambroise Vollard as "an experiment I'm making in flesh tones for a nude,"[2] and he urged Julie Manet to focus on still-life painting "in order to teach yourself to paint quickly,"[3] a lesson he ostensibly took to heart in works like *Still Life with Peach and Tomato* and *Flowers in a Blue Vase,* in which the loose, sketchy brushwork suggests rapid execution. Renoir's comments are unsurprising since the genre lends itself to experiment and improvisation. Usually small canvases featuring a limited number of static objects, still-life paintings do not entail potentially demanding sitters, live models, complicated compositions, or elaborate narratives. Nor do such pictures, which are normally painted indoors, involve the changing conditions of light and weather that challenge the plein-air painter.[4] Thus still lifes enable artists, if they wish, to focus more easily and fully on the quality of paint and on the varied effects of brushwork and color.

The three still lifes now in the Clark collection differ in tone, presentation, and purpose. In *Peonies*, Renoir strikes a balance between informality and artificiality. The peonies appear as if they have just been picked and casually placed in a vase, yet they are painted in the artificial setting of the studio, in a light

that theatrically illuminates the flowers and creates dramatic shadows in the background. Though Renoir executed the canvas in a controlled, staged environment, the spontaneity and sense of freedom he sought in still lifes invigorate *Peonies*. The picture is packed with lively contrasts of rich, impastoed colors and animated brushwork. The red and white flowers jump forward from the dark background, and highlights of white energize the blue tablecloth. Renoir's love of paint—its different rhythms and tempos, its various consistencies—is everywhere apparent. He shifts from manipulating paint to create an image corresponding to an object in the outside world, to using paint to evoke and suggest the qualities of an object, and then to applying paint simply for the sake of paint. He animates the left side of the tablecloth with quick, short flecks of pigment that move the eye toward the vase, then savors the fluidity of the paint by drawing it across the canvas with longer strokes on the right side. There the paint coalesces in an almost hypnotic curve, which echoes the bulbous form of the vessel and eases the eye toward the background. Longer, more languid strokes also describe the leaves, which in some passages seem to dance gracefully among the peonies and in others to droop lyrically, dramatically, as they do in the foreground.

Renoir records the general shape of the flowers, indicates their multiple petals, and describes their thin, daggerlike leaves. Though the canvas is tightly cropped and the vase placed near the picture plane, indicating the closely focused view typical of still-life painting, he does not provide the botanically precise account of the flowers such an intimate view would ostensibly afford. Curiously, his rendering makes the flowers appear as if they are seen from a distant, not a proximal, viewpoint, but this sacrifice of detail enables him to emphasize the general qualities and traits of the flowers, specifically their lushness and density, which he

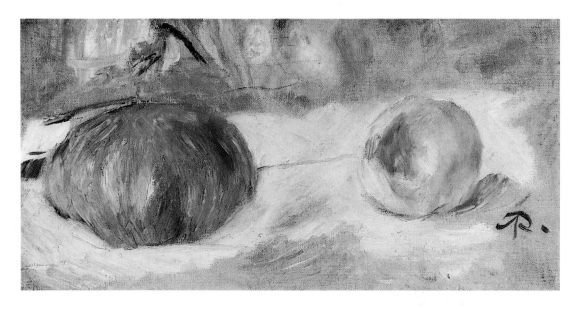

Still Life with Peach and Tomato (*Nature morte, pêche et tomate*)
1878
5⅝ x 10½ in. (14.3 x 26.7 cm)
Signed lower right: *AR.*
Purchased from Durand-Ruel Galleries, November 5, 1941; deaccessioned
from the Sterling and Francine Clark Art Institute, December 1974

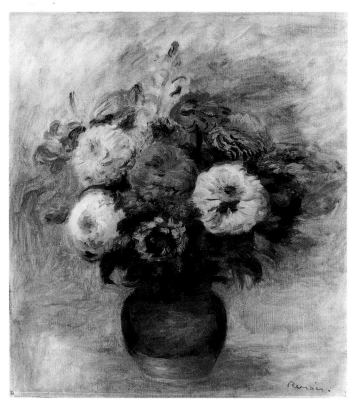

Flowers in a Blue Vase (*Vase of Flowers; Flowers in a Blue Bowl*)
1889
16 x 14⅛ in. (40.6 x 35.9 cm)
Signed lower right: *Renoir.*
Purchased from Carroll Carstairs, February 6, 1940; deaccessioned from the
Sterling and Francine Clark Art Institute, September 17, 1988

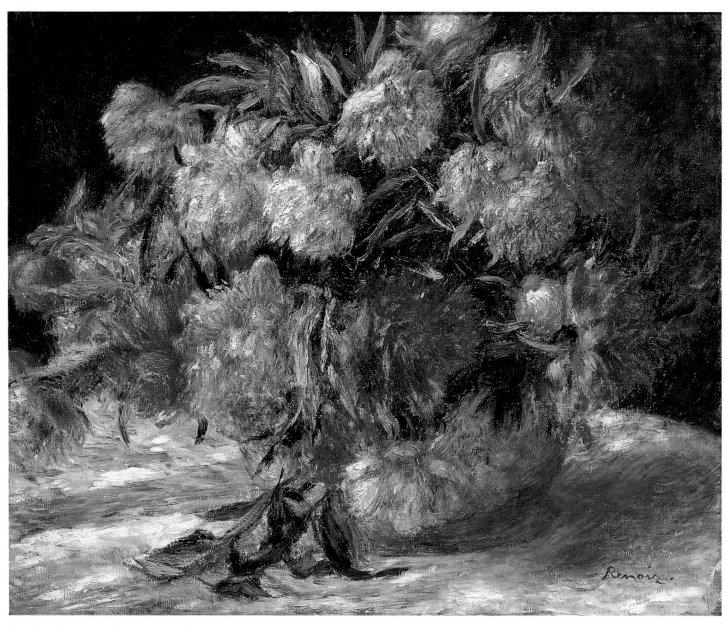

Peonies (*Peonies in a Vase; Bouquet of Peonies***)**

c. 1880

21⅝ x 25¹¹⁄₁₆ in. (54.9 x 65.3 cm)

Signed lower right: *Renoir.*

1955.585

Purchased from M. Knoedler & Company, January 31, 1942

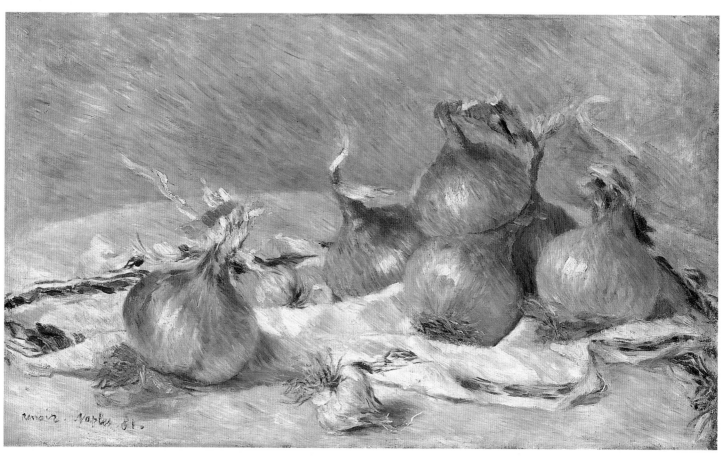

The Onions

1881

15⅛ x 23⅞ in. (39.1 x 60.6 cm)

Signed, dated, and inscribed lower left: *Renoir. Naples. 81.*

1955.588

Purchased from Durand-Ruel Galleries, April 15, 1922

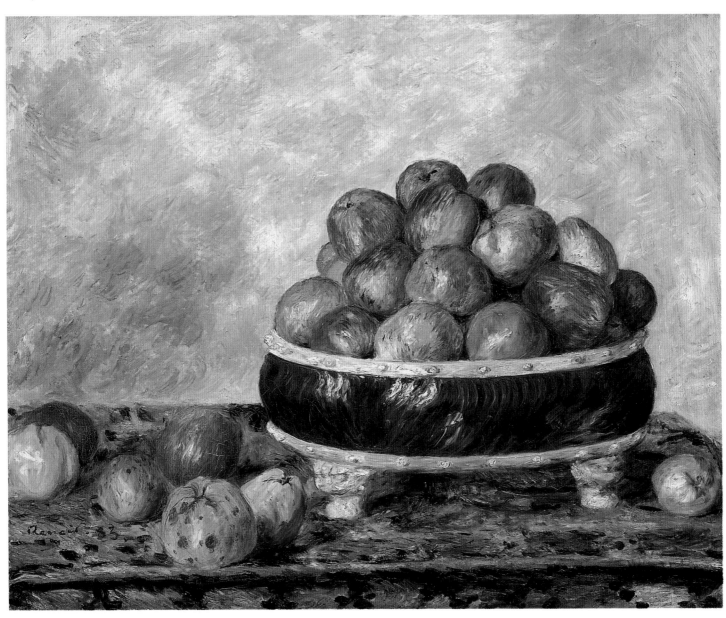

Apples in a Dish *(Apples; Still Life with Apples)*
1883
21¹⁄₁₆ x 25⁹⁄₁₆ in. (53.9 x 65 cm)
Signed and dated lower left: *Renoir. 83.*
1955.599
Purchased from M. Knoedler & Company, May 19, 1951

suggests with thick, rich, impastoed pigment. While Renoir uses pigment to describe and evoke the blossoms, at other points in the picture he simply enjoys the properties of paint itself, caring little that it resemble some recognizable thing or suggest some quality. Thus, liquid dabs of ocher-colored paint found throughout the bouquet simply sit on the surface.

In contrast with the lush, sensual *Peonies, The Onions,* painted in Naples in the fall of 1881, displays a collection of simple, evenly lit objects, handled and arranged to suggest the world of everyday life. In fact, *The Onions* differs in theme and presentation from most of Renoir's earlier still lifes, which generally featured flowers and occasionally pieces of fruit. Unlike those more picturesque motifs, onions and garlic did not readily offer intricate shapes, intriguing colors, or appealing textures. These small, insignificant objects also seem at odds with the professed purpose of his trip to Italy—to master the grand subjects and tradition of painting. Reorienting his practice, however, involved much frustration, as he indicated in a letter to Durand-Ruel, written from Naples. "I still have the experiment disease," he lamented. "I'm not pleased, and I rub out, I rub out again. I hope this mania will end."[5] Perhaps this straightforward, unpretentious picture, with its manageable subject and size, offered respite from the difficulties he faced in his figure paintings and landscapes.

It is tempting to compare *The Onions* with *Blonde Bather,* not only because Renoir painted the two pictures during the same period but also because he himself related his still lifes to his figure paintings. The two canvases share certain characteristics —a palette of light, primarily pastel colors, fairly tight brushwork, firm contours, and "figures" composed of larger bodies culminating in smaller tops or heads. The differences are equally intriguing, and it might be argued that in *The Onions* Renoir explores the qualities and impulses he suppressed in the nude. Where the monumental nude figure of *Blonde Bather* looks back to antiquity and the Renaissance, the still life embraces the prosaic, the ordinary, and the familiar. Where the bather is static and immobile, the bulbous onions roll around the canvas in various directions, their wispy stems waving in the air, as if energized by some life force. Red and blue stripes highlight the curls and folds of the edge of the cloth that snakes around the picture, and though the background is plain and spare, quick, decisive diagonal paint strokes imbue it with movement. If Renoir tries to join past and present, history and contemporaneity in the nude figure, he roots the still life firmly in the moment. He does this both by the suggestion of motion in the application of paint and by the seemingly haphazard disposition of the objects. Though Renoir does not specify where the foodstuffs are located, their casual configuration implies that someone has recently carried them, in the white cloth on which they now lie, from the fields, the garden, or the market and has simply left them on the table, where they await future use.

With its humble objects and simple arrangement, *The Onions* invites comparison with the still lifes of Chardin. Acknowledging differences of palette and handling, the Goncourts' appraisal of Chardin's works might describe at least the spirit of Renoir's canvas: "He scarcely seems to trouble to compose his picture; he simply flings upon it the bare truth that he finds around him."[6] Given Renoir's interest at this point in his career in reconsidering the past and tradition, the works of the eighteenth-century artist may well have been on his mind. It is equally possible that he found inspiration closer to home, in the still lifes that appeared alongside the mythological scenes, landscapes, and architectural fantasies of the Pompeiian frescoes in the Museo Nazionale in Naples.[7] With their bowls of eggs, fruit, vegetables, and household utensils set on simple surfaces against plain backgrounds, those still lifes, like *The Onions,* returned the viewer to the pedestrian rituals and prosaic things of domestic life.

Renoir may have painted *The Onions* to escape the issues and complications that more ambitious paintings such as *Blonde Bather* raised. By contrast, *Apples in a Dish* is a product of, not an antidote to, the more reserved subjects and methodical, hard-edge style that he adopted in the 1880s. The informal arrangement and idiosyncratic objects in a still life like *The Onions* prompt the viewer to develop a story involving a human agent who has left the pieces of food on the table and will eventually use them in cooking. *Apples in a Dish* simultaneously proposes and blocks such stories and associations. To some extent, the large pile of fruit suggests the abundance and fertility of nature. However, the neat pyramidal mound, carefully constructed to prevent the apples from tumbling down, implies not the unruliness, randomness, and irregularity of nature but the artful qualities of control and order—abundance tamed, tidied, and organized. Moreover, the bowl (with dainty feet that indicate an eighteenth-century date of origin) leads the viewer away from thoughts of the fields, or even the kitchen, to visions of a formal dining room. Yet the absence of any other objects, the anonymous setting, and the threat of the pyramid's probable collapse, should someone dare remove an apple, discourage the viewer from developing the story any further. The apples on the table bear the blemishes and bruises of nature and have apparently broken free from the man-made pyramid. But here again, art domesticates nature, since the apples to the left form neat pairs along diagonal lines that indicate they have been deliberately placed rather than casually deposited. Though *Apples* lacks the spontaneous handling of *Peonies* and the lively arrangement of *The Onions,* Renoir nonetheless enjoys his motif. He delights in the apples' spherical shapes and the varied colors of their skins, which he records with careful strokes, finding, as many still-life painters do, myriad variations and possibilities within the seemingly simplest of subjects.

KE

DECORATIVE COMPOSITIONS

In 1854, at the age of thirteen, Renoir began his artistic career in the studio of the Levy Brothers porcelain manufactory. "The work consisted of painting little bouquets on a white background. For this I was paid five cents a dozen. When there were larger pieces to decorate, the bouquets were larger."[1] With this straightforward description, Renoir reduced his work—quickly brushing flowers onto teacups and plates—to essentials. It was simple and pretty, it was a sure way of making money, and the required subject matter could be adapted to meet the needs of any surface.

The fact that decorative painting, unlike landscape and genre painting, quickly proved to be a lucrative undertaking encouraged Renoir actively to seek out commissions for this type of work as he launched his career. He was hopeful of obtaining one of the many state commissions for decorative programs, such as the ones given to the academic artists William Bouguereau, Alexandre Cabanel, and Jean-Léon Gérôme for the new Paris Opéra in 1861. Unfortunately, he never did receive one of these well-paying government assignments and, though lesser work enabled him to survive as an artist, his financial situation remained desperate.

In 1877 Renoir wrote an article in the short-lived journal *L'Impressionniste* that was devoted entirely to the subject of decorative painting in public buildings. He addressed at length the importance of harmonizing paintings with the buildings they decorate and stated that "Delacroix understood decoration in our age. . . . Decorative paintings have value only because they are polychromatic; the more the tones are varied in their harmony, the more the painting will be decorative."[2] Renoir was certainly not alone in the practice of executing decorative commissions. Claude Monet painted several panels for the home of his patron Hoschedé at Montgeron, and the practice was not limited to

Impressionist circles, for Bouguereau and Cabanel decorated the homes of their patrons as well.[3]

Seeking to supplement his income, Renoir, along with Monet, Sisley, and Morisot, organized an auction at the Hôtel Drouot on March 24, 1875, but the four artists failed even to cover the expenses of renting out the space. In the end they actually owed the auction house money. He participated in a second public sale with Pissarro, Sisley, and Caillebotte in May 1877. Again his paintings brought in very little; both sales were bitter failures. Exhibitions with the Société des Indépendants were similarly unsuccessful for Renoir, and by the late 1870s, it was clear to him that if he hoped to make any money with his art he would have to pull back from the publicly ridiculed Impressionists and try other avenues.[4]

The great portrait *Madame Charpentier and Her Children* (1878; The Metropolitan Museum of Art, New York; see fig. 10) was a hinge upon which Renoir's career turned. The Charpentiers were a rich and powerful Parisian family, and partly because of Madame Charpentier's influence, the portrait made a splash at the official Salon of 1879. Accordingly, Renoir did not submit anything to the Indépendants exhibition of the same year, but instead turned his full attention to the world of haute-bourgeoisie patronage and the many collectors to whom the Charpentiers could introduce him. These wealthy men wanted portraits done of their families and, for their city and country houses, decorative paintings.

By 1879 Renoir's patrons, if not the general French public, recognized and appreciated his decorative talents. *A Bouquet of Roses* was done for one of Renoir's greatest patrons, Paul Berard, who was an ambassador and banker. Renoir met Berard at one of the Charpentier salons, and they were soon to establish a lasting friendship.[5] Renoir spent several summers at Wargemont, the summer home of the Berard family in Normandy, between the

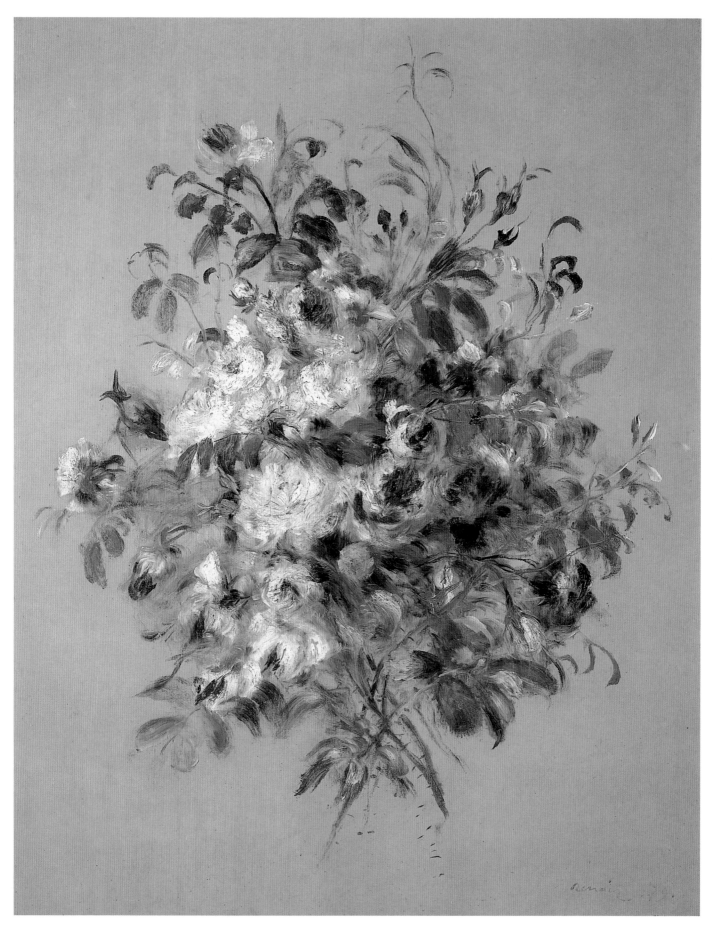

A Bouquet of Roses (*Bouquet de fleurs; Le Bouquet; Flowers*)
1879
Oil on panel
32¹¹⁄₁₆ x 25¼ in. (83.1 x 63.8 cm)
Signed and dated lower right: *Renoir.79.*
1955.592
Purchased from M. Knoedler & Company, May 25, 1933

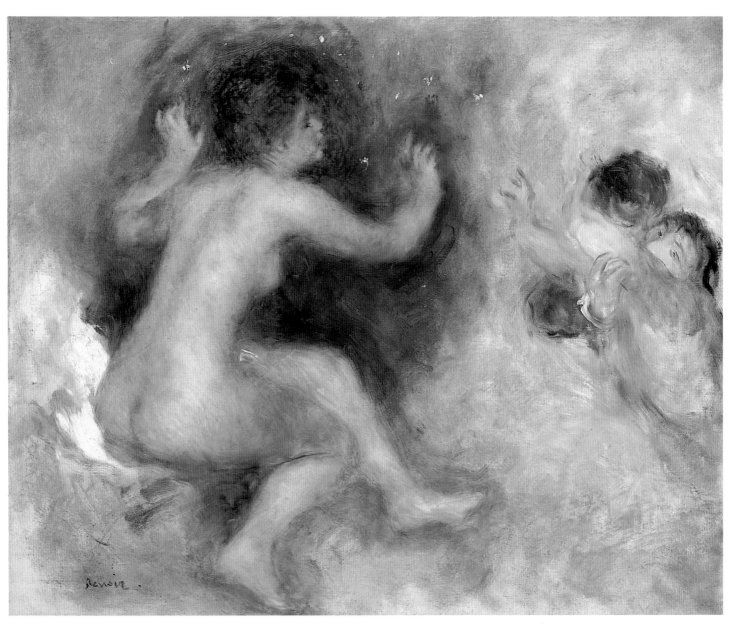

Study for "Scene from Tannhäuser—Third Act" (*Tannhäuser*)

c. 1879

21⅜ x 25⅞ in. (55 x 65.7 cm)

Signed lower left: *Renoir.*

1955.608

Purchased from M. Knoedler & Company, April 5, 1950

years 1879 and 1885. Berard's commissions, as well as the artist's own reaction to the beauty of the Normandy landscape, inspired a flood of productivity that led to the creation of approximately twenty works that first summer. Not all were on canvas: indeed, Renoir moved easily to painting directly onto the wooden doors and panels set into the walls of the Berard house when he ran out of canvas, "much to the annoyance of the kindly Madame Berard, who did not share her husband's blind devotion for their visitor's painting."[6] *A Bouquet of Roses* was painted directly on the upper half of a wooden door, probably that of Paul Berard's library.

Renoir liked decorative painting for several reasons. It entailed none of the aggravations he associated with formal portrait paintings, which required him to interact with a sometimes difficult client while concentrating on capturing his or her likeness. *Madame Charpentier and Her Children* was said to have taken no fewer than forty sittings—and undoubtedly much more time and effort than any of Renoir's decorative works. On a purely practical level, Renoir knew he would be paid for whatever decorative work he did, since it was, for all intents and purposes, preapproved at the time of commission. He would not have to worry whether the sitter would find his work acceptable.

In addition, the subjects of these paintings, usually flowers or female nudes, were more often than not ones he could realize quickly and easily. Certainly, works like *A Bouquet of Roses* did not represent a substantial expenditure of time on the part of the artist; the paint appears in many passages to have been quickly applied right out of the tube and simply articulated with a palette knife or a brush end. The undeniable spontaneity of this work enhances its impression of springlike freshness and abundance. It is easy to imagine this design on a porcelain teacup, and as such it reminds us of Renoir's early artistic training.[7]

The lively execution and high impasto reveal the artist's working methods—how he handled the loaded brush and how he was able to paint such a composition. Jacques-Emile Blanche, son of the Berards' neighbors in Normandy and a frequent visitor to Wargemont, described Renoir at work painting flowers, "which his brush stroked as gently on the canvas as one caresses the cheek of a child, or a woman's neck."[8]

Madame Berard had an extensive flower garden, which Renoir admired, and he painted many flower arrangements during his visits to the château. In memory of this, the artist took it upon himself years later to send the family shipments of flowers to be planted in the gardens. A letter from December 7, 1891, warned Paul Berard of the impending arrival of chrysanthemums and heliantus "and one or two other plants whose names I have forgotten," on the next day's train to Dieppe. "Plant them in a corner somewhere and you will see what comes out there."[9]

The profusion of blooms around the Bérard house inspired several more paintings. *A Bouquet of Fuchsia* (1879; private collection, France), depicting a spray of beautiful red flowers, must have been a pendant piece to the Clark *Bouquet of Roses*. In contemporary photographs, *A Bouquet of Fuchsia* appears on a library door as an oasis of fresh spring air among floor-to-ceiling rows of darkly bound books, the joins between the planks of the door itself clearly visible.[10] The panels were probably cut from the doors by the time of the sale of Berard's collection in May 1905.

The least intellectual of the Impressionists, Renoir created paintings in which the decorative component is always extremely important, and he provides perhaps the most successful realization of this very French eighteenth-century tradition. The color scheme of *A Bouquet of Roses*, partially predetermined by the grayish white of the already painted door, is the swirling mix of blues and pinks that can be found in almost any Rococo painting. Renoir was proud of being aligned with such a distinctively French tradition as the Rococo, and while many critics denigrated the purely decorative painter, Renoir consciously intended for his paintings to be enjoyed only for their beauty. "I have been told many a time that I ought not to like Boucher, because he is 'only a decorator.' As if being a decorator made any difference!"[11]

The Rococo origins of this panel were easily recognized by Clark, who was shown *A Bouquet of Roses* at Knoedler's in 1933, on one of his regular tours through the dealer's stock. He purchased the painting and later noted the acquisition in his diary, saying, "We looked at my bunch of Flowers by Renoir—It is really fine, such a variety of color and so light & airy, just like the French 18th century things" (October 6, 1933). In fact, the works that Renoir executed inside the Berard house were done in part to replace trumeaux, architectural elements from the eighteenth century.[12]

Also during the summer of 1879, Renoir made regular forays from Wargemont into nearby Dieppe, and particularly to the summer home of Dr. Emile Blanche, from whom he received additional decorative commissions. The unhesitating manner in which Renoir again used the style of the French eighteenth-century painters Fragonard and Boucher to meet the demands of this very different patron becomes apparent when *A Bouquet of Roses* is compared to *Study for "Scene from Tannhäuser—Third Act,"* which was painted for Dr. Blanche. The *Study* reproduces exactly the colors and tangible atmosphere of Fragonard, but it is worked in a style taken from the opposite extreme of the Rococo than *A Bouquet*—that of fanciful and imagined scenes rather than those inspired by nature. It also looks ahead to Renoir's later fascination with the art of Rubens.

Dr. Emile Blanche was a prominent Parisian psychiatrist. Ironically, it was Dr. Blanche whose name was invoked in an 1874 newspaper diatribe against the work of the Impressionists, including Renoir, whose paintings were then on display at the boulevard des Capucines. The author suggested that the Impressionist paintings were either "a deliberate attempt to mystify the public [or] a result of mental derangement [which thereby] calls for the opinion not of a critic but of Dr. Blanche."[13] These words illustrate both the harsh public criticism that dogged the Impressionists for many years and the degree to which the patrons of such artists as Renoir were risking public ridicule by collecting Impressionist works. Especially vulnerable were those individuals who commissioned decorative works for their homes; such works were more often than not permanently installed and would not have been hung and rehung according to the evening's guest list.

Renoir met the Blanche family in September, at the end of his first summer with the Berard family. Unfortunately, Madame Blanche was put off by the painter's very obvious lack of social graces, about which she was still complaining several years later in a letter to her husband, "If I had thought that he was going to be a permanent fixture here . . . I might have lost my self-control, since all his twitches at table and his conversation during dinner have had a bad effect on me."[14] Her dislike may explain why the artist was never engaged to paint the family's portrait, but in 1879 Dr. Blanche commissioned a pair of decorative canvases that, perhaps to Madame Blanche's dismay, were intended to go on the dining room ceiling.[15]

The *Study for "Scene from Tannhäuser—Third Act"* is the only extant sketch for this commission. The small canvas shows the goddess Venus sitting in the clouds and eagerly awaiting the return of her tormented lover. The subject is one that, like *A Bouquet of Roses*, resonates strongly with the artist's early training as a porcelain painter: once he had mastered the simpler images, such as flowers on plates, he graduated to other subjects, including most notably, "Venus in a swirl of clouds."[16]

Richard Wagner had completed *Tannhäuser* in 1845, and the opera had had a disastrous Paris premiere in 1861, during which the performance was brought to a standstill several times by a rowdy contingent from the Jockey Club. This group of conservative French aristocrats even had silver dog whistles specially inscribed for the occasion, "*Pour Tannhaeuser*." Their main objection was not the music itself but the placement of the ballet in the first rather than the second act, as was the tradition; members of the Jockey Club liked to arrive late to the theater after having taken the ballerinas out to dinner. The furor raged throughout the first three nights of performance, after which the opera was shut down entirely.[17]

Charles Baudelaire immediately wrote a spirited and passionate defense of Wagner, and this, along with the widespread attention generated by the first performances at the Paris Opéra, proved to be the catalyst for a growing Wagner cult.[18] By 1879, the composer had acquired a large and devoted following among the Parisian elite, and there were entire journals devoted to discussion of his works, among them the *Revue Wagnerienne*.

In all likelihood, it was Dr. Blanche who selected the theme of Tannhäuser for his decorations. He was devoted to the music of Wagner and held regular salons at his home, where it would be the focus of heated discussions. Renoir himself, though he was a member of a core group of Wagner enthusiasts that included Baudelaire, Fantin-Latour, Manet, and Bazille, possessed only a lukewarm interest in German opera. Surrounded by friends, fellow artists, and patrons who were passionate Wagnerians, Renoir seems to have tried with little success to acquire a taste for Wagnerian opera.

Renoir met Wagner in January 1882 in order to fulfill a commission for a portrait of "the Master," who had finished *Parsifal* that very day.[19] Preferring the more straightforward music of Jacques Offenbach, Renoir said that "by the time I had finished [Wagner's portrait] I thought he had less talent than I did at first."[20] In 1896 Renoir went with Martial Caillebotte, the brother of the Impressionist painter, to see a performance of Wagner at the festival in Bayreuth, where, "in an atmosphere that was not his own, he felt entirely out of his element. The dark room oppressed him; during the performance, at the end of his patience, he had the audacity, to the great dismay of his neighbors and of Martial Caillebotte, to strike a match to see what time it was."[21] Needless to say, the artist was too bored to stay for all four days of the festival. But whatever personal opinions Renoir had concerning Wagner, he could not let them get in the way of commissions.

The story of the opera focuses around the knight Tannhäuser, who has tired of Venus's love and wants to return to the world of the mortals. Upon his return, the knights at court spare his life only on the condition that he attempt to receive the pardon of the pope for his many sins. In the third act, Tannhäuser has returned from Rome. His plea for forgiveness has been rejected by the pope, who felt certain of his sins were beyond pardon. In despair, Tannhäuser seeks to return to Venus and calls out to her. A vision surrounded by glowing clouds, the goddess appears with outstretched arms to welcome back her lover. The hero's faithful friend, Wolfram, seeks to restrain him from returning to Venus, for he knows it will mean eternal damnation. This scene is the one that Renoir's painting illustrates.

Seated on a cloud and enveloped in a vibrant blue aura that sparkles with tiny white stars, Venus reaches out to Tannhäuser, who appears to be throwing himself headlong toward her. Surely the hero would fall at her feet but for the strength of Wolfram, who tries desperately to hold him back. Inches from Venus's hands, Tannhäuser struggles yet grasps only a blur of empty air. As befits a ceiling painting, the figures appear free-floating. Wagner's amorphous music is evoked by the composition of the picture, in which scarcely a firm line can be found; the dots of the stars are surprising points of solidity set into an otherwise uncertain framework. The paint is applied very thinly and may even have been rubbed with a soft cloth to create the look of overall softness. Glinting patches of yellow are scattered across Venus's body, and her hair is not painted a single color but includes areas of magenta, orange, and yellow.

The hazy overall treatment of this elegant fantasy adds to its mystical import, which is emphasized both by the lack of setting to anchor the composition and by the absence of any references to a specific reality. Like *A Bouquet of Roses*, the works based on *Tannhäuser* posed no serious difficulty for the artist, although because of faulty measurements, he had to repaint the two final compositions onto slightly smaller canvases so they would fit into the Blanche ceiling.

In addition to the influence of the eighteenth-century French masters, a more contemporary artistic source for Renoir's treatment of the Wagnerian theme was Henri Fantin-Latour, who made a life's work treating scenes drawn from the music of Wagner, Schumann, Brahms, and Berlioz. With his focus on paintings of such imaginative compositions, as well as floral still lifes and portraits, Fantin-Latour's artistic vision was similar to that of Renoir. Preoccupied with the theme of *Tannhäuser* for several decades, by 1879 Fantin-Latour had produced and exhibited at the Salon a major painting and several series of lithographs on the subject.[22]

At the Salon of 1879, where Renoir had his first publicly acknowledged success with *Madame Charpentier and Her Children*, Fantin-Latour exhibited a lithograph taken from his *Tannhäuser* series, which Renoir doubtless saw. It was almost certainly from this series that Renoir drew his inspiration for the Blanche paintings done later that same year. The similarity between both works' overall hazy atmospheres and weightless figures pulled forward from an unspecified background is unmistakable. Dr. Blanche also undoubtedly knew of and appreciated Fantin-Latour's lithographs of *Tannhäuser*. Renoir had been acquainted with Fantin-Latour since their student days, and both were frequent visitors to weekly salons of writers and painters at the Blanche château in Dieppe. But while Fantin-Latour was personally and deeply attracted to the Wagnerian theme, Renoir took it up only after he was prompted by a client.

Renoir's involvement with decorative painting, born of necessity to supplement his family's income, was sustained throughout his career for much the same reason. His first son, Pierre, was born in 1885, and Renoir "is reported to have painted a mural for the home of the doctor because he had no money."[23] The Berards and the Blanches were certainly not the first or the only wealthy patrons whose homes were decorated by the work of Renoir. As early as 1876, in an attempt to recoup some of the money they had lent or given the artist during the past year, the Charpentiers had commissioned two large murals that hung in their stairway and depicted the couple as they came down the stairs. At a time when the success of Renoir's paintings was not at all assured, these commissions served many functions besides simply providing a much-needed source of income. They went a long way toward ingratiating the artist with his rich patrons, and they provided constant proof, and advertisement, of the artist's talent to the patron's guests.

Renoir remained committed to decorative themes throughout his life. Such paintings illustrate a parallel career path, lesser known but no less interesting, that he used to supplement his income and to help him continue working as an artist. While the decorative works were commissioned by many different collectors and drew heavily from the art of the Rococo, each of them retains the sense of joy that Renoir brought to and received from his art.

RM

NOTES

A PASSION FOR RENOIR

[1] Sterling Clark Diaries (RSC Diaries), April 6, 1942, Archives of the Sterling and Francine Clark Art Institute (SFCAI), Williamstown, Massachusetts. Clark kept extensive diaries for most of his life. They included observations on politics, food and wine, his daily appointments, and, above all, the art market. While incomplete, with the notable loss of the years 1913–23, when he was in Paris, the diaries—gritty and opinionated, often irreverent, and occasionally perhaps libelous—offer valuable insight into the character and thoughts of the Clarks as collectors. All subsequent references to the diaries will be by date, in parentheses, at the end of the quotation. The original spelling and punctuation of diary quotations have been retained as much as possible; corrections have been made only to increase readability.

[2] In a review of M. Knoedler & Co., *The Classical Period of Renoir: 1875–1886* in *Apollo*, November 1929: 256, J. B. Manson contrasted *The Loge* of 1874 with the artist's later work, when "his hand lost its cunning through physical causes, and if his eye still beheld beauty in women his brush failed to reproduce the vision on his canvas." In a review of Michel Florisoone's *Renoir*, Douglas Lord credited the author with a critical examination of Renoir's work, but strengthened the criticism: "Renoir is, in his unquestioning bourgeois acceptance of the world, a pleasant enough painter, indeed at times a great painter; but it seems too much to credit him with the 'profound spiritual serenity' of Titian, while, in the light of his later paintings, the meaning of 'Renoir, who remained eternally young, was an ancient Rubens' is, to say the least, ambiguous. It is surely his flabbiness, his desire to 'please and flatter,' his frequently banal sensuality, his lack of Rubens' ebullience, which led him to the spiritual crisis of 1880." *Burlington Magazine*, September 1938: 137–38.

[3] Cited in "Renoir's Brilliant Years 1900–1919 Review," *The Art Digest* 16, no. 4 (April 15, 1942): 14.

[4] Edward Alden Jewell, "The Last Two Decades of Renoir: Benefit Exhibition at D-R Gallery Brings together Work since 1900," *New York Times*, April 5, 1942.

[5] Doris Brian, "This Century's Share of Renoir," *Artnews* 41, no. 4 (April 1–14, 1942): 33.

[6] The institutions the Clark brothers founded or supported include the Sterling and Francine Clark Art Institute, Fenimore House and the Farmers' Museum of the New York State Historical Association in Cooperstown, and the National Baseball Hall of Fame and Museum; in addition, they were responsible for numerous gifts to the Metropolitan Museum of Art and Yale University. For more information on the Clark brothers, see Robert Wernick, "The Clark Brothers Sewed Up a Most Eclectic Collection," *Smithsonian*, April 1984: 122–32.

[7] For a lively discussion of the Clark brothers and their connection with Singer, see Wernick, "The Clark Brothers."

[8] Sterling Clark, *Through Shen-Kan: The Account of the Clark Expedition in North China, 1908–9* (London, 1912).

[9] "[Il] en avait conservé par instant une certaine rudesse et certaines manières pittoresques. Il employait, uniquement entre hommes, un langage militaire où les 'Son of a b . . .', 'Son of a g . . .' ou 'Stick in the mud' revennaient fréquemment." From Charles Durand-Ruel's appreciation of Clark, *Souvenirs de Charles Durand-Ruel sur Monsieur Robert-Sterling Clark*, March 7, 1980, typewritten manuscript, SFCAI Archives.

[10] The division was, in Clark's opinion, unfair. In 1913 he traded a farm to his brother Ambrose for Théodore Géricault's *Trumpeter of the Hussars on Horseback* (which had been in his mother's collection) and, in letters to his brother Stephen from about the same time, complained that he had not gotten his share. He subsequently went to great lengths to recapture some of his father's pictures.

[11] For a brief account of Barnard's trip with the Clark brothers, see Harold E. Dickson, "The Origin of the Cloisters," *Art Quarterly* 28 (1965): 264.

[12] The collection of George Grey Barnard (1863–1938) went to the Metropolitan Museum of Art, where it formed the core of the medieval collections now at the Cloisters.

[13] *Pleasure Guide to Paris for Bachelors* (London and Paris, n.d. [c. 1903]), 5; cited in Charles Rearick, *Pleasures of the Belle Epoque: Entertainment and Festivity in Turn-of-the-Century France* (New Haven, 1985), 40–41. For additional reading on the Belle Epoque, see Roger Shattuck, *The Banquet Years: The Origins of the Avant-Garde in France, 1885 to World War I* (New York, 1968).

[14] For a lengthy and lively discussion of Paris, see Stein, *The Autobiography of Alice B. Toklas* (New York, 1933).

[15] Attributed to Thomas Gold Appleton (1812–1884) in John Bartlett, *Familiar Quotations* (New York, 1968), no. 839b.

[16] Letter to Paul Clemens, March 2 [no year], SFCAI Archives. All subsequent references will be abbreviated to "Clemens letters," followed by the date.

[17] The Clarks had, in fact, already passed up the picture on three occasions: March 15, 1928; December 26, 1928; and February 14, 1929.

[18] Norman Hirschl, retired director of the Hirschl and Adler Galleries, recalled his experience with the Clarks between 1938 and 1942, when he was manager of the John Levy Galleries. The Clarks' weekly visits, Saturday at 10:00 A.M., were always anticipated for their open discussion between the dealers and collectors. When the talk concerned American pictures, in which Levy dealt predominantly, Francine always acquiesced to her husband. When a French painting was presented, however, Hirschl remembers Francine leading the discussion, an indication of a far greater role in her husband's taste and collecting. Telephone interview, August 8, 1995.

[19] *Valuable Paintings and Sculptures by Old and Modern Masters Forming the Famous Catholina Lambert Collection Removed from Belle Vista Castle, Paterson, New Jersey*, The American Art Association, New York, February 21–24, 1916, lot 152, *Girl Knitting*.

[20] The price for *Girl Crocheting* was actually $20,000, noted correctly in the diary entry of November 5, 1941, and corroborated with the bill of sale in SFCAI curatorial files. Also, Scott actually paid $16,200 rather than $16,300.

[21] Howard Greenfeld, *The Devil and Dr. Barnes: Portrait of an American Art Collector* (New York, 1987), 34.

[22] *Great French Paintings from the Barnes Foundation*, exh. cat. (New York, 1993), 9. While these words were written about Dr. Albert C. Barnes, their general tone makes them appropriate for Clark as well.

[23] The sale of nineteenth-century French paintings from the collection of Jean Dollfus, Galerie Georges Petit, Paris, March 2, 1912.

[24] Herbert Elfers made this suggestion at the Durand-Ruel Galleries, as noted in RSC Diaries, September 30, 1942.

[25] I would like to thank James Martin, Director of Analytical Services and Research at the Williamstown Art Conservation Center, for his assistance. During the 1930s and 1940s, analytical techniques allowed crystallographic, chemical, and elemental analysis of a wide range of materials. Much was published during those years on the technical study of paintings.

[26] Ambroise Vollard, *La Vie et l'oeuvre de Pierre-Auguste Renoir* (Paris, 1919).

[27] For a concise evaluation of Vollard's book, see Barbara Ehrlich White, *An Analysis of Renoir's Development from 1877 to 1887* (Ann Arbor, 1965), 9–15.

[28] Clemens letters, July 3, 1955.

[29] Recalled by Charles Durand-Ruel in *Souvenirs*: "Sterling était enthousiaste et, lorsqu'un tableau soulevait son admiration, il brandissait sa canne, qu'il ne quittait que rarement, et frôlait la toile en faisant des moulinets, au grand effroi de nos fidèles garçons de bureau Noirs qui l'adoraient, car il les traitait comme de vieux amis."

[30] "Old boy took me for an art dealer & later for a painter!!!!" (RSC Diaries, December 24, 1940); "asked if I found clients for such china???? taking me for a dealer!!!!" (RSC Diaries, January 3, 1941).

[31] Recalled by Charles Durand-Ruel in *Souvenirs*: "Of the thirty-two [incorrect, actually thirty-eight] Renoirs that he left . . . twenty-eight come from [Durand-Ruel]." ("Sur les trente-deux Renoirs qui'il a légués . . . 28 proviennt de notre maison.")

[32] Ibid.: "Lorsqu'en 1946, mon frère et moi retournâmes alternativement à New-York, l'amitié qui nous unissait aux Clarks se transforma en profond affection. . . . [Ils] auraient pu être nos parents et ils nous traitaient presque comme leurs enfants."

[33] Ibid.: "Quelques tableaux étaient accrochés assez haut et les autres, non cadrés, étaient empilés par douzaines et par ordre de taille le long des murs . . . lorsqui'il en découvrait un qui lui plaisait particulièrement, il le faisait sortir de la pile . . . le contemplait pendant des quarts d'heure entiers en discutant de ses qualités avec nous."

[34] Clemens letters, January 6, 1952.

[35] Probably "The Serene World of Corot," Wildenstein and Company, New York, November 10–December 12, 1942.

[36] Clemens letters, December 13, 1942.

[37] This statement suggests some knowledge of Freudian psychology and, indeed, while it is unknown whether or not Clark was familiar with any of Freud's writings, they were published in translation in 1938 and were readily available (*The Basic Writings of Sigmund Freud,* trans. and ed., with intro., by Dr. A. A. Brill [New York, 1938]). As for Clark's observation about a sexually significant occurrence in Renoir's life about 1881, the artist met Aline Charigot, his future wife, in that year.

[38] Clark guessed the painting had been sent out of Europe, probably by the Rothschilds, to escape the Nazis. The painting was not documented in the Durand-Ruel archives.

[39] Charles R. Henschel, son-in-law of Michel Knoedler, founder of M. Knoedler & Company, joined that gallery in 1904 and became president in 1927.

[40] The Art Institute of Chicago acquired *Peonies* as part of the Coburn bequest, a collection of fifty-nine French paintings dated from 1860 to 1905 given by Annie Swan Coburn in early 1932. For more information on the bequest, see Patricia Erens, *Masterpieces: Chicagoans and Their Paintings* (Chicago, 1979).

[41] Henry McBride, "The Renoirs in America: In Appreciation of the Metropolitan Museum's Exhibition," *Artnews* 35, no. 11 (May 1, 1937): 59–60.

[42] Alfred Frankfurter, "Dark Horse in Williamstown," *Artnews* 54, no. 4 (Summer 1955): 28–31.

[43] Clemens letters, October 27, 1945.

[44] Clemens letters, November 15, 1945.

[45] Ibid.

[46] Ibid.

[47] Ibid.

[48] Ibid.

[49] Ibid.

[50] Daniel Catton Rich (1904–1976) was associate curator of paintings at the Art Institute of Chicago before he assumed the position of director, in which he served from 1938 to 1958.

[51] Clemens letters, November 15, 1945.

[52] Ibid.

[53] Ibid.

[54] Ibid.

[55] Ibid.

[56] Clemens letters, November 21, 1945.

[57] *Barnes*, exh. cat., 79.

[58] Ibid., 8.

[59] See also Greenfeld, *Devil*, 176–78.

[60] Clark had stopped by the Bignon Gallery, one of Barnes's favorites. The director, a Mr. McDonald, "became enthusiastic when he saw I knew Renoir so well & as I left said 'You seem to know as much about the school as Dr. Barnes'!!!!—I had to grin & returned 'I know something but not very much.'"

[61] Greenfeld, *Devil,* 44.

[62] *Barnes*, exh. cat., 29.

[63] Greenfeld, *Devil*, 177.

[64] "Elfers showed us article by Dr. Barnes in Philadelphia papers on his purchase of the Renoir 'Mussel Gatherers' for which he claimed he paid $175,000!!!!—And which he had been after for 8 years or more!!!!—In reality paid for it with 4 pictures & $25,000 in cash on a basis of $125,000. . . . Highly amusing & shows what one can believe in the papers!!!!" (RSC Diaries, January 28, 1942).

[65] For contrasting discussions of Barnes and his relationship with both Glackens and Stein, see *Barnes*, exh. cat. intro., especially 3–16, and Greenfeld, *Devil*, especially 30–50.

[66] Ailsa Mellon Bruce is discussed in the RSC Diaries on a number of occasions in the early 1940s.

[67] Wernick, "The Clark Brothers," 128.

[68] *Souvenirs*: "Dans sa jeunesse [Francine] avait joué à la Comédie Française! C'en était trop pour les frères de Robert qui, très snobs, appartenaient à un cercle resteint de propriétaires de Long Island, et devaient sans doute être snobés par d'autres."

[69] From Lionello Venturi, *Les Archives de l'impressionnisme* (Paris and New York, 1939); cited in translation in Anne Distel, "Renoir's Collectors: The Pâtissier, the Priest and the Prince," in Hayward Gallery, *Renoir*, exh. cat. (London, 1985), 27.

[70] Louis-Marie Philippe, Alexandre Berthier, prince de Wagram (1883–1918), grandson of Louis-Alexandre Berthier, maréchal de France under Napoleon I, formed an outstanding collection from 1905 to 1908 of several hundred paintings by such artists as Gustave Moreau, Pierre Puvis de Chavannes, Edgar Degas, Edouard Manet, Camille Pissarro, Claude Monet, Alfred Sisley, Edouard Vuillard, and, above all, Renoir. Financial difficulties forced the sale of the collection between 1908 and 1914.

[71] Gangnat (1856–1924) purchased over 150 paintings from Renoir from approximately 1905 until the artist's death in 1919. This dedication to Renoir's late work was exceptional, as was the collector's relationship with the artist. As a close friend of Renoir, Gangnat was often invited to Les Collettes, Renoir's villa near Cagnes.

[72] For a discussion of the popularity of Renoir in the early twentieth century, see Distel, "Renoir's Collectors," in Hayward Gallery, *Renoir*, 24–27.

[73] Barbara Ehrlich White, *Renoir: His Life, Art, and Letters* (New York, 1984), 251.

[74] *Apollinaire on Art: Essays and Reviews, 1902–1918, by Guillaume Apollinaire* (New York, 1972), 204.

[75] McBride, "The Renoirs in America," 58–60.

[76] Ibid., 58.

[77] "I found out from Scott that Renoir's chef d'oeuvre of the Dancing Girl for which Edmund de Rochild [sic] offered 500,000 fr before the War was now in Widener's collection, $120,000" (RSC Diaries, March 24, 1926). Clark had also been told that Widener had gotten the painting for $100,000 in cash and a spurious Frans Hals in exchange (RSC Diaries, April 3, 1926).

[78] All of the equivalent values of prices paid by Clark or other collectors have been calculated with information from the Consumer Price Index provided by the Bureau of Labor Statistics of the United States Department of Labor.

[79] RSC Diaries, April 10, 1943.

[80] I would like to thank Robert Bordingham and Carol Troyon at the Museum of Fine Arts, Boston, for their assistance regarding Spaulding's purchase.

[81] RSC Diaries, February 23, 1945. The cash payment plus the sale revenue of the two works accepted in exchange equaled more than $90,000, "what a price for a most unattractive picture and a name!!!" (RSC Diaries, May 19, 1945).

[82] I would like to thank Barbara File of the Archives of the Metropolitan Museum of Art for her assistance with statistics on the 1937 Renoir exhibition.

[83] *The Metropolitan Museum of Art's 68th Annual Report of the Trustees*, 1938, 16.

[84] Alfred M. Frankfurter, "A View of the Magnificence of Renoir," *Artnews* 35, no. 33 (May 15, 1937): 11.

[85] Ibid., 9.

[86] Ibid., 11.

[87] Mary Morsell, "Durand-Ruel Holds Fine Renoir Show," *Artnews* 33, no. 24 (March 16, 1935): 4.

[88] M[artha] D[avidson], "The Late Masterpieces of Renoir," *Artnews* 35, no. 4 (October 24, 1936): 17.

[89] Frankfurter, "A View," 10.

[90] Several other exhibitions were organized before and after the war for the benefit of the needy or underprivileged: Durand-Ruel, "Masterpieces," March 12–13, 1935, for the benefit of Hope Farm, Community School for Children; Wildenstein, March 23–April 29, 1950, for the benefit of the New York Infirmary; and Wildenstein, April 8–May 10, 1958, for the benefit of the Citizens' Committee for the Children of New York City.

[91] From a conversation between Clark and Elfers, quoted in RSC Diaries, April 8, 1942.

[92] Harry B. Wehle, "The Paintings of Renoir," in *Renoir: A Special Exhibition of His Paintings*, exh. cat. (New York: Metropolitan Museum of Art, 1937), 5–6.

[93] Clemens letters, November 27, 1954.

[94] "Paintings by Pierre Auguste Renoir: An Exhibition Commemorating the Twentieth Anniversary of the Opening of the Museum," California Palace of the Legion of Honor, San Francisco, November 1–30, 1944; "A Loan Exhibition of Renoir," Wildenstein and Company, New York, March 23–April 29, 1950; "The Last Twenty Years of Renoir's Life," Paul Rosenberg and Company, New York, March 8–April 3, 1954; and "Pierre Auguste Renoir, 1841–1919: Paintings, Drawings, Prints, and Sculpture," Los Angeles County Museum of Art, July 14–August 21, 1955, and the San Francisco Museum of Art, September 1–October 2, 1955.

[95] Clemens letters, November 27, 1954.

[96] Alfred Frankfurter, "More Treasures Emerge at Williamstown," *Artnews* 55, no. 4 (Summer 1956): 42–43, 68.

[97] Helen Comstock, "Renoirs in the Clark Collection," *Connoisseur* 139, no. 559 (February 1957): 65.

[98] Elaine de Kooning, "Renoir: As If by Magic," *Artnews* 55, no. 6 (October 1956): 43–45, 66–67.

[99] Frankfurter, "More Treasures," 68.

CATALOGUE
IMAGES OF WOMEN
Society Portraiture

[1] François Daulte, *Auguste Renoir, Catalogue raisonné de l'oeuvre peint*, vol. 1, *Figures, 1860–1890* (Lausanne, 1971), 419. The faces are not particularized in any significant way but conform instead to the generic "Renoir face." Renoir would have had a professional investment in cultivating Turquet, whose responsibilities included overseeing the Salon. In 1880 Renoir proposed changes to the structure of the Salon, but Turquet apparently did not respond. For Renoir's proposals, see Nicholas Wadley, ed., *Renoir: A Retrospective* (New York, 1987), 136. On the role the Charpentiers played in helping Renoir develop a market, see Kathleen Adler, "Renoir, His Patrons and His Dealer," in John House, ed., *Renoir, Master Impressionist*, exh. cat. (Sydney: Art Exhibitions Australia, 1994), 30ff.

[2] Renoir disliked Garnier's building, which he described to his son Jean as a "lump of overcooked brioche." See Jean Renoir, *Renoir, My Father*, trans. Randolph and Dorothy Weaver (London, 1962), 54.

[3] Robert L. Herbert, *Impressionism: Art, Leisure, and Parisian Society* (New Haven and London, 1988), 96. Renoir, in addition, had some personal interest in the opera. As a child, he had sung in the celebrated choir of the Church of St.-Eustache, then under the direction of Charles Gounod, who urged Renoir to consider becoming a professional opera singer. See Jean Renoir, 52–55.

[4] In recent evaluations of Impressionism, scholars have recognized that period notions of propriety prevented women painters associated with the movement from visiting many of the public spaces painted by their male counterparts. While lower-class and working women might attend the *café-concerts* or stroll the boulevards by themselves, respectable upper-class women such as Morisot, Cassatt, and Gonzalez could not. They could, however, without reprobation, attend the Opéra unaccompanied, and thus they were able to paint it. For an analysis of their images of the opera and a comparison with Renoir's *The Loge*, see Tamar Garb, "Gender and Representation," in Francis Frascina, *Modernity and Modernism: French Painting in the Nineteenth Century* (New Haven and London, 1993), 223–30, 257–67.

[5] F. Adolphus, *Some Memories of Paris* (Edinburgh and London, 1895), 227.

[6] Jean Prouvaire, "L'Exposition du boulevard des Capucines," *Le Rappel*, April 20, 1874. Of the picture, he also wrote, "Those artificially whitened cheeks, those eyes lit with banal passion, you might be like that, with your gold opera glasses in your hand, attractive and empty, delectably stupid. This woman who takes as little interest in the drama as she does in the gentlemen sitting next to her, slightly behind, she could be your future, and I am afraid that you do not entirely dread it." Quoted in Sophie Monneret, *Renoir*, trans. Emily Reed (London, 1990), 60.

[7] The letters, which Renoir wrote from Algiers in the fall and winter of 1881–82, are collected in Lionello Venturi, *Les Archives de l'impressionnisme* (Paris and New York, 1939), 1:115–22. Renoir also contended to Durand-Ruel that exhibiting with the Impressionists would reduce the value of his canvases by half.

[8] Joel Isaacson, "The Painters Called Impressionists," in Charles S. Moffett et al., *The New Painting, Impressionism 1874–1886*, exh. cat. (San Francisco: The Fine Arts Museums of San Francisco, 1986), 379–80.

[9] Louis Leroy, "Exposition des impressionnistes," *Le Charivari*, March 17, 1882, 2; quoted in Isaacson, 379. For references to the other reviews, see Isaacson, 391 n. 51.

Bourgeois Pastimes

[1] For an example of such writing, see Octave Mirbeau, "Notes sur l'art, Renoir," *La France,* December 8, 1884. Mirbeau wrote, "He is truly the painter of women, alternatively gracious and moved, knowing and simple, and always elegant, with an exquisite visual sensibility, a touch as light as a kiss, a vision as penetrating as that of Stendhal. Not only does he give a marvelous sense of the physique, the delicate relief and dazzling tones of young complexions, he also gives a sense of the *form of the soul*, all woman's inward musicality and bewitching mystery." Translated in Nicholas Wadley, ed., *Renoir: A Retrospective* (New York, 1987), 165.

[2] "Renoir," London, Hayward Gallery, January 30–April 21, 1985; Paris, Galeries Nationales du Grand Palais, May 14–September 2, 1985; and Boston, Museum of Fine Arts, October 9, 1985–January 5, 1986.

[3] Feminist views of Renoir's art include Kathleen Adler, "Reappraising Renoir," *Art History* 8, no. 3 (September 1985): 374–80; Linda Nochlin, "Renoir's Men: Constructing the Myth of the Natural," in "Renoir: A Symposium," *Art in America* 74, no. 3 (March 1986): 103ff.; Tamar Garb, "Renoir and the Natural Woman," *Oxford Art Journal* 8, no. 2 (1985): 3–15; Desa Philippi, "Desiring Renoir: Fantasy and Spectacle at the Hayward," *Oxford Art Journal* 8, no. 2 (1985): 16–20; Marcia Pointon, *Naked Authority: The Body in Western Painting, 1830–1908* (Cambridge, 1990), 83–97; and Anthea Callen, "Renoir: The Matter of Gender," in John House, ed., *Renoir, Master Impressionist* (Sydney: Art Exhibitions Australia, 1994), 41–51.

[4] On this subject, see also the section of this volume entitled "Bathers."

[5] Using dress as evidence of class in this period is admittedly tricky, because of the blurring of social boundaries that occurred with the rise of mass-produced clothing and the department store; other relevant factors included Haussmann's destruction of the old neighborhoods of Paris, the incursion of money into all aspects of life, the rise of mass entertainment and culture, and changes in the nature and organization of work. The growth of prostitution and its infiltration into all parts of the city further compounded the problem. Determining who was who involved not only issues of class identity but also questions of whether a woman was an "honest" one or a *"fille."* On the extremely complex problem of class in this period and its relation to modern painting, see T. J. Clark, *The Painting of Modern Life* (New York, 1984; reprint, Princeton, 1986). On the role that prostitution and fashion played in clouding the social picture in Paris, see Hollis Clayson, *Painted Love* (New Haven and London, 1991).

Although some painters of modern Paris, notably Manet and Degas, explored the increasing illegibility of class boundaries, Renoir very infrequently provides the kinds of prompts or cues that would encourage viewers to question a figure's identity. This is not to say that he completely ignored the issue. His presentation of a heavily made-up, lavishly dressed woman in *The Loge* (Courtauld Institute of Art, London), for example, has led some critics to question who she was (see note 4 to previous essay). On the whole, however, Renoir was one who predicated his world on stability, order, and legibility, and he thus preferred to ignore the problematic matter of class. Unsurprisingly, he

largely eschewed images of courtesans and prostitutes, the women who stood in many contemporary minds as the image par excellence of the pernicious effects of modernity and who served as a focal point for collective anxieties about the commodification of all realms of life and the extent to which disguise and masquerade permeated society.

[6] Bourgeois women do, of course, appear with men, but their interaction is generally more formal and less animated. Compare, for example, *Dance in the City* and *Dance in the Country* (both 1882–83; Musée D'Orsay, Paris).

[7] To gauge the stiffness of the pose, compare this picture with *Woman with a Parasol and a Small Child on a Sunlit Hillside* (c. 1874–76; Museum of Fine Arts, Boston), where the figure, clothed in a loose white dress, lies casually in the grass, while a child plays behind her.

[8] Women's devotion to fashion both amused and irritated Renoir, who was particularly anticorset and antibustle, because both deformed a woman's body. For his comments, see Jean Renoir, *Renoir, My Father,* trans. Randolph and Dorothy Weaver (London, 1962), 83–84.

[9] The artist's contemporaries were well aware of the "Renoir face," which took shape in the 1870s. The noted critic Gustave Geffroy explained it in these terms: "The face and this expression must have been so intensely conceived of and favored by Renoir that he found himself unable to disengage from them; they are recognizable everywhere. 'A Renoir woman!' people will always exclaim before those figures he has immortalized in art. Their eyes and lips are all touched with something strange and unconscious, as are all eyes which see existence anew, all smiling mouths eager to kiss and sing. . . . With all of them, the characteristics Renoir chose were the low forehead, with its implications of niceness and obstinacy, and the slightly heavy jaw implying animal appetite and sensuality." Geffroy went on to note that Renoir even tended to tailor the faces of his female portrait subjects to this mold. See Gustave Geffroy, "Auguste Renoir," in *La Vie artistique* (Paris, 1894), translated in Wadley, 190.

In another portrait showing Madame Monet reading (1872; Calouste Gulbenkian Foundation, Lisbon), Renoir depicts her in a manner more consistent with his standard approach to women. There she appears in a similar blue dressing gown, but lies listlessly on the couch, her hand limply holding a copy of the newspaper *Le Figaro* and her eyes blankly staring into space rather than at the page before her.

[10] Geffroy, translated in Wadley, 191.

[11] On paintings of letter writers, see Sandra G. Ludig, *Between the Lines: Ladies and Letters at the Clark,* exh. cat. (Williamstown: Sterling and Francine Clark Art Institute, 1982).

Provocative Poses

[1] The related paintings are *Young Blonde Girl Crocheting* (private collection, New York) and *The Crocheter* (Weisweiller Collection, Paris). Illustrations can be found in François Daulte, *Auguste Renoir, Catalogue raisonné de l'oeuvre peint,* vol. 1, *Figures, 1860–1890* (Lausanne, 1971), nos. 153 and 155. A fourth picture, *The Crocheter* (1875; Oskar Reinhart Collection, Winterthur; Daulte no. 156), shows a similar motif, but the figure's hair, pinned to her head, and her high-necked, short-sleeved blouse put the accent on prim and proper rather than provocative.

[2] On Nini de Lopez, see Georges Rivière, *Renoir et ses amis* (Paris, 1921), 65. The relation between Renoir's images of young girls with their dresses or chemises slipping from their shoulders and the artist's model is suggested in John House, ed., *Renoir, Master Impressionist,* exh. cat. (Sydney: Art Exhibitions Australia, 1994), 119. Support for House's suggestion comes from Rivière, who reported that Nini often remained in Renoir's studio after a session, reading or sewing "just as, in fact, we see her in many of Renoir's studies."

[3] Linda Nochlin, "Body Politics, Seurat's *Poseuses*," *Art in America* 82 (March 1994): 121.

[4] The body of an "acceptable" nude was generalized and idealized, was usually surrounded by classicizing or exotic references and

trappings, and showed no signs of sexual desire. Examples of nudes that breached the rules include Manet's *Olympia* (1863; Musée d'Orsay, Paris) and Henri Gervex's *Rolla* (1878; Musée des Beaux-Arts, Bordeaux), which was rejected from the Salon of 1878 for indecency.

[5] Sigmund Freud, *Three Essays on Sexuality* (1905), *Standard Edition* 7, 156, quoted in Peter Brooks, *Body Work: Objects of Desire in Modern Narrative* (Cambridge, Mass., 1993), 105.

[6] Philippe Perot, *Fashioning the Bourgeoisie: A History of Clothing in the Nineteenth Century,* trans. Richard Bienvenu (Princeton, 1994), 145–46. For an analysis of women's undergarments in the late nineteenth century, see 143–61.

[7] Jean Renoir, *Renoir, My Father*, trans. Randolph and Dorothy Weaver (London, 1962), 84. Renoir's curious analogy obviously invites further consideration.

[8] As Philippe Perot writes, undergarments "function in a dimension moral and sexual rather than social," *Fashioning the Bourgeoisie,* 143.

[9] This is but a few lines from Zola's lengthy passage, which is translated and analyzed in Brooks, 151–55.

[10] Octave Uzanne, *L'Art et les artifices de la beauté* (Paris, 1902), 215, translated in Perot, *Fashioning the Bourgeoisie,* 141 n. 28.

[11] Rivière, 137–38. Renoir also used Angèle for the woman drinking wine in the center of *Luncheon of the Boating Party* (1880–81; The Phillips Collection, Washington, D.C.). See Barbara Ehrlich White, *Renoir: His Life, Art, and Letters* (New York, 1984), 106.

[12] On the peculiarities of the picture, see Hayward Gallery, *Renoir,* exh. cat. (London, 1985), 218.

[13] Zola's articles, entitled "Le Naturalisme au Salon," were published in *Le Voltaire,* June 18–22, 1880, and are reprinted in Emile Zola, *Mon Salon, Manet, écrits sur l'art,* A. Ehrard, ed. (Paris, 1970), 245–46. Zola's remarks on the hanging of *Sleeping Girl with a Cat* are translated in White, *Renoir,* 97. The picture was also exhibited in 1882 at the seventh Impressionist exhibition, where it attracted favorable, if unilluminating, notices. For a sample of the critics' comments, see Charles S. Moffett et al., *The New Painting: Impressionism 1874–1886,* exh. cat. (San Francisco: The Fine Arts Museums of San Francisco, 1986), 411.

[14] Draner, "Une Visite aux impressionnistes," *Le Charivari,* March 9, 1882.

[15] Jean Prouvaire, "L'Exposition du boulevard des Capucines," *Le Rappel,* April 20, 1874, translated in Hayward Gallery, *Renoir,* 204.

Bathers

[1] Lionello Venturi, *Les Archives de l'impressionnisme* (Paris and New York, 1939), 1: 117. Renoir's nudes, of course, show nothing of the cold, glassy surfaces and deformations of the body that so intriguingly temper the erotic content of Ingres's nudes.

[2] Jacques-Emile Blanche, *La Pêche aux souvenirs* (Paris, 1949), 435.

[3] Hayward Gallery, *Renoir,* exh. cat. (London, 1985), 232.

[4] François Daulte, *Auguste Renoir, Catalogue raisonné de l'oeuvre peint,* vol. 1, *Figures, 1860–1890* (Lausanne, 1971), no. 393. On the provenance of the picture, which is now in a private collection, and its relation to the Clark bather, see Hayward Gallery, *Renoir,* 234.

[5] For a discussion of the frescolike quality of the paint surface of *Bather Arranging Her Hair,* see Hayward Gallery, *Renoir,* 246.

[6] Ibid.

[7] On *Olympia*'s relation to the tradition of the nude and the picture's reception among Parisian critics, see T. J. Clark, *The Painting of Modern Life* (New York, 1984; reprint, Princeton, 1986), 79–146.

[8] John House writes that Renoir's earlier nudes were more available to the gaze, while *Blonde Bather*, by turning to the side and looking beyond the viewer, distances herself (Hayward Gallery, *Renoir,* 232). However, it can also be argued that by averting her eyes, Renoir makes it easier for the viewer to peruse her body.

[9] Georges Rivière, *Renoir et ses amis* (Paris, 1921), 201.

[10] See Hayward Gallery, *Renoir,* 232, for a discussion of the relation between figure and ground. The essay, by John House, underestimates Renoir's attempt to integrate the bather into the seascape.

[11] Ambroise Vollard, *Renoir: An Intimate Record*, trans. Harold L. van Doren and Randolph T. Weaver (New York, 1925), 118.

[12] Letter to Durand-Ruel, March 1881, trans. in Nicholas Wadley, ed., *Renoir: A Retrospective* (New York, 1987), 136. See also Emile Zola, "Naturalism at the Salon," *Le Voltaire,* June 19, 1980, trans. in Wadley, 136. Zola acknowledged the continued importance of the Salon for securing an artist's reputation and supported Renoir's decision to exhibit there.

[13] It has been suggested that Renoir also painted wedding rings on many of his nudes in order to attract more conservative clients. See Barbara Ehrlich White, "Renoir's Trip to Italy," *Art Bulletin* 51 (December 1969): 340, 342–44, 346, and Anthea Callen, *Renoir* (London, 1978), 74. House, however, points out that wedding rings were not standard features of conventional nudes (Hayward Gallery, *Renoir,* 232).

[14] On this tendency, see Kathleen Adler, "Reappraising Renoir," *Art History* 8, no. 3 (September 1985): 376. As Linda Nochlin observes, the "natural" is hardly natural; instead, it is a constructed category, with meanings and uses shaped by, and therefore changed according to, different historical conditions. See Linda Nochlin, "Renoir's Men: Constructing the Myth of the Natural," in "Renoir: A Symposium," *Art in America* 74, no. 3 (March 1986): 103.

[15] In addition to Adler and Nochlin, see Tamar Garb, "Renoir and the Natural Woman," *Oxford Art Journal* 8, no. 2 (1985): 3–15; Desa Philippi, "Desiring Renoir: Fantasy and Spectacle at the Hayward," *Oxford Art Journal* 8, no. 2 (1985): 16–20; Marcia Pointon, *Naked Authority: The Body in Western Painting, 1830–1908* (Cambridge, 1990), 83–97; and Anthea Callen, "Renoir: The Matter of Gender," in John House, ed., *Renoir, Master Impressionist* (Sydney: Art Exhibitions Australia, 1994), 41–51.

[16] Garb, 9–15. On changes in the status of women in late-nineteenth-century France, see also Deborah Silverman, *Art Nouveau in Fin-de-Siècle France: Politics, Psychology, and Style* (Berkeley, 1989), 63–74, and idem, "The 'New Woman,' Feminism, and the Decorative Arts in Fin-de-Siècle France," in Lynn Hunt, ed., *Eroticism and the Body Politic* (Baltimore and London, 1991), 144–63.

[17] Reprinted in Daulte, 53, and trans. in Wadley, 169.

[18] Jean Renoir, *Renoir, My Father,* trans. Randolph and Dorothy Weaver (London, 1962), 82.

[19] This summary comes from Wadley, 32.

[20] On Renoir's ideal world, see John House, "Renoir and the Earthly Paradise," *Oxford Art Journal* 8, no. 2 (1985): 21–27, and idem, "Renoir: Between Country and City," in House, ed., *Renoir, Master Impressionist,* 13–27.

IMAGES OF MEN

[1] John Rewald, *The History of Impressionism,* 4th rev. ed. (New York, 1973), 354, and Barbara Ehrlich White, *An Analysis of Renoir's Development from 1877 to 1887* (Ann Arbor, 1965), 88–89.

[2] De Bellio owned eighty-two Impressionist paintings, including Monet's *Impression, Sunrise* (1873; Musée Marmottan, Paris), the painting which inspired the group's name. For a discussion of de Bellio and his collection, see Remus Niculescu, "Georges de Bellio, l'ami des impressionnistes (I)," *Paragone* 21, no. 247 (September 1970): 25–66, and "Georges de Bellio, l'ami des impressionnistes (II)," *Paragone* 21, no. 249 (November 1970): 41–85.

[3] Ambroise Vollard, *Renoir: An Intimate Record,* trans. Harold L. van Doren and Randolph T. Weaver (New York, 1925), 79. Although one cannot be assured of the validity of Vollard's text, his story is confirmed

by Niculescu, "Georges de Bellio (I)": 54. Other sources such as Barbara Ehrlich White, *Renoir: His Life, Art, and Letters* (New York, 1984), 91, and Melissa McQuillan, *Impressionist Portraits* (Boston, 1986), 118, suggest that Renoir gave this portrait to de Bellio in gratitude for the doctor's services. De Bellio did indeed treat many of the Impressionists and their families and friends, including Renoir's model Margot Legrand. Legrand died in 1879 of smallpox, and White and McQuillan propose that Renoir gave de Bellio this painting at the time of her death.

[4] Jean Renoir, *Renoir, My Father,* trans. Randolph and Dorothy Weaver (Boston and Toronto, 1958, 1962), 28.

[5] White, *Renoir: His Life, Art, and Letters,* 213. This theory is also put forth in Hayward Gallery, *Renoir,* exh. cat. (London, 1985), 270. The French is given in Julie Manet, *Journal (1893–1899)* (Paris, 1979), 249: "C'est si pénible de le voir le matin n'ayant pas la force de tourner un boutin de porte. Il termine un portrait de lui qui est très joli[;] il s'était d'abord fait un peu dur et trop ridé; nous avons exigé qu'il supprimât quelques rides et maintenant c'est plus lui. 'Il me semble que c'est assez ces yeux de veau', dit-il."

[6] Denys Sutton, "Renoir's Kingdom," *Apollo* 121 (April 1985): 243; Sean Kelly and Edward Lucie-Smith, *The Self Portrait: A Modern View* (London, 1987), 18; and White, *Renoir: His Life, Art, and Letters,* 213.

[7] Renoir also painted at least two portraits of Alphonsine Fournaise, the restaurateur's daughter. One, from 1879, is in the Musée d'Orsay, Paris, and the other, from 1875, is in the Museu de Arte de São Paulo, Brazil.

[8] Robert L. Herbert, *Impressionism: Art, Leisure, and Parisian Society* (New Haven and London, 1988), 247; for more information about this area, see the section entitled, "Rowing and Dining at Chatou," 246–54.

[9] For a more complete discussion of this painting, see Martha Carey, *Pierre-Auguste Renoir: The Luncheon of the Boating Party* (Washington, D.C., 1981).

[10] Vollard, *Renoir: An Intimate Record,* 49.

[11] Renoir, *Renoir, My Father,* 210. In Vollard's biography, Renoir claimed that Fournaise ordered a portrait of himself and his daughter as a means of thanking the painter for bringing him additional clientele; see Vollard, *Renoir: An Intimate Record,* 50. Both biographies were written many years after the fact and it is impossible to say whether or not either account is entirely truthful.

[12] Vollard, *Renoir: An Intimate Record,* 50.

[13] Ibid. Renoir remembered the portrait as follows, "I painted Papa Fournaise in his white café vest, in the act of drinking absinthe." In reality, Fournaise wears a white shirt and dark vest and appears to be drinking not absinthe but beer.

[14] *Monsieur Fournaise* has been compared to Manet's *Good Beer (Le Bon Bock,* 1873; Philadelphia Museum of Art), which shows a man seated at a café table, smoking a pipe and drinking a beer. Manet's friend the engraver and lithographer M. Bellot posed for the painting, but it is in no way intended as a portrait. The painting was favorably reviewed when shown at the Salon of 1873 and certainly was familiar to Renoir. See McQuillan, 108, and Alfred M. Frankfurter, "The Portraiture of Renoir: An Important Exhibition Concentrating on His Portraits," *Artnews* 37 (March 25, 1939): 10.

[15] As quoted in John Rewald, "Auguste Renoir and His Brother," in *Studies in Impressionism,* Irene Gordon and Frances Weitzenhoffer, eds. (New York, 1985), 18.

[16] For a discussion of a contemporary portrait of another of Renoir's sponsors, Eugène Murer, in which the artist does try to gain a sense of personality, see Colin B. Bailey, Joseph J. Rishel, and Mark Rosenthal, with the assistance of Veerle Thielemans, *Masterpieces of Impressionism and Post-Impressionism: The Annenberg Collection,* exh. cat. (Philadelphia: Philadelphia Museum of Art, 1989), 33–35, 144–46.

IMAGES OF CHILDHOOD
Portraits of Children

[1] Maurice Berard, "Un Diplomate ami de Renoir," *Revue d'histoire diplomatique,* July–September 1956: 239.

[2] Ibid., 240.

[3] Letter from Paul Berard to Charles Deudon, reprinted in Anne Distel, "Charles Deudon (1832–1914), collectionneur," *Revue de l'art* 86 (1989): 62.

[4] Barbara Ehrlich White, *An Analysis of Renoir's Development from 1877 to 1887* (Ann Arbor, 1965), 88.

[5] Letter from Christian Thurneyssen, April 20, 1976, SFCAI curatorial file.

[6] Letter from Christian Thurneyssen, December 26, 1971, SFCAI curatorial file.

[7] Letter from Christian Thurneyssen, April 20, 1976, SFCAI curatorial file.

[8] Jacques-Emile Blanche, *Portraits of a Lifetime* (London, 1937), 37–38.

[9] François Daulte, *Renoir* (New York, 1972), 86–92.

[10] White, *An Analysis of Renoir's Development,* 92.

[11] Melissa McQuillan, *Impressionist Portraits* (Boston, 1986), 15.

[12] Jacques-Emile Blanche, "Renoir portraitiste," *L'Art vivant,* July 1933: 292.

[13] François Daulte, *Renoir,* 35.

[14] Hayward Gallery, *Renoir,* exh. cat. (London, 1985), 184. The painting is today in the Museu de Arte de São Paulo, Brazil.

[15] Otto Friedrich, *Olympia: Paris in the Age of Manet* (New York, 1992), 148.

[16] Ambroise Vollard, *Renoir: An Intimate Record,* trans. Harold L. van Doren and Randolph T. Weaver (New York, 1934), 109.

[17] Thanks to Dave Steadman, Curator of Birds at the New York State Museum in Albany.

[18] Mary Anne Stevens, ed., *The Orientalists: Delacroix to Matisse* (London, 1984), 20.

[19] Albert Barnes and Violette de Mazia, *The Art of Renoir* (Merion, Pa., 1963), 80.

[20] James Thompson, *The East: Imagined, Experienced, Remembered, Orientalist Nineteenth Century Painting,* exh. cat. (Dublin: National Gallery of Ireland, 1988), 48.

[21] Daulte does state that it was owned by the girl's father until 1888. See François Daulte, "Des Renoir et des chevaux," *Connaissance des arts,* September 1960: 31 caption 9.

[22] Lynne Thornton, *Woman as Portrayed in Orientalist Painting* (Paris, 1985), 206.

[23] Jean Alazard, "Les Peintres de l'Algérie au XIXe siècle," *Gazette des beaux-arts* 3 (June 1930): 386.

[24] Barbara Ehrlich White, *Renoir: His Life, Art, and Letters* (New York, 1984), 217–19.

[25] Anne Donald, "Renoir's Madame X in Glasgow," *Scottish Art Review* 10, no. 4 (1966): 23.

[26] Notes from an undated conversation with Jacques Fray, SFCAI curatorial files.

[27] Jacques Fray died in 1963, but his date of birth is not known.

Portrait of a Pet

[1] Duret defended the Impressionists in a series of Salon reviews and wrote a biography of his friend Renoir that was published in 1924.

[2] Robert Rosenblum, *The Dog in Art: From Rococo to Post-Modernism* (New York, 1988), 53.

[3] A second portrait of Tama painted by Renoir is now in a private collection in Berlin. Manet's portrait is in the Mellon collection, on view at the National Gallery of Art, Washington, D.C. Renoir was not averse to painting animals and in one instance rated them above his more usual female subjects: "Cats are the only women who count, the most amusing to paint. But I remember a big nanny goat: a superb girl! I've liked doing Pekinese too. When they pout they can be exquisite." Jean Renoir, *Renoir, My Father,* trans. Randolph and Dorothy Weaver (Boston and Toronto, 1958, 1962), 65.

[4] It has been suggested that this section of the canvas was partially covered during a past restoration; see SFCAI curatorial file.

[5] See Manet's portrait of a Bichon Frise named Douki (c. 1876; private collection) for a similar treatment of a dog's collar, *Edouard Manet,* exh. cat. (Tokyo, Isetan Museum of Art, Shinjuku, 1986), no. 19.

LANDSCAPES

Suburban Views

[1] The Renoir literature unfortunately reinforces this lack of knowledge. To date, Renoir's landscape practice remains little analyzed. Though Daulte has catalogued the figure paintings from 1860 to 1890, there is no comparable volume for the landscape paintings.

[2] Renoir's paintings, all titled *La Grenouillère,* are in the collections of the Pushkin Museum, Moscow, and the Nationalmuseum, Stockholm; in the Oskar Reinhard Collection, Winterthur; and in a private collection.

[3] The areas around Paris changed in the late nineteenth century because of industrialization, the rebuilding of Paris under the direction of Baron Haussmann, and the expansion of the rail system, which enabled people to leave the city more easily. On the relationship between the suburbs and landscape painting, see T. J. Clark, *The Painting of Modern Life* (New York, 1984; reprint, Princeton, 1986), 147–204. An excellent source of general information about and analysis of late-nineteenth-century landscape painting is Richard Brettell et al., *A Day in the Country: Impressionism and the French Landscape,* exh. cat. (Los Angeles: Los Angeles County Museum of Art, 1984).

[4] In conversation, Christopher Riopelle, Associate Curator of European Paintings at the Philadelphia Museum of Art, suggested Renoir's choice of subjects may have been influenced by Pissarro and Monet, both of whom, on various occasions and with various approaches, dealt with the incursion of industry, urbanism, and tourism on the landscape.

[5] Gustave Geffroy, "Auguste Renoir," *La Vie artistique* (Paris, 1894), 111, quoted in Nicholas Wadley, ed., *Renoir: A Retrospective* (New York, 1987), 187.

[6] Though the title indicates that Renoir has depicted the stretch of the Seine at Argenteuil, it is equally possible, given the prominent rowboats, that the setting is Asnières or Chatou, both centers for that sport. Argenteuil, by contrast, was better known for sailing. Whatever its location, *Rowers at Argenteuil* places a premium on relaxation and beauty. Evoking the leisurely pace of a summer day, the boats move quietly across the river, disturbing neither the water nor the ducks that paddle contentedly to the right. Renoir fashions a more intimate, less ambiguous viewpoint here than in the Clark landscapes of Chatou and Meudon, situating the spectator on the bank near the seated woman, where he or she can easily and unproblematically enjoy the activity on the river. He sketchily indicates a house on the opposite bank, but craftily uses the large tree to block out most of the distant shore. The tree also gives the patch of foreground a sense of seclusion and shelter, which contributes to the picture's overall themes of harmony and pleasure.

[7] On Pontoise, see Richard Brettell, *Pissarro and Pontoise* (New

Haven and London, 1990), and on Argenteuil, see Paul H. Tucker, *Monet and Argenteuil* (New Haven, 1982).

[8] On images of railroad bridges and their associations, see Robert L. Herbert, *Impressionism: Art, Leisure, and Parisian Society* (New Haven and London, 1988), 220–22.

Italian Scenes

[1] Quoted in Barbara Ehrlich White, "Renoir's Trip to Italy," *Art Bulletin* 51, no. 4 (December 1969): 346.

[2] Ibid., 348.

[3] Ibid., 347.

[4] See, for example, the boat with the orange sail on the right side, apparently a gondola transformed into a sailboat.

[5] Letter to Madame Georges Charpentier; quoted in White, 348.

[6] White, 347.

Seascapes

[1] On painting and tourism in Normandy, see Sylvie Gache-Patin and Scott Schaefer, "Impressionism and the Sea," in Richard Brettell et al., *A Day in the Country: Impressionism and the French Landscape,* exh. cat. (Los Angeles: Los Angeles County Museum of Art, 1984), 273–97.

[2] The related sketches are in the Art Institute of Chicago and a private collection. The latter work is illustrated and analyzed in John House, ed., *Renoir, Master Impressionist,* exh. cat. (Sydney: Art Exhibitions Australia, 1994), 77. The three canvases show an expanse of water and a band of sky behind. In all three, there is a sense of disorientation, since it is not clear where the viewer would be situated in order to take in the panoramic sweep of sea and sky.

[3] Clark bought the work from Durand-Ruel in New York as *Marine Soleil Couchant,* 1879. It was subsequently redated to 1883, but in view of its relation to the two versions of *The Wave,* the earlier date seems more accurate.

[4] Take, for example, a painting like *Garden in Rue Cortot, Montmartre* (1876; Museum of Art, Carnegie Institute, Pittsburgh). The work certainly shows flecked, seemingly quick brushwork, a flattening and dissolution of form, and a tendency in various passages to push representation to its limits. At the same time, however, the "spontaneous" application of paint seems deliberate and stiff, and in some sections—the leafless branch sticking up in the foreground, the growth sprouting from the ground, and the flowers—Renoir insists on blending the paint, modeling the forms, and defining their edges.

[5] The phrase comes from a letter Renoir wrote on September 27, 1883, to Durand-Ruel from Guernsey. The letter is reproduced in Lionello Venturi, *Les Archives de l'impressionnisme* (Paris and New York, 1939), 1:125–26, and translated in John House, *Renoir in Guernsey,* exh. cat. (Guernsey: Guernsey Museum and Art Gallery, 1987), 15.

[6] My discussion of Guernsey and Renoir's trip derives largely from House, *Renoir in Guernsey,* a good brief account of the history and economy of the island and the artist's activities there.

[7] Ibid., 8, 16 n. 12.

[8] Ibid., 8.

[9] "A Selection from the Pictures of Boudin, Cézanne, Degas, Manet, Monet, Morisot, Pissarro, Renoir, Sisley," London, Grafton Galleries, January–February 1905, no. 245. The show was organized by Durand-Ruel.

[10] It was sold by Durand-Ruel to Clark as *Marine à Guernsey.*

[11] My thanks to Steven Kern for bringing the relation between the Clark and Barnes pictures to my attention. In his consideration of the Guernsey pictures, House argues that the seascape resembles the beach and coastline of Yport, but does not link the canvas with the Barnes picture; see *Renoir in Guernsey,* 19. For a discussion of the Barnes

picture, see *Great French Paintings from the Barnes Foundation* (New York, 1993), 60–63.

[12] House, *Renoir in Guernsey*, 13–14.

[13] Renoir to Durand-Ruel, letter no. 1/95, Archives Durand-Ruel. Quoted in Judy Le Paul, *Gauguin and the Impressionists at Pont-Aven* (New York, 1983), 144.

STILL LIFES

[1] Georges Rivière, *Renoir et ses amis* (Paris, 1921), 81; trans. (London, Paris, Boston, 1985), 183.

[2] Quoted in Nicholas Wadley, ed., *Renoir: A Retrospective* (New York, 1987), 34.

[3] Julie Manet, *Journal (1893–1899)* (Paris, 1979), 190.

[4] This is not to say that still-life painting has never posed difficult issues for a painter or intriguing interpretive problems for critics. For an analysis of the complexities of this deceptively straightforward genre, see Norman Bryson, *Looking at the Overlooked* (Cambridge, Mass., 1990).

[5] Lionello Venturi, *Les Archives de l'impressionnisme* (Paris and New York, 1939), 1: 117, translated in Barbara Ehrlich White, *Renoir: His Life, Art, and Letters* (New York, 1984), 115.

[6] Edmond and Jules de Goncourt, *French XVIII Century Painters*, trans. Rubin Ironside (New York, 1948), 116. The Goncourts did much to revive Chardin's reputation in the late nineteenth century.

[7] Renoir praised these frescoes in a letter to Marguerite Charpentier. The passage is quoted in White, *Renoir*, 115.

DECORATIVE COMPOSITIONS

[1] Ambroise Vollard, *Renoir: An Intimate Record*, trans. Harold L. van Doren and Randolph T. Weaver (New York, 1934), 23.

[2] Auguste Renoir, "Contemporary Decorative Painting," *L'Impressionniste* 4 (April 28, 1877): 5.

[3] Kathleen Adler, "Renoir, His Patrons and His Dealer," in John House, ed., *Renoir, Master Impressionist*, exh. cat. (Sydney: Art Exhibitions Australia, 1994), 32.

[4] For a discussion of Renoir's efforts to distance himself from the stigma of being grouped with the Impressionists, see especially Barbara Ehrlich White, *An Analysis of Renoir's Development from 1877 to 1887* (Ann Arbor, 1965), 88–109.

[5] Renoir painted many portraits of the Berard family, including two in the Clark collection: *Studies of the Berard Children* and *Thérèse Berard*.

[6] Jean Renoir, *Renoir, My Father,* trans. Randolph and Dorothy Weaver (London, 1962), 127.

[7] For more on Renoir's early artistic training, see François Daulte, *Renoir* (New York, 1972), 12–14.

[8] Jacques-Emile Blanche, *Portraits of a Lifetime* (London, 1937), 37.

[9] Letter from Renoir to Paul Berard, reprinted in François Daulte, "Renoir et la famille Berard," *L'Oeil* 222 (February 1974): 7.

[10] See Maurice Berard, *Renoir à Wargemont* (Paris, 1938).

[11] Vollard, *Renoir: An Intimate Record,* 25.

[12] Maurice Berard, "Un Diplomate ami de Renoir," *Revue d'histoire diplomatique,* July–September 1956: 245.

[13] This article, from *La Presse,* April 29, 1874, is reprinted in its entirety in Jean Renoir, *Renoir, My Father,* 144–45. Dr. Blanche's early opinions on the work of the Impressionists are not known.

[14] Nicholas Wadley, ed., *Renoir: A Retrospective* (New York, 1987), 137–38. Renoir was also engaged as a painting instructor for Jacques-Emile Blanche, the couple's son, who went on to become a well-respected and prolific painter and author. He later purchased Renoir's first version of *The Bathers* (1887; Philadelphia Museum of Art).

[15] Apparently, these two larger works were intended to be accompanied by no fewer than eight smaller ones, also devoted to a Wagnerian opera, *The Ring of the Nibelungs,* but these were never executed. See Jacques-Emile Blanche, *La Pêche aux souvenirs* (Paris, 1949), 151 n. 2.

[16] François Daulte, *Renoir* (New York, 1972), 74.

[17] Otto Friedrich, *Olympia: Paris in the Age of Manet* (New York, 1992), 126.

[18] Charles Baudelaire, "Richard Wagner et *Tannhäuser* à Paris," in *Selected Writings on Art and Artists*, trans. P. E. Charvet (Baltimore, 1972), 325–57.

[19] This unsuccessful portrait was rejected by the patron who commissioned it, either the Charpentiers or another friend, Judge Lascoux, and it stayed in the artist's collection for several years. See Barbara Ehrlich White, *Renoir: His Life, Art, and Letters* (New York, 1984), 92, and Daulte, *Renoir,* 42.

[20] Jean Renoir, *Renoir, My Father*, 170.

[21] Jeanne Baudot, *Renoir: Ses amis, ses modèles* (Paris, 1949), 77.

[22] Henri Fantin-Latour's *Tannhäuser on the Venusberg* was exhibited in the 1864 Salon and is today in the Los Angeles County Museum of Art.

[23] John House and Alexandra Murphy, *Renoir Retrospective*, exh. cat. (Nagoya: Nagoya City Art Museum, 1988), 244.

PIERRE-AUGUSTE RENOIR

A BRIEF BIOGRAPHICAL CHRONOLOGY

1841 born in Limoges, sixth child of Léonard Renoir and Marguerite Merlet, February 25

1844 moves with family to Paris

1854–58 begins apprenticeship as a porcelain painter with Levy Brothers and Company in Paris

1858–59 works as decorator painting blinds

1860–64 has yearly passes to copy paintings at the Louvre

1861–64 studies in the studio of Charles Gleyre, where he meets Claude Monet, Alfred Sisley, and Frédéric Bazille

1862 admitted to the Ecole des Beaux-Arts

1863 meets Paul Cézanne and Camille Pissarro; in spring and summer paints en plein air in the Fontainebleau forest, where he meets Gustave Courbet, Narcisse Diaz, Camille Corot, and Charles Daubigny

1866–70 shares a studio with Bazille and, on occasion, Monet

1869 works with Monet at La Grenouillère at Bougival, where he paints his first Impressionist landscapes

1870 drafted into the military during the Franco-Prussian War; stationed in Libourne; Bazille killed, November 28

1872 introduced by Monet to Paul Durand-Ruel, who purchases his paintings *Flowers* and *Pont des Arts*; works with Monet in Argenteuil

1874 shows seven works in the first Impressionist exhibition; his father dies, December 22

1876 shows sixteen works in the second Impressionist exhibition

1877 shows twenty-one works in the third Impressionist exhibition

1879 has success at the Paris Salon with *Madame Charpentier and Her Children*; meets Paul Berard through the Charpentiers, summers in Wargemont with the Berard family; meets Aline Charigot

1880 has success at the Paris Salon with *Sleeping Girl with a Cat*

1881 travels to Algeria, mid-February through mid-April; summers in Wargemont with the Berard family; departs for Italy, stopping in Venice, Rome, Florence, Naples, Sorrento, Capri, late October

1882 remains in Italy through January, visiting Naples and Palermo; visits Cézanne in L'Estaque; travels to Algeria, March 5 through May 3; Durand-Ruel sends twenty-five of Renoir's works to the seventh Impressionist exhibition; summers in Wargemont with the Berard family

1883 seventy works shown at Durand-Ruel Galleries in first one-man exhibition, April 1–25; visits Mediterranean coast with Monet, stopping at Marseilles, Hyères, St.-Raphaël, Monte Carlo, Menton, Bordighera, Genoa, December 16–30

1884 spends summer in Wargemont with the Berard family

1885 Aline Charigot gives birth to son Pierre, March 21; spends November in Wargemont with the Berard family

1888 afflicted with rheumatoid arthritis

1890 marries Aline Charigot in Paris, April 14

1891 travels to Toulon, Tamaris-sur-Mer, Les Martigues, Le Lavandou, Nîmes, January through April

1892 French Government purchases *Girls at the Piano*; has one-man exhibition of 110 works at Durand-Ruel Galleries

1894 second son, Jean, born September 15

1896 his mother dies, November 11

1898 visits Cagnes-sur-Mer; purchases home in Essoyes

1899 in Cagnes-sur-Mer and Nice, mid-February through mid-April

1900 appointed Chevalier of the French Legion of Honor

1901 third son, Claude (Coco), born August 4

1905 patrons Georges Charpentier and Paul Berard (whose collection is sold at the Galerie Georges Petit in Paris) die

1907 buys property, Les Collettes, in Cagnes-sur-Mer, to build new home and studio

1911 biography published by Julius Meier-Graefe, the first major work on any of the Impressionists; promoted to Officier of the French Legion of Honor

1912 suffers a stroke and recovers

1914 World War I begins; Pierre and Jean enlist in the military, both wounded in action

1915 Aline dies, June 27

1919 promoted to Commandeur of the French Legion of Honor; dies, December 3

KB

SELECTED BIBLIOGRAPHY

Major sources are given below. The reader is directed to the notes for additional sources.

André, Albert. *Renoir*. Paris: G. Cress, 1928.

Bade, Patrick. *Renoir*. London: Studio Editions, 1990.

Barnes, Albert C., and Violette de Mazia. *The Art of Renoir*. Merion, Pa.: Barnes Foundation Press, 1963.

Baudot, Jeanne. *Renoir, ses amis, ses modèles*. Paris: Editions Littéraires de France, 1949.

Berard, Maurice. *Renoir à Wargemont*. Paris: Larose, 1939.

Bernheim-Jeune [Gallery]. *Exposition A. Renoir*. Exhibition catalogue, January 25–February 10, 1900. Paris: Les Galeries, 1900.

Brettell, Richard, et al. *A Day in the Country: Impressionism and the French Landscape*. Exhibition catalogue. Los Angeles: Los Angeles County Museum of Art, 1984.

Cabanne, Pierre. *Renoir*. Paris: Réalités-Hachette, 1970.

California Palace of the Legion of Honor. *Paintings by Pierre Auguste Renoir: An Exhibition Commemorating the Twentieth Anniversary of the Opening of the Museum*. Exhibition catalogue, November 1–30, 1944. San Francisco: California Palace of the Legion of Honor, 1944.

Chambaudet, Jacques. *Renoir: Vision & technique*. Paris: Editions Pétrides, 1947–48.

Coginat, Raymond. *Renoir: Children*. New York: Tudor Publishing, 1958.

Daulte, François. *Auguste Renoir*. Milan: Fratelli Fabbri Editori, 1972.
————. *Auguste Renoir. Catalogue raisonné de l'oeuvre peint*. With a foreword by Jean Renoir and a preface by Charles Durand-Ruel. Lausanne: Editions Durand-Ruel, 1971.
————. *Renoir*. Garden City, N.Y.: Doubleday, 1973.

De Grada, Raffaele. *Renoir*. Translated by Andrew Cannon and Jay Hyams. New York: Arch Cape Press, 1989.

Distel, Anne. *Renoir, "Il faut embellir."* Paris: Gallimard; Réunion des Musées Nationaux, 1993.

Durand-Ruel Galleries. *Exhibition of Masterpieces by Renoir after 1900; for the Benefit of Children's Aid Society*. Exhibition catalogue, April 1–25, 1942. New York: Durand-Ruel, 1942.

Duret, Théodore. *Renoir*. Paris: Bernheim-Jeune, 1924.

Duveen Brothers. *Renoir: Centennial Loan Exhibition, 1841–1941, for the Benefit of the Free French Relief Committee, November 8–December 6, 1941*. Exhibition catalogue. New York: W. Bradford, 1941.

Faison, S. Lane. *Renoir's hommage à Manet*. Berlin: Gebr. Mann, 1973.

Fierens, Paul. *Renoir classique*. Paris: Art Vivant, 1933.

Florisoone, Michel. *Renoir*. Paris: Editions Hyperion, 1937.

Fosca, François [pseud.]. *Renoir; l'homme et son oeuvre*. Paris: Editions Aimery Somogy, 1961.

Fox, Milton S. *Pierre Auguste Renoir*. New York: Abrams, 1972.

Gaunt, William. *Renoir*. With notes by Kathleen Adler. Oxford: Phaidon, 1982.

Hanson, Lawrence. *Renoir: The Man, the Painter, and His World*. New York: Dodd, Mead, 1968.

Hayes, Colin. *Renoir*. London: Hamlyn, 1967.

Hayward Gallery, London. *Renoir*. Exhibition catalogue. London: Arts Council of Great Britain, 1985.

Herbert, Robert L. *Impressionism: Art, Leisure, and Parisian Society*. New Haven and London: Yale University Press, 1988.

House, John, ed. *Renoir, Master Impressionist*. Exhibition catalogue, Queensland Art Gallery. Sydney: Art Exhibitions Australia, 1994.

M. Knoedler & Co. *The Classical Period of Renoir, 1875–1886*. Exhibition catalogue, November 4–24, 1929. New York: [Knoedler], 1929.

Leymarie, Jean. *Renoir*. London: Eyre Methuen; Woodbury, N.Y.: Barron's, 1979.

Los Angeles County Museum of Art. *Pierre Auguste Renoir, 1841–1919: Paintings, Drawings, Prints and Sculpture*. Exhibition catalogue. Los Angeles: Los Angeles County Museum of Art, 1955.

Meier-Graefe, Julius. *Renoir*. Leipzig: Klinkhardt & Biermann, 1929.

The Metropolitan Museum of Art. *Renoir, A Special Exhibition of His Paintings*. Exhibition catalogue, May 18–September 12, 1937. New York: William Bradford Press, 1937.

Moffett, Charles S., et al. *The New Painting, Impressionism 1874–1886*. Exhibition catalogue. San Francisco: The Fine Arts Museums of San Francisco, 1986.

Musée de l'Orangerie. *Exposition Renoir*. Exhibition catalogue. Paris: Musées Nationaux, 1933.

Nagoya City Art Museum. *Renoir Retrospective*. Exhibition catalogue, October 15–December 11, 1988. Nagoya: Chunichi Shinbun, 1988.

Nochlin, Linda. *Bathtime: Renoir, Cézanne, Daumier and the Practices of Bathing in Nineteenth-Century France*. Groningen: Gerson Lectures Foundation, 1991.
————. *Impressionism and Post-Impressionism, 1874–1904*. Englewood Cliffs, N.J.: Prentice-Hall, 1966.

Pach, Walter. *Pierre Auguste Renoir*. New York: Abrams, 1960.

Phillips Collection and Martha Carey. *Pierre-Auguste Renoir: The Luncheon*

of the Boating Party. Mount Vernon, N.Y.: Artist's Limited
Collection, 1981.

Renoir, Jean. *Renoir, My Father*. Translated by Randolph and Dorothy
Weaver. Boston and Toronto: Little Brown, 1958, 1962; London:
Collins, 1962.
Rewald, John. *The History of Impressionism*. 4th rev. ed. New York:
Museum of Modern Art, 1973.
————. *Studies in Impressionism*. New York: Abrams, 1986.
Rivière, Georges. *Renoir et ses amis*. Paris: H. Floury, 1921; translated
London, Paris, Boston, 1985.
Roger-Marx, Claude. *Renoir*. Paris: Floury, 1937.

Schneider, Bruno F. *Renoir*. Translated by Desmond and Camille
Clayton. New York: Crown, 1984.

Vollard, Ambroise. *Renoir, An Intimate Record*. Translated by Harold L.
van Doren and Randolph T. Weaver. New York: Knopf, 1925, 1934.
————. *La Vie et l'oeuvre de Pierre-Auguste Renoir*. Paris: A. Vollard, 1919.

Wadley, Nicholas, ed. *Renoir: A Retrospective*. New York: Hugh Lauter
Levin, 1987.
Wheldon, Keith. *Renoir and His Art*. London, New York: Hamlyn, 1975.
White, Barbara Ehrlich. *An Analysis of Renoir's Development from 1877 to
1887*. Ann Arbor: University Microfilms, 1965.
————. *Renoir: His Life, Art, and Letters*. New York: Abrams, 1984.
————. "Renoir's Trip to Italy." *Art Bulletin* 51, no. 4 (December 1969).
Wildenstein and Company. *Renoir, the Gentle Rebel: A Loan Exhibition for
the Benefit of the Association for Mentally Ill Children*. Exhibition
catalogue, October 24–November 30, 1974. New York:
Wildenstein, 1974.

Numbers in *italics* indicate pages with illustrations.